JOHN RUSKIN

Modern Critical Views

These and other titles in preparation

Modern Critical Views

JOHN RUSKIN

Edited and with an introduction by
Harold Bloom
Sterling Professor of the Humanities
Yale University

CHELSEA HOUSE PUBLISHERS ◇ 1986
New York ◇ New Haven ◇ Philadelphia

© 1986 by Chelsea House Publishers,
a division of Chelsea House Educational Communications, Inc.
 133 Christopher Street, New York, NY 10014
 345 Whitney Avenue, New Haven, CT 06511
 5014 West Chester Pike, Edgemont, PA 19028

Printed and bound in the United States of America

∞ The paper used in this publication meets the minimum re-
quirements of the American National Standard for Permanence of
Paper for Printed Library Materials, Z39.48–1984.

Library of Congress Cataloging-in-Publication Data
Main entry under title:
John Ruskin.

 (Modern critical views)
 Bibliography: p.
 Includes index.
 1. Ruskin, John, 1819–1900—Criticism and interpretation—
Addresses, essays, lectures.
I. Bloom, Harold. II. Series.
PR 5264.J63 1986 828′.809 86–940
ISBN 0–87754–692–4 (alk. paper)

862704

Contents

Editor's Note

This book gathers together a representative selection of the best criticism devoted to the work of John Ruskin during the period from 1965 through 1985, arranged in the chronological order of its composition. I am grateful to Henry Finder for his erudition and insight as a researcher, in helping me to edit this volume.

The editor's introduction, originally published in 1965 in an edition of Ruskin's literary criticism, centers upon Ruskin's achievement as a literary theorist and student of myth. George Landow's analysis of the relation between Ruskin's typology and Evangelical modes of reading the Bible traces the origins of Ruskin's strong refusal to see allegory and symbolism as being antithetical to one another. Venice as an allegory of Ruskin's own mind, a labyrinthine city representing a capriciously sinuous consciousness, is the subject of the meditation by Jay Fellows, the most labyrinthine of Ruskin's exegetes.

With John Dixon Hunt's exploration of Ruskin's revision of the picturesque mode, we enter a much more historicizing kind of inquiry, which is developed further in William Arrowsmith's investigation of Ruskin's obsessive conceptual image of fireflies. Arrowsmith intricately demonstrates how Ruskin transforms personal compulsiveness into prophetic art. No less intricately, Stephen Bann argues that Ruskin's refusal to develop a coherent theory of representation is indicated with striking force by the equivocal treatment that Ruskin gives to the question of aesthetic color.

Elizabeth Helsinger, linking Ruskin to Walter Benjamin as modern celebrants of a nostalgia for the Sublime, attempts to explain the difficult Ruskinian revision of the High Romantic Sublime. Some of the same concerns are analyzed in Gary Wihl's advanced study of Ruskin's epistemology of metaphor.

This book concludes with Sheila Emerson's return to Ruskin's origins as a writer, seeking out the genesis of his later, more elaborate critical inventions in his earliest work. In some sense, all of Ruskin's critics are driven back to origins, Ruskin's and their own, because that may be the largest power of his work, to compel us to the dangerous recognition that origin and aim cannot be separate

entities, however much we seek to honor Nietzsche's great injunction that, for the sake of life, we ought to keep them apart.

All references to Ruskin's works in this volume direct you to volume and page of the great edition of his writings: the *Library Edition, The Works of John Ruskin*, edited by E. T. Cook and Alexander Wedderburn, published in London from 1903 to 1910 by George Allen.

Introduction

—But there's a Tree, of many, one,
A single Field which I have looked upon,
Both of them speak of something that is gone:
The Pansy at my feet
Doth the same tale repeat:
Whither is fled the visionary gleam?
Where is it now, the glory and the dream?

Ruskin was born in London, on 8 February 1819, in the same year that Queen Victoria was born. His father, John James Ruskin, the son of a bankrupt, self-slain Edinburgh wine merchant, had prospered in partnership with the Domecq sherry vineyards, and aspired to raise himself out of his lower middle class position, though he was forced to put aside artistic and literary interests while he made his fortune. Ruskin's mother, Margaret Cox, was John James Ruskin's cousin, and had waited nine years to marry him, while he made his way in London. Energetic and shrewd as John James Ruskin was, he appears to have been a weaker character than his fiercely Evangelical wife, whose rigid nature dominated the formative years of her only child's life, and who clearly was responsible for the psychic malforming that made John Ruskin's emotional life a succession of disasters. Margaret Ruskin, before her son's birth, dedicated him to the service of God, intending him for the ministry. Nature intended otherwise, and made even of the infant Ruskin an aesthetic visionary, fascinated by the world of form and color. The world of language was revealed to the child, between the ages of four and fourteen, by daily Bible readings with his mother. That ten-year march and countermarch through the Book made Ruskin as Bible-soaked a writer as Milton or Blake, and formed the ultimate basis for the characteristic Ruskinian prose style, with its ornate and opulent diction, prophetic rhythm, and extraordinary emotional range.

1

Ruskin had the misfortune to be a child prodigy, as forced a one as John Stuart Mill. A poet at seven, educated largely at home, scarcely allowed friends, brooded over by a sternly loving mother and a totally indulgent and admiring father, Ruskin was ruined before his thirteenth birthday. He was ruined, one qualifies, in terms of his fully human potential, but not at all in regard to the unique gift that was his, and that his peculiar upbringing did much to nourish.

On his thirteenth birthday, Ruskin received the present of a copy of Samuel Rogers's long poem *Italy,* richly illustrated with steel engravings, including twenty-five plates from drawings by J. M. W. Turner. Immediately captured by Turner, Ruskin was to become an artist under this influence, but his painting like his poetry finally proved marginal, and the lasting effect of Turner was to confirm a critical gift of genius. As a critic of all the arts and of society, Ruskin became, and still remains, a unique figure in the European cultural tradition. This uniqueness was finally a uniqueness of sensibility, and cannot be understood apart from the history of sensibility.

The natural world Ruskin saw was half-created by his Romantic vision, a vision for which his personal sensibility provided the beginnings, but in which his great and essential teachers were Wordsworth and Turner, the dominant figures in the poetry and painting of their generation. Like Shelley before him, Ruskin was haunted throughout his life by Wordsworth's great "Ode: Intimations of Immortality from Recollections of Earliest Childhood." The fundamental experience of the Ode, and of "Tintern Abbey," is at one with the central and decisive experiences of Ruskin's life. Attempting to describe the unifying element in Ruskin's complex religious development, Derrick Leon, perhaps unintentionally, paraphrased "Tintern Abbey":

> Ruskin's real communion, throughout his life, was the communion of the artist and poet: his *panis supersubstantialis* those rare moments of fully awakened consciousness when the mind is detached and deliberately at rest; when the usual egotism of being is deliberately suppressed, and the emotional faculties, cleansed of all human desire and sorrow, respond in serenity and joy to the mystery and beauty of the external world.

In his old age, Ruskin looked back at his essential character as a child, and recognized again his affinity to Turner, Wordsworth, and Shelley, though he did not hesitate to give the preference to himself, the failed poet, over those who had succeeded:

> I was different, be it once more said, from other children even of my own type, not so much in the actual nature of the feeling, but in the mixture of it. I had, in my little clay pitcher, vialfuls, as it were, of

Wordsworth's reverence, Shelley's sensitiveness, Turner's accuracy, all in one. A snowdrop was to me, as to Wordsworth, part of the Sermon on the mount; but I never should have written sonnets to the celandine, because it is of a coarse, yellow and imperfect form. With Shelley, I loved blue sky and blue eyes, but never in the least confused the heavens with my own poor little Psychidion. And the reverence and passion were alike kept in their places by the constructive Turnerian element; and I did not weary myself in wishing that a daisy could see the beauty of its shadow, but in trying to draw the shadow rightly, myself.

This self-congratulatory paragraph tells us why Wordsworth and Shelley were poets, and Ruskin only a critic, albeit a great one. Reverence, sensitiveness, and accuracy, taken together, are the theological virtues for criticism, but the combination can thwart creation. Ruskin, at the age of nine, was a better poet than Ruskin at twenty, when he won the Newdigate Prize at Oxford. At nine, Ruskin wrote good Wordsworthian verse, better perhaps than Wordsworth was writing in 1828:

> Skiddaw, upon thy heights the sun shines bright,
> But only for a moment; then gives place
> Unto a playful cloud which on thy brow
> Sports wantonly, — then floats away in air, —
> Throwing its shadow on thy towering height;
> And, darkening for a moment thy green side,
> But adds unto its beauty, as it makes
> The sun more bright when it again appears.

But, by 1839, Ruskin's imagination had not the patience to wait upon the restraints of verse. He knew the truth, or many divisions of it, and he sought the prophet's style in which to deliver it. Fortunately, the truth always remained a poet's truth, and relied on the sources of visionary experience, known to Ruskin from his childhood on, and confirmed in him by his discovery of the visual equivalent in Turner's work.

Ruskin's life, from the revelation of Turner on to his disastrous marriage, was a continuous process of self-discovery, assured and "organic" in its development. Foreign tours, with his parents, encouraged his passion for close observation of nature, for the study of geology and botany, and for incessant sketching and versifying. Even his unreciprocated first love, for Adele Domecq, daughter of his father's business partner, created no more disturbance than could be quieted by an outpouring of much pseudo-Byronic verse. The closeness of the family-circle was not affected by his studies at Christ Church, Oxford, from

January 1837 on, as Mrs. Ruskin imperturbably settled in that city and required her son to appear for tea every evening, with Ruskin's father hastening to join them from London every weekend. Despite the family presence, Ruskin had a successful career at Oxford, composing his first book, *The Poetry of Architecture,* while still an undergraduate. But an attack of tuberculosis delayed his taking a degree, and sent him abroad instead, creating the circumstances that altered his career. His return to the Vale of Chamounix, his confronting again the sight of the sublimity of Mont Blanc, renewed the sense of exaltation he had first encountered at the same spot when he was fifteen. The visionary dialectic of Wordsworth's "Tintern Abbey" was renewed in Ruskin, and prepared him for a climactic return to Chamounix in August 1842. In *that* moment of renewal, as Wordsworthian a "spot of time" as any in *The Prelude,* the first volume of *Modern Painters* had its genesis. Ruskin returned to England, gave up all plans of taking orders, and devoted himself to vindicating the genius of Turner's Romantic landscape art, on principles grounded in the critic's own visionary experience.

By the time Ruskin had to seek healing consolation through another return to Chamounix, in 1854, his critical reputation was established, and his personal life was fairly well set toward destruction. He had published the second volume of *Modern Painters, The Seven Lamps of Architecture,* and *The Stones of Venice,* and he had married Euphemia Gray in 1848 with motives that have puzzled the best of his biographers. The marriage was not consummated, and was annulled in 1854, after the lady fled back to her parents. She married the Pre-Raphaelite painter Millais, whom Ruskin had befriended and patronized, and the entire affair soon passed out of the realm of scandal. Ruskin himself remained reticent on the matter (his marriage is not mentioned in his autobiography, *Praeterita*) and devoted himself more passionately to his work, which increasingly moved from art criticism to social prophecy. As the friend of Rossetti, Carlyle, and the Brownings, as the foremost expositor of the visual arts ever to appear in Great Britain, and as a prose poet of extraordinary power who took the whole concern of man as his subject, Ruskin appeared to have realized himself during the years from 1854 to 1860. Volumes three and four of *Modern Painters* came out in 1856, eliciting from George Eliot the definitive comment: "He is strongly akin to the sublimest part of Wordsworth." By 1860, Ruskin ought to have been at the supreme point of his development, and in a sense he was, but not in terms of continuity, for by 1860 he was at the turning, and entered into what was at once his great decade and his tragedy.

In 1860, Ruskin stood forth as a prophet fully armed in *Unto This Last,* his most eloquent and vital book. The central experiences of his life had led him beyond Wordsworth's quietism, and returned him to the biblical origins of his vision. The "theoretic faculty" of man, our ability to enter into the state of aesthetic

contemplation depicted in "Tintern Abbey," had now to issue in the Hebraic and Protestant impulse to free all men toward finding the way to individual vision, to an enjoyment of the sense of something more divinely interfused. Eloquent as he always was, Ruskin rose to the heights of his rhetorical power in *Unto This Last*. If there is a kernel passage in his work, it is the one that climaxes:

> *There is no wealth but Life* — Life, including all its powers of love, of
> joy, and of admiration. That country is the richest which nourishes
> the greatest number of noble and happy human beings.

This is the moral force behind the apocalyptic yearnings of the fifth and final volume of *Modern Painters,* also published in 1860. A fully perceptive reader in that year might have seen Ruskin as being poised on the threshold of a creative period akin to the great years granted to a whole tradition of English poetic visionaries before him. The expectation would not have been altogether disappointed by Ruskin's works in the sixties, particularly by the sequence of *Munera Pulveris* (1863), *Sesame and Lilies* (1865), and *The Queen of the Air* (1869), but the decade essentially was one of brilliant decline, and two decades of writing after it showed the decline more consistently, until there came the final, intermittent brilliance of *Praeterita,* after which Ruskin had to be silent.

Part of the cause of this downward movement is found clearly enough by an examination of Ruskin's life from 1860 on. In that year Ruskin, already forty, met Rose La Touche, not yet ten, and their extraordinary love began. By 1860 Ruskin had no religious belief in any orthodox sense, having become intellectually agnostic, though his temperament remained a deeply Evangelical one. Rose was, at ten, something of a religious fanatic, and she evidenced already the tortured sensibility that was to result in the illness (at least partly mental) that killed her when she was twenty-five. Despite all the obvious barriers — of differences in age and belief, of the strong opposition of Rose's mother (who, perhaps unconsciously, seems to have desired Ruskin for herself) — Ruskin proposed marriage to Rose on her seventeenth birthday. Ambiguously, Rose delayed her answer for over a year, until correspondence between Ruskin's former wife and Mrs. La Touche revealed the supposed fact of his impotence. There followed a complex cycle of estrangements and reconciliations, concluding with a final reconciliation in 1874, by which time Rose's mental illness had become extreme. With her death, in 1875, Ruskin's long decline commenced. He became involved in spiritualism, and began to identify the memory of Rose with Dante's Beatrice and with Saint Ursula. One sympathetic biographer called the Ruskin of the late 1870s a morbid prig, and he was not far wrong. By 1878, Ruskin believed himself to have failed, in love and work alike, and with this sour belief came the onset of his own mental illness. He had been Slade Professor of Fine Art at Oxford

since 1868, but the controversy with Whistler and subsequent trial, in 1877, caused him to resign that influential forum. He resumed the chair in 1883, but resigned again when it became clear he could no longer lecture coherently. Thenceforward he lived under what he termed the Storm Cloud, and his whole existence took on the beauty and terror of nightmare, haunted by the Evil One, who had intercepted all his desires, and who plagued him now in the shapes of peacock and cat. From this terror Ruskin partly rescued himself by a Wordsworthian return to childhood, celebrated by the writing of *Praeterita*. He returned also to a kind of religious belief, though he continued to hate the notion of justification by faith, and seems in his last days to have been more Catholic than Protestant in his outlook. In a final twilight period of deep peace alternating with total alienation from reality, Ruskin lived out his last days, dying on 20 January 1900.

There are three major areas of Ruskin's achievement: art, social, and literary criticism, and this essay is wholly devoted to only one of the three. I have allowed myself a broad interpretation of "literary criticism," since Ruskin is very much an anticipatory critic in regard to some schools of literary criticism in our own time. Ruskin is one of the first, if not indeed the first, "myth" or "archetypal" critic, or more properly he is the linking and transitional figure between allegorical critics of the elder, Renaissance kind, and those of the newer variety, like Northrop Frye, or like W. B. Yeats in his criticism. Even if he did not have this unique historical position, Ruskin would stand as one of the handful of major literary critics in nineteenth-century England, though his importance has been obscured by misapprehensions about his work. Most histories of literary criticism tag Ruskin as a "moral" critic which is true only in Ruskin's own terms, but not at all in conventional ones. An Oxford lecture delivered by him in 1870 makes clear the special sense in which Ruskin insists upon the morality of art:

> You must first have the right moral state, or you cannot have art. But when the art is once obtained, its reflected action enhances and completes the moral state out of which it arose, and, above all, communicates the exultation to other minds which are already morally capable of the like. For instance take the art of singing, and the simplest perfect master of it—the skylark. From him you may learn what it is to sing for joy. You must get the moral state first, the pure gladness, then give it finished expression, and it is perfected in itself, and made communicable to others capable of such joy. Accuracy in proportion to the rightness of the cause, and purity of the emotion, is the possibility of fine art. You cannot paint or sing yourself into

being good men; you must be good men before you can either paint or sing, and then the colour and sound will complete in you all that is best.

In this passage the "right moral state" and "being good men" are phrases that suggest conventional moral attitudes, yet the only moral state mentioned is that of the skylark, "the pure gladness." Behind Ruskin's passage are Wordsworth and Shelley, both in their skylark poems, and in their insistence upon the poet's joy and on poems as necessarily recording the best and happiest moments of the happiest and best minds. Ruskin's literary theory is primarily a Wordsworthian one, and as such it shows a family resemblance to all such theories down to Wallace Stevens, with his eloquent, Paterian insistence that "the morality of the poet's radiant and productive atmosphere is the morality of the right sensation." Ruskin's morality, as a critical theorist, is a morality of aesthetic contemplation, like the morality of "Tintern Abbey." It is not, in content, an Evangelical morality, though its fervor stamps it as a displaced version of Evangelicism. Ruskin's literary criticism has an explicit moral purpose, as Wordsworth's poetry does also, yet the purpose no more disfigures the criticism than it does the poetry. To understand Ruskin's criticism we need to study not only the pattern of Ruskin's life and career, but also the radical version of Romanticism his entire sensibility incarnated. Literary criticism rarely communicates the critic's own *experience* of literature, but in Ruskin's hands it very nearly always does, and in doing so touches upon the incommunicable. Ruskin did not believe that the imagination could create truth, but he did believe that it was the crucial faculty for the communication and interpretation of truth. Though Ruskin's judgment as a critic was fairly unsteady (he once declared Mrs. Browning's *Aurora Leigh* to be the greatest poem in the language), his central aesthetic experience was so powerful as to make him an almost miraculous medium for the truth of imagination to work through in order to reach sensibilities less uniquely organized than his own. In this respect, as in so many others, he resembles Wordsworth. Thus, speaking of Gothic as being representative of our universal childhood, Ruskin observes that all men:

> look back to the days of childhood as of greatest happiness, because those were the days of greatest wonder, greatest simplicity, and most vigorous imagination. And the whole difference between a man of genius and other men . . . is that the first remains in great part a child, seeing with the large eyes of children, in perpetual wonder, not conscious of much knowledge, — conscious, rather, of infinite

ignorance, and yet infinite power; a fountain of eternal admiration, delight, and creative force within him, meeting the ocean of visible and governable things around him.

If this is the source of creative imagination, it follows tragically but pragmatically that the workings of the mature imagination must be compensatory, for the story of art must be one in which gain can come only through loss, and the subsequent memory of the glorious time preceding loss. This pattern is familiar to every reader of Wordsworth, and is nowhere more eloquently expressed than it is by Ruskin. In a letter (28 September 1847) written to Walter Brown, once his tutor at Christ Church, Ruskin states the central experience of his life in phrases directly borrowed from the *Intimations* Ode:

> there was a time when the sight of a steep hill covered with pines cutting against blue sky, would have touched me with an emotion inexpressible, which, in the endeavour to communicate in its truth and intensity, I must have sought for all kinds of far-off, wild, and dreamy images. Now I can look at such a slope with coolness, and observation of *fact*. I see that it slopes at twenty or twenty-five degrees; I know the pines are spruce fir—"Pinus nigra"—of such and such a formation; the soil, thus, and thus; the day fine and the sky blue. All this I can at once communicate in so many words, and this is all which is necessarily seen. But it is not all the truth: there is something else to be seen there, which I cannot see but in a certain condition of mind, nor can I make anyone else see it, but by putting him into that condition, and my endeavour in description would be, not to detail the facts of the scene, but by any means whatsoever to put my hearer's mind into the same ferment as my mind.

Ruskin's activity as a critic of all the arts, of society, and of nature, is a quest to fulfill that "endeavour in description." What makes him a tragic critic (if so odd a phrase may be allowed) is his post-Wordsworthian and post-Turnerian sense of reality. In reply to Walter Brown's Wordsworthian statement of recompense for a loss of primal delight in nature, Ruskin wrote a letter (27 November 1847) which is an epilogue to the *Intimations* Ode:

> You say, in losing the delight I once had in nature I am coming down more to fellowship with others. Yes, but I feel it a fellowship of blindness. I may be able to get hold of people's hands better in the dark, but of what use is that, when I have no where to lead them but into the ditch? Surely, devoid of these imaginations and impressions, the world becomes a mere board-and-lodging house. The sea

by whose side I am writing was once to me a friend, companion, master, teacher; now it is *salt water,* and salt water only. Is this an increase or a withdrawal of *truth?* I did not before lose hold or sight of the fact of its being salt water; I could consider it so, if I chose; my perceiving and feeling it to be more than this was a possession of higher *truth,* which did not interfere with my hold of the physical one.

This sense of loss haunts Ruskin's criticism, until at last it becomes the apocalyptic desire of his later works, from *Modern Painters* V (1860) on to *Praeterita* (1885–89). Kenneth Clark has said, very accurately, that Ruskin was by nature an impressionist, to which one can add that an apocalyptic impressionist is a very strange being; it is difficult to conceive of Revelation as Proust would have written it, yet that is what the prophetic Ruskin gives us. Ruskin remained true to Wordsworth and Turner in being interested primarily in *appearances,* and in taking those appearances as final realities. Yet Wordsworth learned how to evade the apocalyptic element even in the sublime modes of poetry, and Turner, like Keats, thought the earth and the sun to be enough. If there is a central meaning to Ruskin's great change about 1860, it is that his movement from description to prophecy refused to abandon the external world or the arts that he had learned to scrutinize so accurately. Instead Ruskin demanded more from both nature and art than even he had asked earlier, and so made more terrible the process of loss his sensibility had made inevitable. The Ruskin of the Storm Cloud is what Wordsworth would have been, had he allowed his characteristic dialectic of love between man and nature to survive, unchanged, the crisis of 1805, out of which "Peele Castle" was written as palinode.

This is the terrible pathos of Ruskin's art as a critic, that no one else has had so intense an intimation of loss within the imaginative experience itself. Remembering the vision that was his as a child, Ruskin could say that "for me, the Alps and their people were alike beautiful in their snow, and their humanity; and I wanted, neither for them nor myself, sight of any thrones in heaven but the rocks, or of any spirits in heaven but the clouds." This primary humanism never left Ruskin, as it did finally leave the older Wordsworth. What preserved it in Ruskin was the greater purity of his own Wordsworthianism; like the poet John Clare, he excelled Wordsworth as a visionary, and *saw* constantly what the greater poet could see only by glimpses:

My entire delight was in observing without being myself noticed, — if I could have been invisible, all the better. I was absolutely interested in men and their ways, as I was interested in marmots and chamois, in tomtits and trout. If only they would stay still and let me look at them, and not get into their holes and up their heights! The

living inhabitation of the world—the grazing and nesting in it,—
the spiritual power of the air, the rocks, the waters, to be in the
midst of it, and rejoice and wonder at it, and help it if I could,—
happier if it needed no help of mine,—this was the essential love *of
Nature* in me, this the root of all that I have usefully become, and
the light of all that I have rightly learned.

If we call Ruskin's view of nature or of the self a mythical one, we need to
qualify the classification, as Ruskin scarcely believed his view of either to be the
product of his own creative powers. Wordsworth, and most of the Romantics
after him, sought continuity between the earlier and the future self even at the
expense of present time; Wordsworth indeed is mute in the face of nature at the
living moment. Ruskin, like Blake, celebrated the pulsation of an artery, the
flash of apprehension in which the poet's work is done. And, again like Blake,
Ruskin placed his emphasis on *seeing* as the special mark of imagination. For
Ruskin, unlike Wordsworth, the deepest imaginative effects are connected with
the finite phenomena of nature, and the minute particulars of artistic detail.
Wordsworth valued most highly in poetry "those passages where things are lost
in each other, and limits vanish," but Ruskin, regarding art or nature, never
ceased to see firm, determinate outlines, and every subtlety of detail. Ruskin,
unlike Wordsworth, would not sacrifice either the landscape or the moment to
the quest for continuity. Wordsworth's rewards for such sacrifices were im-
mense, as Ruskin well knew, for no other writer has felt or made others feel so
great a sense of the renewal of the past in the present, through the renovating
influence of nature. Ruskin was an extraordinary psychologist, though a largely
involuntary one, and did not believe that the therapy for an individual con-
sciousness could come largely through a pursuit of after-images. Yet he wished
to believe this, frequently wrote in the Wordsworthian mode, and achieved his
final, autobiographical vision and last broken intervals of lucidity primarily
through following Wordsworth's example, by tracing the growth of his own imag-
ination. If Ruskin became one of the ruins of Romanticism, and even one of its
victims, he became also one of its unique masters, who could justify asserting that
"the greatest thing a human soul ever does in this world is to see something, and
tell what it saw in a plain way. Hundreds of people can talk for one who can think,
but thousands can think for one who can see. To see clearly is poetry, prophecy
and religion all in one." Yet to see clearly was finally no salvation for Ruskin, but
only gave him a maddening sense of loss, in the self and in nature alike.

Ruskin never gave up insisting that all art, literature included, was worship,
but this insistence does not make him either a "religious" or a "moral" critic of
literature. Though he moved in outward religion from Evangelical Protestantism

to agnostic naturalism and on finally to a private version of primitive Catholicism, Ruskin's pragmatic religion always remained a Wordsworthian "natural piety," in which aesthetic and spiritual experience were not to be distinguished from one another. Ruskin's literary taste was formed by the King James Bible, more than any other reading, and therefore from the start he associated expressive and devotional values. In this also he stands with the great Romantics, whose theories of the Imagination are all displaced, radical Protestant accounts of the nakedness of the soul before God.

Ruskin's own theory of the Imagination is clearly derived from Coleridge's and it has been argued that all Ruskin adds to his master's account is a multiplication of unnecessary entities. Yet Ruskin does add to Coleridge's theory a confidence in the autonomy of the imagination that Coleridge himself never possessed. Indeed it is Coleridge whose criticism is distorted by the claims of conventional morality and institutional religion, and not Ruskin. Ruskin could not have written "that it has pleased Providence, that the divine truths of religion should have been revealed to us *in the form of* poetry" (italics mine) or that "an undevout poet is mad: in the strict sense of the word, an undevout poet is an impossibility." Because he lacked Coleridge's doubts, Ruskin allowed himself to elaborate upon Coleridge's categories, there being no point at which he felt the imagination had to yield to a higher or more assured faculty. If these elaborations have failed to be influential, they yet remain interesting in themselves and indicate where a less inhibited Romantic theory of Imagination may still quarry for its materials.

Fundamentally Ruskin favored two groups of poets, those like Dante, Spenser, Milton, and Wordsworth who dealt in detail with the whole destiny of man, from creation to apocalypse, and those he had loved in his own youth, like Scott and Byron. It is in the first that Ruskin's great strength as a critic lies, since he is given to special pleading for his childhood favorites. But there is an honorable place for special pleading in criticism, if it is done with the eloquent passion and exquisite discrimination of a Ruskin.

It is in his examination of the larger outlines of the structure of literature that Ruskin appears today to have been a major critical innovator. Because of his intimate knowledge of biblical and classical iconology, and of Dante, Spenser, and Milton as the heirs of such iconology, Ruskin arrived at a comprehensive theory of literature, which he never made fully explicit but which is evident throughout his criticism. One major assumption of this theory is that all great poetry whatsoever is allegorical; and that what it allegorizes is a fundamental myth of universal man, his fall from Paradise and his quest for a revelation that would restore him to Paradise. This myth is clearest in the Ruskin of the 1860s, of *The Queen of the Air,* and of *Sesame and Lilies.*

Though it is an obsession in the later Ruskin, a consciousness of this myth was always present in his criticism, since he relied from the start on a Wordsworthian experience of paradisal intimations within a wholly natural context. The Wordsworthian principle of continuity and dialectic of love between man and nature were generalized by the older Ruskin into the universal figures he had encountered in his early journeys from Genesis to Revelation. The symbols of *Modern Painters* V, *Munera Pulveris, Sesame and Lilies,* and *The Queen of the Air* are primarily biblical ones, even when Ruskin investigates the many guises of Athena in the elaborate mythologizings of *The Queen of the Air.* The Garden of Eden, the Serpent or Dragon, the unfallen maiden who replaces Mother Eve and becomes the prime hope of salvation; these are for Ruskin the principal figures in a mythopoeic fantasia of his own, which is almost too available for psychoanalytical reduction, of the kind to which Ruskin is generally subjected in our time. When, in *The Queen of the Air,* this fantasia is mixed with extraordinary excursions into botany, political economy, and primordial folklore, the result demands a reader more exuberant than most Ruskin scholars have been.

The Queen of the Air, in one of its aspects, resembles some works of Elizabethan mythography like Henry Reynolds's *Mythomystes,* but an even closer parallel can be found in Blake's poetry and prose. Like Ruskin, Blake counterpoints both classical and biblical myth against an imaginative story of his own, which in itself is a deliberate modification of Milton's accounts of Fall and Redemption. Ruskin does not seem to invent "Giant Forms" or titanic personages, as Blake does, but he invents and explores states-of-being in a manner very similar to Blake's, though he does not give them Blake's kind of categorical names. Ruskin's Athena is finally a goddess of his own creation, and as such she is one of the major myth-makings of the Victorian age.

Ruskin's earlier, and more Wordsworthian literary criticism, is dominated by the problem of landscape, in the same way that his later criticism centers on typological figures of redemption. *Modern Painters* III (1856) contains Ruskin's principal achievement as a literary critic before he entered upon his own mythical phase, but it is an achievement that has been misunderstood, partly because Ruskin's famous formulation of the Pathetic Fallacy has been misinterpreted. The theory of the Pathetic Fallacy is a searching criticism of Romanticism from within, for the sake of saving the Romantic program of humanizing nature from extinction through excessive self-indulgence. Ruskin is the first writer within the Romantic tradition to have realized the high spiritual price that had to be paid for Wordsworthianism, the human loss that accompanied the "abundant recompense" celebrated in "Tintern Abbey."

Ruskin was, more so even than most artists and critics, a kind of natural phenomenologist, to use a term now in fashion, or simply, a man to whom things

spoke, and who spent his life describing "the ordinary, proper, and true appearances of things to us." Ruskin knew that, as man and artist, his debts and affinities were to what he called the second order of poets, the "Reflective or Perceptive" group (Wordsworth, Keats, Tennyson) and not to the first order, the "Creative" group (Shakespeare, Homer, Dante). Ruskin's purpose in expounding the Pathetic Fallacy, which characterizes the second order, is not to discredit the Wordsworthian kind of poetry, but to indicate its crucial limitation, which he knew himself to share.

Wordsworth and his followers present states of mind that "produce in us a falseness in all our impressions of external things." A. H. R. Ball, the most sympathetic student of Ruskin's literary criticism, was convinced that the theory of the Pathetic Fallacy contradicted Ruskin's own imaginative theory, which may be true, but the contradiction, if it exists, is only a seeming one. Ruskin understood that Romantic poetry, and its imaginative theory, were grounded upon the Pathetic Fallacy, the imputation of life to the object-world. To believe that there is the one life only, within us and abroad, was to heal the Enlightenment's split in consciousness between adverting mind and the universe of things, but at the price that the intuitive phenomenologist in Ruskin understood and resented. The myth of continuity, in Wordsworth and in his followers, Ruskin included, is the result of a homogeneity of sense-experience, which can result only from reduction. The psychiatrist J. H. Van den Berg, in his fascinating study *Metabletica* traces this reduction to Descartes, who saw objects as localized space, extensiveness. Wordsworth's quest was to find a way out of all dualisms, Cartesian included, but ironically Wordsworth and his school followed Descartes, unknowingly, in reducing the present to an elaborated past, and making the future also only a consequence of the past. Ruskin's formulation of the Pathetic Fallacy is a profound protest against nineteenth-century homogeneities, particularly landscape homogeneities. It is perhaps sour wit, but it seems true to remark that Wordsworth could see only landscapes that he had seen before, and that no landscape became visible to him that he had not first estranged from himself.

Ruskin's protest is against this estrangement of things, and against the Romantic delight in seeing a reduction, and then elevating that reduction to the ecstasy of enforced humanization. Van den Berg remarks somberly that the Romantic inner self became necessary when contacts between man and the external world became less valued. Ruskin's rejection of Romantic mythopoeia as the Pathetic Fallacy shows a similar distrust of Wordsworthian self-consciousness, but the later Ruskin put such distrust aside, and became the major Romantic myth-maker of the Victorian era. The aesthetic tragedy of Ruskin is that works like *Sesame and Lilies* and *The Queen of the Air* are giant Pathetic Fallacies, but the mingled grandeur and ruin of those books only make them still more

representative of post-Romantic art, and its central dilemma. Ruskin may yet seem the major and most original critic that Romanticism has produced, as well as one of its most celebrated avatars.

GEORGE LANDOW

Ruskin's "Language of Types"

In contrast to many other nineteenth-century critics, Ruskin does not oppose allegory and symbolism to each other, for he holds that allegory, an imaginative mode, forms one kind of symbolism and not a lesser replacement for it. Not unexpectedly, his conceptions of allegory and allegorical art enable him to read painting, poetry, and architecture composed in this mode more sensitively than most of his contemporaries. In addition, Ruskin allegorizes not only art but natural phenomena as well—not only Dante, Spenser, and Giotto but also the facts of geology and meteorology. Like his theories of beauty, his interpretative methods partake of a larger vision of an orderly universe in which God has ordained that all phenomena bear moral and religious valences. As Mircea Eliade has pointed out, "the *completely* profane world, the wholly desacralized cosmos, is a recent discovery in the history of the human spirit." Ruskin, we must observe, had not yet made that discovery, and although many men of the eighteenth and nineteenth centuries had long accepted what has come to be the modern view of the universe, the universe emptied of the spirit of God, he did not. In fact, for all Ruskin's interest in scientific geology, he still existed within a conception of the world more congenial in many ways to the Middle Ages than to the age of Queen Victoria.

Believing that God intended natural phenomena, the rock, the tree, and the cloud, to bear moral meanings, Ruskin reads them in a manner that makes parts of *Modern Painters* much resemble earlier physico-theologies. In the fourth volume, for example, he remarks that "there is one lesson evidently intended to be taught by the different characters" (6:132) of the rocks which form the earth and its mountains:

From *The Aesthetic and Critical Theories of John Ruskin.* © 1971 by Princeton University Press. Originally entitled "Ruskin and Allegory."

It can hardly be necessary to point out how these natural ordinances seem intended to teach us the great truths which are the basis of all political science; how the polishing friction which separates, the affection that binds, and the affliction that fuses and confirms, are accurately symbolized by the processes to which the several ranks of hills appear to owe their present aspect; and how, even if the knowledge of those processes be denied to us, that present aspect may in itself seem no imperfect image of the various states of mankind: first, that which is powerless through total disorganization; secondly, that which, though united, and in some degree powerful, is yet incapable of great effort or result, owing to the too great similarity and confusion of offices, both in ranks and individuals; and finally, the perfect state of brotherhood and strength in which each character is clearly distinguished, separately perfected, and employed in its proper place and office.

(6:132–33)

Ruskin, like the Physiologus, conceives himself living in an allegorical universe in which natural fact reverberates with further meanings. Unlike the eighteenth-century divines, Ruskin is not primarily interested in argument from analogy. He concerns himself more with allegory, reading "Nature-scripture" (5:191) as he had been taught to read God's written Word — in terms of type and shadow. In his treatise *On Christian Doctrine* St. Augustine writes that the world divides between things and signs, and only in the world of the Bible can one take things as signs, rocks and mountains for bearers of meaning. By turning this earth into scripture, "Nature-scripture," Ruskin finds himself able to interpret "the ordinances of the hills" (6:117). The faith of some would move mountains; Ruskin prefers to read them, and just as he finds the laws of politics and morality embodied in the crystalline rocks, he finds in the sky an "ordinance of the firmament" that states the presence of God to all men: "God means us to acknowledge His own immediate presence as visiting, judging, and blessing us" (6:113). Ruskin does take into account the argument from design and from analogy, but he concerns himself far more with explicating the meaning of the world in which we find ourselves. Thus, Ruskin explains that the "conditions of mountain structure" have been invariably "calculated for the delight, the advantage, or the teaching of men; prepared, it seems, so as to contain . . . some beneficence of gift, or profoundness of counsel" (6:385). In short, God has constructed the mountains and the seas, the forests and the plains, for man: they offer sustenance for the body, beauty for the soul, and instruction for the mind. Nature-scripture, then, was "written" the way Augustine, Dante, and other men of the Middle

Ages believe the Bible to have been: with a literal sense that upon inspection revealed further, deeper, richer significance.

Ruskin also conceives the laws of human life to be similarly founded so that principles can be read for significance. *The Seven Lamps of Architecture* thus explains that "there is no branch of human work whose constant laws have not close analogy with those which govern every other mode of man's exertion. But, more than this, exactly as we reduce to greater simplicity and surety any one group of these practical laws, we shall find them passing the mere condition of connection or analogy, and becoming the actual expression of some ultimate nerve or fibre of the mighty laws which govern the moral world" (8:22). Whenever Ruskin can choose between analogy and allegory, he chooses allegory, as he has done here.

Realizing that "to the minds of many persons nothing bears a greater appearance of presumption than any attempt at reasoning respecting the purposes of Divine Being," Ruskin argued in a footnote against the notion that "the modesty of humanity" should limit its inquiries to "the ascertaining of physical causes": "Wisdom can only be demonstrated in its ends, and goodness only perceived in its motives. He who in a morbid modesty supposes that he is incapable of apprehending any of the purposes of God, renders himself also incapable of witnessing His wisdom" (6:134). Few ever accused Ruskin of morbid modesty, to be sure, and even when his conventional faith had disappeared the impulse to interpret the world to others and to convert them to his vision remained.

Long after Ruskin had both lost his Evangelical faith and then returned to his own version of Christianity, he added a note to the fourth volume of *Modern Painters* that significantly altered his conception of these "natural ordinances." "I should have said now," he wrote in 1885, "rather than 'seem intended to teach us,' '*do*, if we will consider them, teach us' " (6:132). Having lost the faith which allowed him to allegorize the world, he now becomes willing to use natural phenomena for examples and analogies. But it was his early views which formed his readings of art, life, and nature, and to them we must turn to perceive the sources and reasoning of his interpretation.

In 1852 when Ruskin published the last volume of *The Stones of Venice*, he was aware that he stood alone, like a prophet, in a vision of things not shared by many; and yet he expressed hope:

> that someday the language of Types will be more read and understood by us than it has been for centuries; and when this language, a better one than either Greek or Latin, is again recognised amongst us, we shall find, or remember, that as the other visible elements of the universe — its air, its water, and its flame — set forth, in their pure

energies, the life-giving, purifying, and sanctifying influences of the
Deity upon His creatures, so the earth, in its purity, sets forth His eter-
nity and His TRUTH. I have dwelt above on the historical language of
stones; let us not forget this, which is their theological language.

(11:41)

Ruskin's use of the word "type" here and elsewhere throughout his writings in-
dicates his debt to Evangelical Anglican readings of scripture. Although he has
obviously extended the meaning of the term beyond its chief exegetical use as
"forerunner of Christ," one must examine Evangelical methods of reading the
Bible to understand the habits of mind which shape his criticism, his conception
of the world, and his theories of art.

As a young child Ruskin, like all Evangelicals, learned that daily Bible read-
ing, the duty of every worshipper, had to be a search for Christ. The famous
tracts of Bishop Ryle, which Ruskin later recommended to others, characteris-
tically advised the reader:

> *Read the Bible with Christ continually in view.* The grand primary
> object of all Scripture is to testify of Jesus. Old Testament cere-
> monies are shadows of Christ. Old Testament judges and deliverers
> are types of Christ. Old Testament history shows the world's need of
> Christ. Old Testament prophecies are full of Christ's sufferings, and
> Christ's glory yet to come.

Bible reading had to be meditation on the types of Christ, but the believer did
not read his Bible figurally to authenticate Jesus Christ as the true Savior of man,
for the devout reader was already convinced of this truth. Instead, he read the
Bible as a means of discovering and meditating upon the universal role of Christ's
coming in human history. The Evangelical was supposed to read continually to
perceive foreshadowings of Christ, to feel wonder at the universal beauty of
God's plan, and to exercise his intellect in the service of his own soul's salvation.
Bible reading was to be not only devotional exercise, unraveling of the greatest
of all puzzles, but also the aesthetic appreciation of divine order.

These attitudes toward studying scripture, which Ruskin learned as a child,
recall similar attitudes underlying medieval and Renaissance allegorical im-
agery. According to Rosemond Tuve, "Men do not weary of meeting, especially
in interesting disguise, ideas and beliefs that they hold with real firmness. We
shall have little sympathetic understanding of this mediaeval and Renaissance
taste in imagery unless we can conceive of readers who thought deliverance from
hell to heaven was extraordinarily interesting good news." Similarly, we can
have little feeling for the fusion of aesthetic, intellectual, and spiritual concerns

that prompted both Victorian preachers and congregations to look forward with pleasure to two long sermons every Sunday, unless we conceive of the Evangelical love of discovering evidences of Christ. Since Ruskin learned his habits of reading in such a milieu, it is not surprising that when he later transferred religious exegetics to secular works, he maintained a similar fusion of apparently diverse attitudes.

Although the Evangelicals and other groups, such as the Baptists and Presbyterians who shared their methods, made full use of tracts and biblical commentaries, they considered preaching the most effective weapon of the elect; and consequently it is in sermons that we find the most important use of biblical types. While still a young child Ruskin had learned from sermons the correct way to search the Bible for types and shadows of Christ, and the degree to which typological exegetics had become a commonplace to him appears in one of the *Letters Addressed to a College Friend,* which Ruskin wrote to the Reverend Edward Clayton in 1843: "To-day being the first Sunday of the month, Mr. Melville [*sic*] preached at the Tower, and his curate gave us a sermon on 'Unto Adam also, and to his wife, did the Lord God make coats of skins,' etc. 'Now,' thought I, when he began, 'I know what you're going to say about that; you'll say that the beasts were sacrificed, and that the skins were typical of the robe of Christ's righteousness'" (1:490). He could thus anticipate the curate in such a superior manner because the sermons of Melvill and other preachers, particularly the Reverend E. Andrews of Beresford Chapel, Walsworth, had long before instructed him in the practice of typological readings of scripture. When Ruskin was only nine years old he made elaborate summaries of sermons, probably those of Andrews, which demonstrate the theological and exegetical sophistication which he had attained by 1828. In Sermon X, "The law of sacrifice," Ruskin makes use of the characteristic Evangelical application of figural reading to Leviticus. This third book of the Pentateuch, which sets forth the Judaic ceremonies of sacrifice used before the destruction of the Temple, apparently had little to offer the Christian reader, since it details the outmoded rules of an abrogated law. Ruskin, explaining that he will "follow up the law of the shadow of sacrifice to its substance Christ," points to the difficulties created by Levitical ceremonies when he mentions "the beginning of the 10th chapter, of Hebrews where it is said that the law, having a shadow of good things to come, and not the very image of these things, can never make the comers thereunto perfect, & it goes on to say that the blood of bulls and goats can never take away sin. Now, if it is impossible, that blood can take away sin, can we suppose that these momentous ordinances, were only for show, for ceremony[?] Can God institute anything of no moral worth[?]" Such apparent irrelevance would have created great difficulties for Evangelical belief, which held not only that God had directly

inspired every word of the Bible but also that each of its parts bore equal value. Since they did not accept an evolutionary theory of scripture, they found themselves forced to make the best of this unpromising material, and their universal solution was that God had instituted Levitical sacrifices as types to prefigure Christ's sacrifice:

> As the law threw forward a shadow to another economy these sacrifices must be to intimate[?] that sacrifice is necessary in the other economy and sacrifice, which shall be capable of taking away all sin. Now . . . in the Gospel this sacrifice of animals is done away with, and yet we know that we must have sacrifices of some sort[;] we are shut up to the death of Christ as the very essence of atonement. The law[s] of sacrifices derive their value only because they referred to the Gospel and if this be correct, the view which [we] have taken of them, must be referred to Christ. . . . As the law is a shadow of good things to come and as sacrifice is the foundation of the law[,] we have a striking proof of the efficacy of the atonement of Christ.

In the next sermon, "Sacrifices of the old law," Ruskin again makes use of the usually circular argument from types. After stating that ceremonial law "was to shadow forth the future sacrifice of Christ," he adds "[I]f these were not shadow[s] of this great sacrifice, they were trivial ceremonial forms and unworthy of the being who appointed them." Such clearly could not be the case.

Ruskin here follows a very common Evangelical authentication of types. Ryle, for example, arguing from the assumption that God had written the Bible with types and shadows, uses this principle to attack the Socinians who believed that Christ was mortal. Their belief, he held, strikes "at the root of the whole plan of salvation which God has revealed in the Bible, and . . . [would] nullify the greater part of the Scriptures. It overthrows the priesthood of the Lord Jesus, and strips him of His office. It converts the whole system of the law of Moses touching sacrifices and ordinances, into a meaningless form. . . . It turns man adrift on a sea of uncertainty, by plucking from under him the finished work of a divine mediator." In other words, if Christ were not divine, God could not and would not have instituted types; and if God had not instituted types, the Bible would have become all too frequently the record of "meaningless form." The Evangelicals perceived themselves living in a universe of divinely instituted order of which the Bible was the key; and types, which reveal a consistent principle in the Bible, the principle of Christ, create order and meaning in the Bible.

In addition to the fact that these childhood sermon records demonstrate Ruskin's early acquaintance with the usual Evangelical applications of typology, they gain further interest because the ideas he draws upon when he was nine

years old appear again twenty years later in *The Seven Lamps of Architecture*. In his first chapter, "The Lamp of Sacrifice," he asks "the broad question, Can the Deity be indeed honoured by the presentation to Him of any material objects of value. . . ?" (8:31) Summoning the tone, vocabulary, and arguments of an Evangelical preacher, Ruskin examines the nature of sacrifice in the Bible, coming to the conclusion that this second question "admits of entire answer only when we have met another and far different question, whether the Bible be indeed one book or two, and whether the character of God revealed in the Old Testament be other than His character revealed in the New" (8:32). Drawing upon the theory of types, Ruskin argues that since the same principle—salvation by Christ—unites Old and New Testaments, "God is one and the same, and is pleased or displeased by the same things for ever, although one part of His pleasure may be expressed at one time rather than another, and although the mode in which His pleasure is to be consulted may be by Him graciously modified to the circumstances of men. Thus, for instance, it was necessary that, in order to the understanding by man of the scheme of Redemption, that scheme should be foreshown from the beginning by the type of bloody sacrifice" (8:32). Ruskin so emphasizes the notion of the figural significance of ceremonial law that he holds "God had no more pleasure in such sacrifice in the time of Moses than He has now; He never accepted, as a propitiation for sin, any sacrifice but the single one in prospective" (8:32–33). Arguing that it was not "necessary to the completeness, as a type, of the Levitical sacrifice, or to its utility as an explanation of divine purposes, that it should cost anything," since the sacrifice it prefigured "was to be God's free gift" (8:33), he concludes that "costliness, therefore, must be an acceptable condition in all human offerings at all times" (8:33–34). Hence Ruskin, using Evangelical method and manner, can convince Evangelicals to build costly Gothic houses of worship. He directed *The Seven Lamps of Architecture* at his English Protestant audience which, he knew, would not accept Gothic archicture as long as it seemed a Roman Catholic style. Ever a polemical writer, he adapts himself to his readers, wielding the phrases of the preacher and the evidence of scripture, to convince them that an Evangelical reading of the Bible demanded sacrifice.

"The Lamp of Sacrifice" shows how thoroughly typology had permeated Ruskin's habits of thought. But although his Evangelical habits of scriptural interpretation thus enabled him on occasion to conduct arguments that would appeal to an Evangelical reader, the major effects of these modes of reading appear in his art and literary criticism. In order to gain a sense of the exegetical procedures that so impressed themselves upon Ruskin's thought, we would do well to examine the sermons of Henry Melvill, Ruskin's favorite preacher. This preacher's gracefully written sermons, to which Ruskin paid such close attention, frequently

take the form of elaborate revelations and explanations of typical resemblances. Like many other Evangelicals, he believed that the presence of types in the Bible is its distinguishing characteristic. Consequently, he warns his listeners: "If we fail to search the scriptural narratives for lessons and types, it is evident that we shall practically take away from a great part of the Bible its distinctive character as a record of spiritual truth." Melvill's sermons are of particular interest to a student of Ruskin's criticism not only because he makes sophisticated use of figuralism, but also because in the course of elaborating Christ's types and shadows he provides rules for the applications of typology.

One of his sermons, "The Death of Moses," which was delivered sometime between 1836 and 1843, provides a good example of his methods. Speaking on Deut. 22:48–50, in which God orders Moses to leave his people before they entered Canaan, Melvill asks why Moses was not permitted to enter the Promised Land. The preacher carefully sets his listeners within the narrative, reminding them of Moses's past actions, the wanderings in the wilderness, the beauties of Canaan, and the prophet's great desire to see the land of milk and honey. One of Melvill's principles, which he elucidated in another sermon, is that "We should never spiritualize any narrative of facts, till the facts have carefully been examined as facts, and the lessons extracted which their record may have been designed to convey." He thus proceeds to examine the details of the narrative, searching for any explanation for God's forbidding Moses to enter the Promised Land. He then reminds the congregation that, on one occasion, Moses had sinned: when the water supply failed just as the Jews were about to enter Canaan, God directed Moses, "speak ye unto the rock before their eyes, and it shall give forth his water." But Moses became angered at his people, because they forgot that God had saved them before in Horeb when a similar thirst prevailed, and they reproached him for leading them into the desert: "And Moses and Aaron gathered the congregation together before the rock, and he said unto them, Hear now, ye rebels, must we fetch you water out of this rock? And Moses lifted up his hand, and with his rod he smote the rock twice." According to Melvill, Moses sinned because he allowed himself to become subject, not to righteous indignation, but to human anger, because he displayed arrogance in speaking as though he and Aaron could fetch water out of the rock alone, and because, falling into unbelief, he disobeyed God's command, not speaking to the rock but striking it twice. From the punishment of Moses's sins of "passion, and arrogance, and unbelief," and from the fact that Moses accepted God's punishment, all men are to learn, says Melvill, that their sins are great and that even the most mighty need obey God. Furthermore, Moses's acceptance of God's sentence that he go up the mount and die teaches all men how to accept death, which comes only by God's

will. These moral lessons, or tropological applications of history, are, however, not all that Melvill finds in this incident.

This mild act of disobedience, this brief moment of human weakness, does not seem enough to explain why Moses was prevented from entering Canaan, and therefore Melvill searches for, finds, and elucidates the typological significance of the story. At this point, we come to a major principle of figural interpretation: when a detail appears particularly striking, unnecessary, or puzzling it probably demands the application of types. Melvill states this principle in a sermon devoted to Jacob's ladder, where he remarks that "If nothing had been intended beyond the assuring Jacob of divine favour and protection, the ladder with its attendant circumstances, seems unnecessarily introduced; for the words, spoken by God would have sufficed." Melvill here makes the same demand for meaning that Ruskin did when he held that unless the Levitical sacrifices signified beyond themselves, unless they foreshadowed Christ, they were "trivial" and "unworthy of the being who appointed them." Evangelical devotion to typological interpretation arises in a demand for meaning and a desire to recognize God's orderly purpose in human history; and though they led to an occasional abuse of scripture, they more commonly produced careful and ingenious readings of the Bible. In addition to this demand for proper significance, Melvill requires an appropriateness in the manner in which the truth is conveyed. Thus he comments that if the ladder is to convey the unwearied communication of God with man via the angels, "the figure . . . scarcely seems distinguished by the aptness and force which are always characteristic of scriptural imagery." Finally, since every part of God's dealings with man "is generally significative, and none can be shown to have been superfluous," we must search farther. Melvill concludes that the ladder typically signifies Christ, for Christ is both man's way to heaven and man's way of communicating with God, and he substantiates his traditional interpretation by the usual reference, made by Simeon and others, to John 1:51 where Christ says to Nathaniel, "Verily, verily, I say unto you, Hereafter ye shall see heaven open, and the angels of God ascending and descending upon the Son of Man." Therefore, another principle of typological exegetics is that Christ's (or in some cases Paul's) confirmation is final proof.

Returning to "the Death of Moses," we can now recognize the gravity of Moses's sin. When he struck the rock in Horeb on divine command, he did so because God wanted to make the rock typify Christ: "The circumstance of the rock yielding no water, until smitten by the rod of Moses, represented the important truth, that the Mediator must receive the blows of the law before he could be the source of salvation to a parched and perishing world." By striking the rock a second time, Moses disrupted God's scheme, or would have done

so had not God's later action allowed the preacher to realize the significance of Moses's action:

> Having been once smitten, there is nothing needed, in any after dearth, but that this rock should be spoken to; prayer, if we may use the expression, will open the pierced side of the Lamb of God, and cause fresh flowings of that stream which is for the cleansing of the nations. Hence it would have been to violate the integrity and beauty of the type, that the rock should have been smitten again; it would have been to represent a necessity that Christ should be twice sacrificed, and thus to darken the whole Gospel scheme.

God punished Moses, then, in order to draw attention to his act, and thereby suggest another entry in the book of Christ's revelations.

Melvill next proceeds to examine the story once more, finding another reason, in a figural significance, why Moses could not enter Canaan.

> You will all remember that Moses, though he must die before entering Canaan, was to rise, and appear in that land, ages before the general resurrection. When Christ was transfigured on Mount Tabor, who were those shining forms that stood by him, and "spake of the decease which he should accomplish at Jerusalem?" Who but Elias and Moses. . . ? . . . Moses was the representative of the myriads who shall rise from the grave; Elias, of those, who, found alive upon earth, shall be transformed without seeing death.

As part of the transfiguration, Moses then becomes part of a type which has not yet been fulfilled.

Melvill then returns once more to his original question, and for a third time finds an answer. Why has Moses not been allowed to complete his great work of deliverance? "Why, except that Moses was the representative of the law, and that the law of itself, can never lead us into heavenly places? The law is as 'a schoolmaster, to bring us unto Christ' [Gal. iii]." Moses, then, as representative of the Jewish law, could not enter the Promised Land, because to have done so would have mistakenly suggested that the old dispensation could earn that salvation made possible only through Christ.

Something very interesting has happened here: by the recognition of this typical significance, Melvill seems to be saying that what the man Moses, as emblem, signifies is more important than what the man as agent does. One feels that no matter what the prophet had done, the burden of figural meaning, of reference beyond himself, would have prevented him from entering the land of milk and honey. According to a figural interpretation of history, such as we

encounter here, the personages exist simultaneously on several planes and in separate worlds. First of all, there is Moses the human being, a man who has direct dealings with the Lord; he exists here in this life as we all do. Secondly, every one of his actions, like those of all men, has a moral meaning, for he exists in a moral universe; and because the prophet is more important than most men are or have been, each action is doubly significant, each action is emblematic of the actions of morality in human life. Thirdly, there is the fact that Moses exists as a part of the Gospel scheme which God created before — or perhaps outside — time. Furthermore, Moses exists in several different ways, or dimensions, within this typical structure that underlies or is intertwined with earthly history and time. Moses is, first of all, a figure of Christ, for like Christ he brings the law and guides his people; secondly, he, as a representative of the law, is the type of those who do not attain heaven, the Promised Land, because they do not have Christ; thirdly, he enforces another type, when, signifying the law, he strikes the rock, now a figure of Christ, thus showing that Christ must die by the law which he has come to replace; fourthly, by striking the rock a second time, he is again a type of those who will not reach heaven because they disobey God, because they hurt Christ by their sinning, and because they do not pray to Christ. What has happened is that while Moses is conceived as dwelling solidly within the world of physical fact, of the visible here and now, he is also seen to exist multivalently in a realm of sacred meaning.

What is most striking about this vision of history is that Melvill, unlike some earlier Evangelical preachers, does not hold that reading figural significances is primarily important as a meditational exercise. Instead, Melvill states that many types are as yet unfulfilled, that they await completion, that man, even man in the time of Queen Victoria, lives within a typologically structured universe. We have already seen that because Moses figures forth those who, at the resurrection, will rise from the grave, he takes part in a yet unfinished typological scheme that embraces the preacher's contemporaries. Melvill also holds that not only individual men, but even entire nations, must be seen as partaking in divine schemes whose fulfillment awaits the fullness of time. For example, the history of the Jews, who are to be regarded as "a typical people," shadows forth both the histories of the human race and the Christian church. So also with those who have oppressed the Jews, for

> from the first the enemies of God and his people which one age has produced, have served as types of those who will arise in the latter days of the world; and . . . the judgments by which they have been overtaken, have been so constructed as to figure the final vengeance on Antichrist and his followers. Hence it is that so many prophecies

appear to require as well as to admit a double fulfilment: they could
hardly delineate the type and not delineate also the antitype.

Types, as Melvill so well phrases it, are to be seen "spreading . . . over the
whole of time, and giving outlines of the history of this world from the beginning
to the final consummation." Thus, when he preaches upon the text of Zech.
10:1, which directs that we should ask the Lord for rain in the time of latter rain,
Melvill comments "that time must include the whole christian dispensation,
and . . . must comprehend such days as our own." The preacher insists that his
listeners still exist within biblical history, within prophetic and figural time.

That Ruskin, like his favorite preacher, finds himself living within sacral,
figural time perhaps appears in those arguments which draw upon the typical
laws in Leviticus to demonstrate the sacredness of color and the need for sacrifice
in architecture. Here, however, he chiefly emphasizes, not that types have yet to
be fulfilled, but that the truths contained in typical law remain valid. A far
clearer indication that he accepts a figural conception of history occurs when *The
Stones of Venice* uses the destinies of Tyre and Venice as types for nineteenth-
century England. The opening pages of this work demonstrate forcibly that
when he wrote it, he believed God structured time so that the events of the scrip-
tural narrative would prefigure contemporary history.

Although Ruskin evidently shared with Melvill and other Evangelicals this
sense of dwelling in figural time, his conception of the world as allegory plays a
far more central role in his writings. Similarly, although he frequently makes
skillful use of typology, as in his interpretations of Giotto, his uses of allegory are
more important than his applications of figuralism. Both this allegorical concep-
tion of the world and his ideas of allegory in general derive from Evangelical
typology, for despite the fact that members of this Church party, including
Wilberforce and Melvill, mention allegory with distaste and distrust, many
preachers unknowingly practiced allegorization under another guise: the Evan-
gelical Anglican penchant for elaborate figural interpretation frequently
prompts nineteenth-century exegetes to move from typology to allegory, thus
repeating a phenomenon familiar in the history of scriptural exposition.
Whereas typology (or figuralism), which traces the connections between two
unique events, stresses what an historian of exegetics has called a "similar situa-
tion," allegory, which interprets one thing as in reality signifying another, does
not attempt to establish this unique situational parallel. Strictly speaking, Moses
is not a type of Christ. Rather "Moses leading the children of God from Egyptian
slavery into the Promised Land" acts as a type for "Christ leading men from spiri-
tual slavery into the heavenly kingdom." Thus, although writers often sound as
though one person or thing may foreshadow another, in fact situation and action

are also required to have a true type. Another difference between figural and allegorical interpretation is that, whereas in typology one real, physically existing being or event represents another real, physically existing being or event, in allegory a thing may often represent a doctrine or abstract idea, such as grace, whose duration cannot be confined to one moment or one period in time. Thus, although both typological and allegorical interpretations are meta-historical, typology must work within human time, while allegory may often work outside of it. We can perceive this shift from typological to allegorical reading of the Bible in Melvill's sermons. For example, when he uses the traditional notion, found in Scott, Simeon, and others, that God's creation of the waters typified grace, he has in fact applied allegory and not typical symbolism; although one can perhaps argue that the physical creation of water figures forth countless individual acts of grace that have occurred and are yet to occur throughout history, this is not true "prefiguring," since the first event is linked not to one but to an infinite number of following events, and since the weakened connection between events is far less important than the fact that one thing, water, is seen to represent a theological doctrine. In other words, whereas a type focuses attention on both its historical existence and its meaning, an allegory places most importance on its significance. The difference between the two is often not very great, and therefore Evangelical attempts to perform intricate typological readings frequently lead the interpreter to shift unknowingly from type to allegorization.

Working within this Evangelical tradition of scriptural interpretation, Ruskin himself frequently extends the primary sense of type to include allegory and symbol. Nonetheless, however far he extends the original meaning of the term "type," his uses of it almost always bear overtones of that original meaning. For example, because typology assumes that on the narrative level there must be a real, historically existing person or thing, it places much greater emphasis upon the literal level than does allegory. Unlike most nineteenth-century critics, including Arnold, who believe that once the meanings of allegory make themselves clear the narrative tends to disappear like a useless husk, Ruskin places essentially equal emphasis upon both signifier and signified. The influence of typology appears in Ruskin's theory of typical beauty, which emphasizes *both* the formal elements of the beautiful and its deeper theological significance. Similarly, his theories of art formed under the influence of typology encourage him to maintain a balance between the formal elements of a painting, its aesthetic surface, and its complex significances. Thus, as we shall observe [elsewhere], when he interprets the allegory of one of Turner's works, he tends to pay close attention both to form and iconography.

Although such a relation between typology and Ruskin's theories of allegory may explain why he rather unfashionably defended the values and procedures of

allegorical art and literature, it presents us with another problem; namely, how in the first place could Ruskin and other Evangelicals have maintained a belief in typology, a belief that was obviously an anachronism by the Victorian age. The answer to the question how the Evangelicals could sustain this belief in a hostile intellectual environment lies in their belief, never officially accepted by the Church of England, that God had literally dictated the words of the Bible. This noncanonical doctrine of Verbal Inspiration created that conception of language fundamental to allegorical and typological readings of scripture. As Thomas P. Roche has pointed out in his study of Spenser, "Allegorical reading (or more simply allegory) is a form of literary criticism with a metaphysical basis. It postulates a verbal universe at every point correspondent with the physical world in which we live, that is a Realistic view of language." Allegory and allegorical interpretation both depend upon and implicitly create a Realistic view of language, a view which since the late seventeenth century has become increasingly difficult to accept. As long as men assumed that language had, corresponded to, or participated in essences, allegorical art and an allegorical reading of scripture were possible and perhaps inevitable. But after Hobbes and Locke referred language not to metaphysics but to psychology, a Realistic conception of language which provides the basis for allegory became largely untenable. Hobbes, who denied that words have essences, believed that language is merely the means "whereby men register their Thoughts." Thus, there is no such thing as "an *Universall;* there being nothing in the world Universall but Names; for the things named, are every one of them Individuall and Singular." Similarly, Locke states that language functions as a sign for ideas within the speaker's mind that communicates these ideas to another person. According to Locke, human convention, not participation in essences or correspondence to them, establishes meaning. Furthermore, because man has no access to any metaphysical existence, he therefore cannot define his words by reference to something that thus lies above or beyond him. Words are defined ultimately by reference to the speaker's mind. Once Hobbes and Locke moved the reality of language from metaphysics to psychology, from the external realm of forms to the internal realm of the mind, they simultaneously dissolved the linguistic foundations of allegory.

The Evangelical Anglicans did not maintain their Realistic conception of biblical language by consciously opposing Locke and his philosophical heirs, the Scottish empiricists such as Thomas Reid, Dugald Stewart, and Adam Smith. Smith's *The Theory of Moral Sentiments,* in fact, received something very like official sanction when William Wilberforce's *Practical Christianity* (1797), cited it approvingly. But although the Evangelicals accepted empiricist philosophy, they were nonetheless able to read scripture figurally and allegorically, because

they believed, as Melvill stated, that "The Bible is as actually a divine communication as though its words came to us in the voice of Almighty, mysteriously syllabled, and breathed from the firmament." This Evangelical doctrine that the Bible was literally the Word of God placed the scriptures in a special category unaffected by empiricist theories of language. For since God had dictated the words of scripture, these words, unlike any others, necessarily participated in a greater reality. In other words, the Evangelicals had accepted the Lockean notion that the context created by the mind of the speaker ultimately defines language, and then referred scriptural language to the eternal mind of God.

Only the conservatism of the Evangelical party, which insulated it for a time from the corrosive implications of contemporary historical and scientific speculation, enabled its members to maintain their noncanonical belief in Verbal Inspiration. Ruskin soon lost that belief, but not before his habits of reading had been formed.

JAY FELLOWS

Capricious Sinuousities:
Venice and the City as Mind

*My runs with cousin Mary in the [Hampton Court] maze, (once as in
Dantesque alleys of lucent verdure in the moon, with Adèle and Elise)
always had something of an enchanted and Faery-Queen glamour in them:
and I went on designing more and more complicated mazes in the blank
leaves of my lesson books—wasting, I suppose, nearly as much time that way
as in the trisection of the angle.*

 *Howbeit, afterways, the coins of Cnossus, and characters of Daedalus,
Theseus, and the Minotaur, became intelligible to me as to few: and I have
unprinted MSS. about them, intended for expansion in* Ariadne Florentina,
and other labyrinthine volumes.

<div align="right">(35:247)</div>

A. WHITE CLUES: INSTINCTS FOR THE EXIT

The act of "unravelling their arabesques" is, we know, the paradoxical, centri-
petal raveling of "slow travel"—the joy of the labyrinthine "nothing but process,"
which is, at this stage of the Transformations of the Maze, an intricately inev-
itable motion that leisurely winds toward the central interior of potential Reple-
tion. Still, integrated within concentricity, the Maze, like a Museum, would
domesticate that Centre, making it habitable by its slowly extensive and slackly
serial procedure, while, at the same time, transforming the terror of the rec-
tilinear "long shadow" into the figment of someone else's imagination by a kind
of "transcendental myopia" (or, perhaps inverted, an enforced immanence of

From *Ruskin's Maze: Mastery and Madness in His Art.* © 1981 by Princeton University Press.

dim perception) that approaches blindness. The winding entrance into the Maze predicts the Thesean necessity of an unwinding Exit, which may be an end, a new beginning, or the ambiguous null-set's absence / presence of White Silence.

Presumably, the notion of a conventional ending is anathema in Ruskinian design. The final period would become the series of addenda of Stendhal's *De l'amour*—or closer to home, the tacked-on "Notes and Correspondences" that begins to follow the letters of *Fors Clavigera*. Textual conclusion is the prophecy of death. To write the final period is to feel the substance, the rectilinear weight, of death's "long shadow." Syntactical periods in the middle of a text, lacking force, become nothing more than transitional punctuation—strong commas or anticipation of new capitals. In the labyrinth, the language of conjunctions is a necessity. There is always a curvilinear expectation of origins, of syntactical rebeginnings that are very much like a new turn within "Dantesque alleys" of Lucent Verdure. Syntax aspires toward the self-perpetuation of futurity. And in the end, with *Praeterita,* there is a new beginning, which is also an old beginning, with fresh paper taking up where old life has left off.

But before that end or rebeginning, with its "language of return," the possibility of future autobiography is something to be accomplished by an aspiration, however dimly perceived, that goes beyond the Maze's next turn, which is the origin of a new sentence. Even early, though after the experience within Hampton Court, there is the impulse for "an escape forward": "Escape, Hope, Infinity, by whatever conventionalism sought, the desire is the same in all, the instinct constant" (4:83). Still, it is possible to view the landscape of Hope (a postcircumferential Promise[d] Land), if it is to be an end in itself, with qualms.

Like "clues" that are "labyrinthine wanderings," the Hampton Court dance in the moonlight, which is the assuagement (especially in recollection) of a linear involvement that is both fortunately fallen and necessarily myopic, seems to require a way out that may, after all, only be a fiction of the Exit. There is at least the sense of another kind of light far beyond the next turn of Lucent Verdure and Gothic immediacy. Perhaps prophecy is not inevitably an elevated Greek perfection that sees its own death. And if not, what is presumably needed, after the experience within the Maze, is precisely that "conventionalism" which is a constant "instinct" for the Exit—an instinct for the centrifugal, Thesean "escape forward" that must include, even in its sense of futurity, the curvilinear "nothing but process" of present tense negotiations.

In the intermediate stages of the Transformations of the Maze, the end, which is where and when the "long shadow" will be traced to its source, would itself be transformed, by an act of imaginative will, into at least an instinctive search for an Exit. Any myopic "advance" of filigree toward a conditional futurity that Ruskin might enjoy is a partial solution to the central density resulting from

the Parallel Advance and Strange Chords of an extraordinary peripheral vision that would master what it can barely include. Labyrinthine "clues," which might be called serial clues of the conjunction, become a centrifugal answer to True Centres that may, in fact, be "mephitic cancers."

The Parallel Advance prepares for, if it does not necessitate, a labyrinthine leave-taking. The way out, the way toward those problematic spaces that are "of" the future and "beyond" the Maze, must be as narrow and curvilinear as flamboyant line—that line of cautiously narrow convolution, which, unraveling in the present for the sake of the future, is the essence of the Lucent Verdure of recollected pastoral that mnemonically precludes horizontal and peripheral responsibilities. To exit with centrifugal filigree is not only to be myopic but to wear blinders as well; the vision on the way "out" is as narrow as it is nearsighted. As long as he can feel the thread, Theseus might just as well be blind. And a Thesean Ruskin, when and if the thread has been cut and the "clues" either lost entirely or submerged, may be blind even to himself. Ariadne's thread may become Arachne's web and the serial clues of immediacy may not be prophetic enough. In an early incarnation, before the doubling of labyrinths, the Theatre of Blindness may be an essentially present-tense version of the mnemonic pastoral of Lucent Verdure. But for now, that is speculation dependent upon, among other things, the eventual condition of thread and clues.

Maps suggest the mastery of Strange Chords—the elevated grasp of a situation from a Centre that is "true" before it is "mephitic." To have a map that will lead toward the Exit is to dominate experience rather than be dominated by it. Further, it is to achieve the geometric and mechanical altitude of Jack—an altitude in which the unfailing or perfect Daedalean death is implicit. Nevertheless, one might assume that with a map, the playful involvement in the process of the present might predict a later present that would be something other than a dead end. And, in fact, Ruskin was as attracted to maps as he was to attempted mastery. But the Gothic disposition, which is Ruskin's curvilinear disposition of "vital" life, is without the fatal elevation of maps. The height of cathedral towers is a necessary product of an essentially fallen and irregular condition. Now, at this stage of labyrinthine metamorphosis, the mastery of maps (as well as bird's-eye views) would be banished, along with the extensive inclusion of the rectilinear field; the straight lines of altitude, width, and distance anticipate more despair than hope. Salvation, if it is to come, will be incarnated in the solution of the labyrinthine "clues" of immediacy.

Like maps, the vantage points of altitude—once as privileged as "the rectitude of the verticals" (1:238)—would attempt to master central cities. Problems are compounded. To be lost in Lucent Verdure is one thing; to be lost in the mixed or superimposed "geometries" of a labyrinthine central city, without even

a sense of the Exit, is quite another. The tight complexity of Venice, which, in
The Stones of Venice, is an early, objectified version of a kind of urban auto-
biography—the central city as Cock-Robinson-Crusoe self—is momentarily
mastered, as we know, by the altitude of St. Mark's, an altitude that brings
synoptic coherence to the narrow irritation of streets that are not called "Straight."
Apparently, without the necessary evil of altitude, the traveler would be lost in
the myopic curvilinearity of the Centre, rather than either assuaged or found.
Nevertheless, the farsightedness of Greek perfection must be avoided in order to
salvage existence and sanity.

Yet "within" the concentricity of Venice, as if "within" the fallen pastoral
of the recollection of Lucent Verdure, there is a solution to both the problems of
maps and the altitudes of the bird's-eye view. There is an alternative to St. Mark's
ambiguous mastery that predicts its own downfall—an alternative that is even
lower than the happily fallen "vital hawthorn" at Hampton Court. The farsighted
map (or map of the overview), which is the perception of the bird's eye that is
close to an angel's, has felicitously descended to the level of the fortunate im-
perfection inherent in Gothic myopia. With the later Transformations of the
Maze, the Exit that might be achieved by either St. Mark's altitude or maps from
"above" has instead become dependent upon a nearsighted, labyrinthine "clue"
of conjunction "within" that brings mastery especially to pedestrians. Amidst
the apparently contradictory design—or design of superimposition—of labyrin-
thine concentricity, one can be "found" enough to be able to endure one's lost,
if not entirely "blind," condition. Merely the "sense" of the Exit makes the fallen
and myopic condition at least as endurable as an "error" that will eventually find
"recovery."

Here, in any case, is Ruskin's Venetian traveler, who might well be, as we
shall see, moving through the "involution of alleys" of Ruskin's own troubled
consciousness—maneuvering "through," but more importantly "from," the
city's claustrophobic and plenitudinous centricity, with his "fallen map" that
speaks of a kind of salvation via the solution of pedestrian "clues." As though in-
structed by not entirely "blind guides," he finds himself propelled by feet that
can never walk on the perfectly "Straight" way of water:

> to those, however, who seek it [SS. Apostoli] on foot, it becomes
> geographically interesting from the extraordinary involution of the
> alleys leading to it from the Rialto. In Venice, the straight road is
> usually by water, and the long road by land; but the difference of
> distance appears, in this case, altogether inexplicable. Twenty or
> thirty strokes of the oar will bring a gondola from the foot of the
> Rialto to that of Ponte SS. Apostoli; but the unwise pedestrian, who

has not noticed the white clue beneath his feet, may think himself fortunate if, after a quarter of an hour's wandering among the houses behind the Fondaco de' Tedeschi, he finds himself anywhere in the neighborhood of the point he seeks. With much patience, however, and modest following of the guidance of the marble thread, he will at last emerge.

(10:295–96)

Engaged in intricate performance, that traveler, no less than Ruskin himself, is in love with filigree and embroidery, as well as "interesting" geography—an affection that we know "extremely wise men do not share." But in that condition of fallen "foolishness," which is also a kind of humility, there resides, as if incarnate, the traveler's survival that is dependent upon the conditional futurity of a sense of the Exit. Yet in passing, it might be noted that the Ruskinian traveler's survival is not always Ruskin's. Writing *The Stones of Venice,* shortly after his marriage to Effie Gray, Ruskin might well be said to be married more to a Venice that is like his New Jerusalem, "prepared as a bride," than to Effie—more to the central Rialto than to Effie, who is little more than a "farthest extremity," in which case the sense of the Exit is a centrifugal fiction. That intricate performance, which is fallen "foolishness," will become, despite the allegiance to the central Rialto-bride, when transformed from "marble" and consciousness into a verbal process of serial conjunction, Ruskin's own temporary style of survival in the face of penultimately replete Strange Chords and the excessive "nothing" of Illth that lies ominously, in its White Silence, beyond.

The exact nature of the key to the deciphering of the "extraordinary involution of the alleys," which is contrasted to the "straight road" of the water, is explained, fittingly enough, in a "footnote" which makes a case for the hitherto "unwise pedestrian" to pay attention to something very much like a foolishly necessary filigree. Serpentine intricacy, transformed into a "clue" of "white marble," speaks of the future, connecting Circumference with the Centre, the "farthest extremity" of Venice with the Rialto:

> Two threads of white marble, each about an inch wide, inlaid in dark grey pavement, indicate the road to the Rialto from the farthest extremity of the north quarter of Venice. The peasant or traveller, lost in the intricacy of the pathway in this portion of the city, cannot fail, which thenceforward he has nothing to do but to follow, though their capricious sinuousities will try his patience not a little.
>
> (10:296)

With characteristic Gothic disposition, Ruskin, making a strength out of an apparent weakness, wisdom out of fallen foolishness, is preparing for a form of

pastoral—a pastoral of "capricious sinuousities" that is like those other "Dantesque alleys" at Hampton Court. Yet there is a difference. The "capricious sinuousities" of "two threads" offer more than the recollected experience of serial plenitude and myopic delight within Lucent Verdure. Located or "found," they offer, along with a kind of pedestrian mastery, the possibility of an Exit as well as the inevitability of the entrance. The future tenses of prophecy are joined to the Maze's already existing memory and myopic immediacy. With "clues" of "white marble" at ground level, the Maze has now become a design of low (and therefore "high") grace, whose serial prediction is coherence at a pedestrian Gothic altitude, and whose better, if one is to survive, instincts, like those implicit in the labyrinthine Museum, are "for the arrangement of pure line, in labyrinthine intricacy, through which the grace of order may be a continual clue" (22:451).

The physical involvement in the fallen "capricious sinuousities" of the "continual" clue-yielding white marble is fundamentally a circumferential involvement that is imitated from "within" at the potentially "mephitic" True Centre. At first, as with Museums, it seems as if the "inside" might be "tamed" by following the act of Ruskin's ambitious and avaricious parenthesis and turning the "outside in." At first, it is as if a breath of fresh air might be imported in the form of a new line of possible salvation. For without those playful "capricious sinuousities," which are to become lines of centrifugally linear pastoral, central plenitude leads to a perception of the penultimate and intricately related Strange Chords. And the Repletion of that attempted mastery is nothing less than the inevitable preparation for the naked night watch, the screaming peacocks, and that mirror behind which, after the departure of the black cat, lies the terrible vacuity of White Silence, as of ripped immanence, the muteness arrived at by white stones.

But eventually it would appear that fresh air cannot be imported, that fresh air, having gone stale "within," must be found amidst the "provincial" location of originally fresh air. The circumferential source of flamboyant line, which is like both the sacrament of Athena's breath or oxygen and the "vital" life that has been lost in centripetal motion, is energetically sought, as though even the centrifugal process toward the "outside" could temporarily resurrect a "pedestrian" line. After the labyrinthine winding process—the coiling attempt at central domestication—there is the labyrinthine process of unwinding, the Ariadne-guided movement for the Exit. And the consequences of that movement, which is like the tracing of the spiraling *Helix virgata* from interior origins to the surface of the exterior shell, cannot be known until arrival. We know that "the labyrinth of life itself," an "interwoven occupation," may well be composed, finally, of "blind lanes" (22:452) that are dead ends. Yet, the centrifugal sense of the Exit, even if the Exit proves to be a "farthest extremity" that is a "blind," dead end,

might be written about by a bewildered, occasionally lost traveler in a curvilinear syntax incorporating both Ruskin's circumferential instincts and his myopia: in order for that problematically lost traveler / writer to be "found," like an "error" that has been "recovered," the future must be anticipated, but it cannot, in any case, be seen. Before Ruskin is unfortunately blind to himself, he is fortunately blind, by virtue of his recollected fall into the Maze of Lucent Verdure, to a future that must nevertheless be sensed.

Almost always himself antiphonal, like his "choral landscape," Ruskin, lost as traveler / writer, is almost found, like an "error" of admitted irrationality that can almost be recovered in a necessary condition of imperfect sanity. Blind, he can almost see. Or at least he can sense the point that will, tentatively, enable him to find himself—although that location, somewhere within the present-tense, labyrinthine Theatre of Blindness, might be as "spinning" as the infernally central squirrel-cage of London which has served only as centrifugal impetus. The "spinning" origin may, in fact, predict the pirouetting just before the end, when Ariadne's spun thread is penultimately severed.

B. COLUBRINE CHAINS:
THE MAZE OF CONSCIOUSNESS

Ruskin's Venice is a mind. More accurately, it is his own mind, and, as has been suggested, *The Stones of Venice* is a kind of urban autobiography of consciousness—an anticipation of the autobiography of the censored self, *Praeterita.* Similar designs, in different locations, perform similar functions. Urban planning is a way of organizing the mind. But the failing architecture of the House of Usher—its deconstruction—is a way of going mad. Topographical maps, taken too seriously, as if something more than the aerial view of a bird's flight, predict insanity. And thought, having advanced with parallel extension, creates problems of overpopulation, the central density of that squirrel-cage turning forever on its own axis. Like either an overcrowded city or an Index that delivers "cross-references *ad infinitum*," the mind's problem is both the "press of coincident thought," which is an act of perception, and the unwinding of what has been panoramically perceived, which is the necessarily serial act of expression that is like following "continual clues." He writes a favorite correspondent, Susan Beever: "I was greatly flattered and petted by a saying in one of your last letters, about the difficulty I had in unpacking my mind. That is true; one of my chief troubles at present is with the quantity of things I want to say at once" (37:111).

Simply, there is no parallel exit from a mind burdened with the "quantity of things I want to say at once"—a quantity that is either a version of overpopulation or especially dense and vertical architecture. With something to express,

Ruskin cannot commute "all at once" what he has to say to a blank page that is like suburban space. Although the simultaneous perception of the eyes is at least a possibility, words, it would seem, are as serial as threads of white marble, whose only sense of either the future or something other than themselves is a clue that is "continual." If perception, albeit a theoretical and highly demanding perception that is impossible either in the case of "reading" St. Peter's or language on a page, may be "all at once," expression—the unpacking or "unravelling" of what has been perceived—occurs, most likely, with a serial narrowness.

And since Ruskin's mind, in the later stages of the Transformations of the Maze, is an overcrowded city in need of fresh air and new space, it is also a place where the circumferential movement of Fancy occurs, which, as a process of thought, proceeds step by step, or "point by point," as if by "continual clue," instead of "all at once," like the perception of panoramic sight of the demanding amalgamations of a central Imagination moving toward either Strange Chords or a stultifying sameness. The Fancy, pirouetting on the outskirts of the mind, running circumferentially "hither and thither, and round and about to see more and more, bounding merrily from point to point, and glittering here and there, but necessarily never settling, if she settle at all, on a point only, never embracing the whole" (4:258)—that Fancy, "necessarily never settling," perhaps impelled by an urge toward transcendental discriminations, imitates the serial act of departing expression from a mind approaching the replete homogeneity of insanity.

The lines of Fancy, "bounding merrily," are pastoral lines of the Exit that would centrifugally release the pressures of a highly concentrated Imagination, just as the superimposed Maze of contrary designs, bringing extensive series to simultaneity, would attempt to tame the central demands of excessive privilege and responsibility: the fallen, step by step lines of the "white clues" of conjunction, whose mastery is necessarily and happily "pedestrian," are also lines, like Ariadne's thread, that make the central "inside" at least temporarily bearable by making the circumferential "outside" a Thesean possibility. But the path of apparent survival to the "farthest extremity" of the "outside," which is the path that seriously follows the "capricious sinuousities" of white marble, makes no immediate attempt to accommodate the panoramic perception of the enveloping Circumference.

In any case, perception is not expression; arrival is not leave-taking; centripetal winding only predicts centrifugal unwinding; and writing, which is the externalizing search for an Exit that is a blank page to be filled before it is the impossible-to-fill blank page of final Illth and White Silence, is the elaboration and extension of simultaneous centricity to the condition of the serial slack of a line of syntax, whose conjunctions impel the traveler / writer with the urgency of

"white clues." The "wide circumference" toward which Ruskin's language travels — as sensing the Exit, he moves toward the "farthest extremity" — can be panormically perceived but only sinuously expressed: "this morning so full of so useful thoughts that I can't set down one, they push each other round in my head. As a man gets older, he takes in all knowledge at a wide circumference, but can only speak it from his little mouth in the middle like an echinus: and his mouth is no bigger than it used to be."

Just as Ruskin would fill empty space with the equivalent of Scott's "curlie-wurlies" that come, as we recall, "out of my head" (35:623), so those "curlie-wurlies" — Hampton Court brought to the blank page — are the only lines that can get "out" of a head with a mouth no bigger than that of an echinus, or from the tip of a pen whose diameter is only slightly smaller. What was once parallel extension, now on the way "out" toward the fresh air of a blank page, has been reduced to the serial procedure of intricate line. [Elsewhere], we shall come across the language of the Exit, incarnating the style of the tightrope, which is also, somewhat paradoxically, the language of return with a difference. That language, holding the capacity to release infernal pressure, becomes an imitation of the recollected and ecstatic shaping experience in Hampton Court — a mnemonic experience that has perhaps been given the reflexive significance of an imaginative autobiographer. The Ruskinian syntax of both exit and return, without the elevation of synoptic generalization, becomes proximate, sinuous and "pedestrian," only incorporating the peripheral by touching upon its "point to point" and step-by-step multiplicity, as though the traveler / writer were viewing St. Peter's or Rome without visiting express points of "lionisation." A process of rational and necessary division of perception itself becomes the serial expression of the echinus's mouth. And the echinus's mouth, through which Ruskin would find expression, is as narrow as the spiraling line of the shell of the *Helix virgata* in which Ruskin might himself live.

Following something less formal and predictable than either itinerary or map, Ruskin, led more by circumstance than premeditation, seeks a ground-level Exit from an imperfectly Gothic altitude that is, at first "curiously," more a lowly serpentine movement toward solution, if not salvation, than one that is either avian or angelic. The farsightedness of rectilinearity and altitude is, we know, Jack's suicide, the "fall" of the house that he has built, which is not as sturdy as a shell that spirals like either the "defensive exit" of the snail or the slithering "advance" of a snake: "The opening of the second volume of *Deucalion* with a lecture on Serpents may seem at first a curiously serpentine mode of advance toward the fulfillment of my promise. . . . But I am obliged now in all things to follow in great part the leadings of circumstance" (26:295–96). Those "leadings of circumstance" are directed toward the "farthest extremity" of circumferential emptiness.

"Advancing" with serpentine motion toward an Exit that may justifiably be called Ariadne's, with a curvilinearity that might be called the earthly Athena's (though we must remember that Atropos, with her shears, is always above and, further, that the Exit may have a diameter no wider than the point of a pen), Ruskin reduces expressed thought to the linear progress-as-egress of a snake that may be a metamorphosis of both Theseus and Ruskin (or a Thesean Ruskin as traveler / writer), on the centrifugal way out of the Maze. Perhaps, though it is doubtful, the snake, Theseus, or Ruskin, may travel with "Devil-speed instead of God-speed." Still, that "speed" *should* be "slow travel." And if, as we shall see, the logic of that necessarily low syntax, which, though not "extricated" by Christian grace, is also high, follows the peregrinations of the serpent (which is like the tracing of pedestrian "clues" from the central Rialto), so Ruskin, as though magnifying or making his models life-size, would have the entire body of his work imitate the binding of threads that have achieved the strength of serpentine "chains":

> I would rather indeed have made this the matter of a detached essay,
> but my distinct books are far too numerous already; and if I could
> only complete them to my mind, would in the end rather see all of
> them fitted into one colubrine chain of consistent strength, than
> allowed to stand in any broken or diverse relations.
>
> (26:296)

The chainlike logic of the snake, thin, capable of fitting through openings as small as the mouth of an echinus—labyrinthine openings that are like doors leading from a centrally "mephitic" perception of the simultaneous—is essentially a "nothing but process" of immediacy. At first, it seems to be a movement almost entirely within an uncalculated present tense that possesses only the history and prophecy that can be found in the "error and recovery" of Gothic design. But Ruskin, employing the same pattern, uses multiple tenses, rewriting (or reexperiencing) original effect. And the later Ruskinian mind, as the present-tense Theatre of Blindness, which in this case is the antiphonal consciousness between Centre and Circumference, is an imitation of that fallen design of Lucent Verdure at Hampton Court, which in its curvilinear intricacy, is felicitously recalled in the golden-stained light of memory. The sense, if not sight, of the Exit "finds" the traveler / writer in a condition that might otherwise be hopelessly "lost." But if the Exit must be sought, it must be done so without any established notion of a "beforehand" that is more than "clues" of white marble or "veins of the mine as they branch" both "here and there":

> the labour of seeking must often be methodless, following the veins
> of the mine as they branch, or trying for them where they are broken.

And the mine, which would now open into the souls of men, as they
govern the mysteries of their handicrafts, being rent into many dark
and divided ways, it is not possible to map our work beforehand, or
resolve on its directions. We will not attempt to bind ourselves to
any methodical treatment of our subject, but will get at the truths of
it here and there, as they seem extricable.

(19:59)

In the act of exploring a mine that is both like a mind and Venice itself—the
veins of ore being equivalent not only to the "serpentine mode of advance" of a
lecture but also to a consciousness that attempts to deal with Repletion in the
same way as either "clues" of white marble amidst central architecture or a "colu-
brine chain" holding together and making sense of an ambitious work—the end
of that act, which, were it more orthodox, would be predictable by an uncharac-
teristically "methodical treatment," is, in fact, unpredictable. If the Exit, which
may only be preliminary to the end, is sensed, that end, it is becoming ap-
parent, is either blind or an "act" that Ruskin would have disappear.

Yet before it is at least blind, the path of that end travels both "here" and
"there," from "side to side," like a snake. And since the finding of the "there" is
a process that would occur most felicitously with a nearsighted Ruskin wearing
blinders (dispelling shadows not only "long" but "wide"), the peripheral, as op-
posed to that distantly rectilinear "there," can only be discovered by extensively
employing the horizontality implicit in "capricious sinuousities." Further, per-
haps one can say that death's encroaching shadow is "long," while the shadow of
madness is essentially wide, and that, with Ruskin, the unguarded perception of
both leads to penultimate Repletion and final madness. But concerned now, if
not always, with the "here"—with what is as close at hand (or foot) as the next
unexplored turn of a labyrinth that is like the unprophetic experience of self-
perpetuating "life itself"—Ruskin, in order to get to a "there" that may be a
location of the "farthest extremity," as well as the fresh air that is more impor-
tant than food, can only do so by attending to the "here" beneath the foot.

Atropos is immediately above, and Ariadne's thread, which promises a cir-
cumferential "there" that might also be a location for a spiritual Rose, is at no
more than the "extremity" of a long arm's length. The "here" is a preliminary
"there." The "colubrine chain" of the traveler / writer's "serpentine advance,"
which, at times represents a kind of weaving, is also the "spinning" digression of
"capricious sinuousities," and at best a link-by-link process. But the "warp and
woof" of the Maze of Ruskin's consciousness may, in the future, include a per-
ceived thread of autobiography and history more intricate than lines of Lucent
Verdure, the thread of Ariadne, the "clues" of white marble, or a "colubrine
chain." Then (and "there"), filigree—or more specifically, "inlaid threads"—

would be wisdom incarnate: "Now I hope some day to trace out a few threads of this history. . . . I cannot disentangle for you even the simplest of the inlaid threads of this tapestry of the fates of men that here lies beneath us" (19:434). If the threads of fate are to be eventually disentangled, if the end is not to be dead and blind, perhaps Ruskin's "mine" should be a marble quarry.

C. THE GOTHIC ANOMALY: PERIPHERAL SHADOWS
OF MADNESS AND NARROW CAUTION

The "curiously serpentine" advance / exit that Ruskin effects is one that, adapted to the narrow mouth of the echinus, vitiates the panoramic extension of Repletion simultaneously perceived. The wanting breadth of vision leaves one first virtually breathless (as if there were oxygen only in the "farthest extremity" of the horizon) and then finally witless in the same way that Ruskin's imitation of Scott's "curliewurlies" would turn the rectilinearity of the "long shadow" into nothing but an avoidable thought. Its narrowness is ironically, after the ambitious perception and winding process that would condescend to "narrow caution" (10:191), a fall away from both angelic perfection and Jack's altitudinous and optical death—a fall toward the irregularity of "error and recovery" that is mere mortal existence chronicled most effectively in a language of turn and return, like a traveler / writer, recording his experiences, who is "lost" in order to be "found."

Ruskin's initial attitude toward the expressive narrowness offered at last by the unwinding toward the Echinus Exit by thread or pen is no more enthusiastic than his early (after he has left the confinement of the Herne Hill garden) response to the foreground, which, despite the sacrifice of the foreground for the distance, becomes the necessary "here" of the later Transformations of the Maze. The narrowness of "colubrine" structures, which are serpentine structures after the fall from Daedalean pride, would appear to be a threat of limitation to the initial unqualified good of plenitude, which is innocently blind to a penultimate Repletion that can itself anticipate — or "see" — the inevitable excesses of a vacuous IIIth. At first, what is narrow—with a world as empty or unexplored as a blank page that cannot, in the madness of post-Repletion, be written — is viewed as something less than worthy. And narrowness as an "un-Gothically" elevated and perfectly safe condition, which is to say a condition / dimension that has not yet fallen into the significance of the mnemonic experience of Lucent Verdure, is a concept that, for a while, persists without a sense of necessity that will become apparent.

Later, the narrow curvilinearity of Lucent Verdure will be thought of as a lost paradise to be recalled by an affective, involuntary memory, and perpetually imitated, if not entirely resurrected, in the Transformations of the Maze, which,

ironically, are versions of serpentine intricacy. It is as if the "colubrine chains" of the serpent would not only "locate" the traveler / writer but attempt to "find" the Paradise Lost of Hampton Court. Whether that Paradise Lost can be found in the "farthest extremity" of the Exit in the same way it can be recalled in Origins is, for now, problematical. The possibility of a Paradise Regained, which may become a kind of Promise(d) Land, may also be "lost" or disappear in the final page of White Silence that is a tragic parody of the innocently inaugural blank page, which is itself the starting point (or garden) where the serpent of solution and salvation is as hidden as are the serpentine problems to come.

In the same way that, earlier, the ambitious and amalgamating Imagination is contrasted with the Fancy, which is a quasi-imaginative process that knows its own limitations, so later, even after the "mephitic" experience of the Centre, in a lecture on Brunelleschi (1874), Ruskin, with judgment implicit in tone, will contrast "aesthetic observation" with an uninspired "mathematical study" that is a slim, serial procedure, moving "part to part," as if seeking Ariadne's Echinus-like Exit: "aesthetic observation, even if weak, takes in the whole at a glance; but mathematical study proceeds from part to part, and may pause at an unimportant part" (23:211–12). Nevertheless, with Ruskin, digression, which is apparent evasion, is often finally central thought, becoming a new heart of the matter, and the "unimportant part" becomes a matter of life and death, in the same way that fallen altitude can provide the breath of life in the promise of the right kind of elevation beyond the Exit.

And if mathematical study is, at first glance, somehow unworthy in the exclusiveness of its vision, the problems inherent in aesthetic observation, which are essentially the familiar problems of the Centre, swiftly result in a higher valuation being placed on the mathematics of limitation—mathematics that would proceed, like the fanciful "point to point," or "part to part," as if much could be conquered by a kind of serial, Thesean division of necessarily limited perception. Just as the recollection or imitation of the curvilinear experience of the Hampton Court Maze would temper the terror of death's "long shadow," so, eliminating peripheral vision by the "narrow caution" of the traveler / writer's "blinders" as he moves myopically toward the Echinus Exit, that same fallen curvilinearity would also temper the horizontal panorama first perceived with the Parallel Advance—the original panorama in which there are, incipiently, both Strange Chords that will attempt an impossible mastery and the shadows of eventual madness.

The inclusion of aesthetic observation, taking in "the whole at a glance"— the glance, precisely, of the "wide circumference," which is the opposite of circumferential sight, if it is not released, if it is without an adequate sense of Ariadne's unwinding Exit, even if that Exit is only the size of the mouth of an echinus—

breeds a "grotesque" perception of Illth. The implicit metaphor is almost unavoidable gastronomic, intestinal, and labyrinthine: too much perceived without adequate expression—expression that does not "stutter"—leads to the obstruction of infernally replete plenitude which is the penultimate "nothing but process" of going mad even as one attempts to go to that "extremity" which is "farthest" from the centrally "mephitic" "Cloaca Maxima." Still, there may remain, in circumferentially concluding madness, "one leg [of] dung." Beyond bodily hygiene, Repletion, which translates to a Ruskinian claustrophobia, yields an idiosyncratic aesthetics of insanity: "chiefly, with respect to Florentine art at this period, the greatest subjects on which it was occupied involved the exercise of the aesthetic faculty in what I ventured in my last lecture [delivered in 1874] to call an insane degree of intensity; that is to say, to the point of actually seeing and hearing sights and sounds which had apparently no external cause" (23:212). Simply, aesthetic observation, which is the perception of the "wide circumference" "all at once," is the condensed central perception of simultaneity that finally has the capacity—in Ruskin's case, the inevitable capacity—to possess, or be possessed by, an "insane degree of intensity."

With Ruskin, history is often ambitious autobiography. Unsurprisingly, that intensity which is insane is as autobiographical as it is historical; it is not only reached in Florentine art at the time of Brunelleschi, but by Ruskin himself, who, in the manuscript of the Brunelleschi lecture, links Florentine intensity with his own visionary dreams—that "acute inflammatory illness at Matlock." Discussing another history—Milman's *History of Latin Christianity*—Ruskin also discerns both autobiographical substantiation and amplification:

> The last sentence—equally, and violently, foolish and false—I must put well out of the reader's way. Whatever these phenomena [i.e. religious visions at the time of St. Gregory] were, they were not poetry. They might have been insanity, or the reports of them may be folly, but they were neither troubadour romances nor Newdigate prize poems. Those who told them, believed what they had seen, — those who heard them, what they had heard; and whether sane or insane, some part of the related phenomena is absolutely true, and may be ascertained to be so by any one who can bear the trial. And this I know simply because I have been forced myself to bear it not once or twice, and have experienced the two forms of state, quickening of the senses both of sight and hearing, and the conditions of spectral vision and audit, which belong to certain states of brain excitement.
>
> (33:198)

If Venice is Ruskin's mind, architectural design is writing, a house is a book, and a Gothic self, like a successful Walter Scott (as if led at ground level through Hampton Court), has no more than a "clue" of what lies in the future. Near-sighted, if not blind, Scott cannot predict the end. If his art succeeds, his prophecy fails; the proposed end is instead a discursive middle. And his initially classical, or "regular," architecture is, in the process, transformed into a book, like a building, that is a "Gothic anomaly" accommodating the present-tense meanderings of a consciousness close to a myopic and curvilinear ground level. Significantly, Ruskin quotes from an introduction to *The Fortunes of Nigel* — an introduction written in the fallen, unprinted immediacy of Scott's own hand:

> "But to confess to you the truth the books and passages in which I have succeeded have uniformly been written with the greatest rapidity and when I have seen some . . . my regular mansion turns out to be a Gothic anomaly and the work is done long before I have attained the end I proposed."
>
> (29:264)

Scott's classically "regular mansion," like the house-as-Noun Substantive, which is a verbless study in reflexive autonomy — that early, anathematic "word-house" from *The Poetry of Architecture* — is predictable. But, dependent upon an unmapped process of "unravelling," the "Gothic anomaly," like a syntax of consciousness (and a language that, arriving at the end, will "return to itself") is not the result of prophecy. Unlike that early architecture / syntax of the Noun Substantive, the structure of the "Gothic anomaly," which is not located on a "street which is called Straight," does not cast the "long shadows" of inevitablility: "he who sees one end should feel that, from the given data, he can arrive at no conclusion respecting the other" (1:187). Further, the "Gothic anomaly," succeeding with an unplotted rapidity that undercuts propositions with the transcendence of immediacy, is not a structure for the perfect sheen of editorial process. The second time around is a time for maps and floor plans.

With Scott — and later with Ruskin — speed, whether the Devil's or God's, replaces "slow travel." And the unpremeditated writer is a traveler without itinerary or maps, who is also an architect without blueprints. It is as though, at this stage of the Transformations of the Maze, the centricity of the Rialto must be left before Repletion becomes the excessive presence as absence of Illth: the "farthest extremity" must be swiftly, if serpentinely, attained. There is a certain urgency of the Exit that speeds up the serial elaboration of "capricious sinuousities." (And there is always Atropos, with shears or nail above, if un-Christian "extrication" proves more necessary than Ariadne's thread below.) Refusing to (rather than failing to) rise to the angelically orthodox position of

either Jack's deadly altitude or Newman's True Centre, Scott, pointing the swift, if centrifugally "spinning," way toward both the expressive Exit, which is not necessarily the end, and Ruskin's own penultimate style, finds his guiding angel fallen (one might say "pedestrian"), though not "daemonic":

> Alas, he did not half know how truly he had right, to plead sorcery, feeling the witchcraft, yet not believing in it, nor knowing that it was indeed an angel that "guided," not a daemon . . . that misled his hand, as it wrote in gladness the fast-becoming fancies. For, truly in that involuntary vision was the true "design," and Scott's work differs from all other fiction by its exquisiteness of art, precisely because he did not "know what was coming."
>
> (29:265)

A combination of the serial conjunctions of Ariadne and Ruskin's paratactic Atropos of present-tense chance, Scott's fallen angel, whom Ruskin takes to heart, is an angel of the Maze, trailing threads behind a glorious design—threads like clues of white marble—that speak of both the coherence of immediacy and an unpredictable, serpentine advance. If Scott did not "know what was coming," someone else did. The unwinding or "unravelling" of Scott's "true 'design,'" which would be Newman's false Centre, is as involuntary as a mnemonic imagination whose gift of dream involves as angelic imagination. And if a "lost" paradise can be remembered and imitated in remembrance, perhaps as the Exit is sought, its regaining can at least be imaginatively conceived: there may be the hope of origins in the end, the promise of what has been lost, and Ariadne's way would seem to be related to the "recovery" that Rose La Touche might have offered Ruskin in his "error."

Ruskin's notion of modern greatness—and perhaps previous greatness—comes no more from premeditation than elevation. Rather, that perception of greatness is a perception resulting from a narrow sense of organic immediacy—the transcendentally intricate proximity of a labyrinth of "curliewurlies" uninfluenced by Daedalus' symmetrical and hubristic elevation. The movement toward greatness occurs in a "vital present" (5:127) whose potential greatness, necessarily fallen, is in its fortunately imperfect and unpredictable life.

The "vital present" is the tense of a low, meandering design of intricate immediacy—no True Centre of premeditation but a True Design of "involuntary vision"—that is the recollected shape of Hampton Court's Maze of "vital hawthorn," which has taken on the reflexive significance of present meaning imposed upon previous experience. And greatness is composed of both a shape and tense of serpentine vitality that is either a way out, a way toward the exits of the "farthest extremity," or a method of myopic survival—a way of maintaining

precarious sanity (of keeping the peacocks from the ears) in the face of shadows both rectilinearily longer and peripherally wider than "narrow caution" would permit.

Yet before the exit to the "farthest extremity," if not the expressive and vital process that connects the dense Rialto with that "extremity," there are the angels—and the druggists. Or, more accurately, there is a heaven whose involuntary tense is without the apothecary guile of, say, Jack's perfect and deadly premeditation:

> as I have a thousand times before asserted—though hitherto always
> in vain,—no great composition was ever produced by composing nor
> by arranging chapters and dividing volumes; but only with the same
> heavenly involuntariness in which a bird builds her nest. And
> among the other virtues of the great classic master, this of enchanted
> design is of all the least visible to the present apothecary mind."
> (29:265)

Curiously, in Ruskin's hierarchy in which angels fall to the pedestrian altitude of mere "clues," the "clues" of immediate transcendence, it is the overtly apparent druggists who prophesy, as if from the altitude of Newman's True Centre where Mazes may be mastered. And it is the True Design, which is the design of heavenly enchantment, that is invisible. In any case, although leery of heights, even after (or because of) a bird's-eye trip over Europe, Ruskin would nevertheless have his birds fly rather than fan their blind tails at ground level— and scream.

The "enchanted design," like Ariadne's thread that might have pointed the way to Rose's postcircumferential Promise(d) Land, at least points to cautiously narrow Exits without apparent shadows or "long perspectives." And Scott's "Gothic anomaly," which is also Ruskin's is an architecture that is not a "regular mansion" but one of "heavenly involuntariness" constructed from the "unindexed" Maze of a storehouse memory. On paper, Scott's "anomaly," with the discursive energy of expressive "fast-coming fancies," eases what in Ruskin is the "press of coincident thought"—the more than panoramic encompassment of the "wide circumference." Translated to Ruskin, that ease becomes the pastoral and "enchanted design" that, if not paradisiacal, offers at least temporary sanity in "involuntary" release. And the enchantment of Scott's Gothic design, which is a first-time design without the blueprints of regularity, is necessarily an imperfectly perfect enchantment, taking process for anticipation of the "farthest extremity" of the "outside," and the "vital present" as all the intimation of prophecy one can reasonably—or sanely—aspire toward. Always now, the shadows—both wide and far—would be avoided.

We have perhaps come to understand that the Parallel Advance is not the arabesquelike "unraveling" of the Exit, and that neither horizontal and peripheral perception, which may be the uncircumferential perception of the "wide circumference," nor depth perception, which is the future tense made visible, is the linear and serial expression manifested in the transforming Maze: that there is no accurate verbal equivalent to the Parallel Advance, and that an inaccurate equivalent—elevated prediction, say, or even the lofty and youthful (as of Cock-Robinson—Crusoe geometric centricity) "apothecary" tone of *Modern Painters* II, with elaborate tables of contents and paragraph summaries in the margins—is to be avoided, at the cost of one's wits. The early, elaborate "Table of Contents" is replaced by a less elevated, "involuntary" wandering that will, with its assumed myopic transcendence of immediacy, reduce broad perception to the narrow width and fallen line of often playful, and even "capricious sinuousities." As we shall see, if Venice is a mind, architecture—flamboyant architecture—is a model for an increasingly idiosyncratic syntax. And the stones of Venice—the stones of white marble, that is, which anticipate the stones or archaeology, of White Silence—are closer to being the stones of pedestrian continuity (with line as a fallen version of pastoral) than the stones of implicitly elevated prophecy, like a towering St. Mark's.

What is sought, before the inevitability of the "long shadow," before it comes into short perspective, which may be an autobiographical version of the closing Storm-Cloud of the Nineteenth Century (with Ruskin, meteorology is often autobiography), and with a mind as densely populated as a central city that has ambitiously imported the "wide circumference"—what is sought, almost ultimately, is an architecture of words, a verbal "Gothic anomaly" to be built by an impulse that is at least an approximation of Thesean advance, an "involuntary" advance below, as of pedestrian "white clues," that is impelled by elements more heavenly than infernal, more angelic than "daemonic." For apothecary, or (logo)concentric, prophecy—the hubristic prediction and synthesis from the Index (an unrevised Jack / Daedalus being both a builder of mechanical houses, perhaps like St. Peter's, and Mazes of "right angles," as well as being the perfect Renaissance druggist)—leads not only into the history of the irredeemable labyrinth of feverish and insane Florentine intensity about the time of Brunelleschi, but to more personal fevers and less historical insanity. Even when "unravelled" and expressed with a kind of "heavenly involuntariness" that is decidedly not the building of a peacock's nest, the encroaching peripheral shadows of the maddening "wide circumference," shortly to overlap, bring with them the cries of those infernal peacocks, along with a cat soon to be dead—a cat from behind a mirror that may also be a contrasting mirror of consciousness, that is, at least in feverish fact, seen as the Devil incarnate.

Scott's "Gothic anomaly," which is Ruskin's lost Hampton Court recollected in Lucent Verdure and transformed into a labyrinthine architecture of language, is, in the later Transformations of the Maze, among other things, a sanctuary, that is a kind of halfway house for a traveler / writer between vast mnemonic storehouses "behind" and a "regular mansion" dangerously "above" and "in front" (perhaps built by Jack precariously close to the Exit). And that "regular mansion" may be like nothing so much as a version of Bedlam — the Hospital of St. Mary at Bethlehem done in the Greek style of the rectilinear fret of "right angles" — a style that, for Ruskin, is more wrong than "right." In any case, next to a Bedlam that may itself be as replete as a dangerously overpopulated Centre, Ruskin would take the "Gothic anomaly" of, say, the *Helix virgata* for architectural and syntactical shelter, replacing True Centres and Strange Chords with designs that are both "true" and "enchanted" in their eccentric geometries. And in that anamorphic eccentricity, which is like concentricity twisted by a centrifuge, there may reside sanity — or at least a sanity within a temporary sanctuary composed of a shell's spiraling and "aedicular" architecture.

But Ruskin may not have an "architectural" choice. If he would take that *Helix virgata* for shelter, he may instead find himself, if not in St. Mary's designed in perfect "right angles," then enclosed in the final Theatre of Blindness, with its antiphonal double labyrinths of the three-dimensional Maze, which is in fact his own highly idiosyncratic architecture, his own "Gothic anomaly" that is indeed an imprisoning asylum for the "erroneous consciousness" ultimately without either an Exit or "extrication" other than White Silence.

Yet Ruskin's way toward madness is not St. Paul's way to the Kingdom of God, though, curiously, Redemption, whether heterodox or not, is in either case close to a promise that might be kept. Unrectilinear, Ruskin's peregrination is one of characteristic centrifugal digression that, at the point of verbal dissolution, is transfigured in an agonized attempt at an articulation that would be a fallen "error's" still fallen "recovery," as if the "recovery" of a lost tongue could aid in a landscape's elevation, and this, in a highly idiosyncratic version of the anonymous, universally repressed lexicon of pathos and *"folie"* mentioned by Foucault that would include, above all, "those words deprived of language whose muffled rumbling, for an attentive ear, rises up from the depths of history, the obstinate murmur of a language which speaks by itself, uttered by no one and answered by no one" — after which, with Ruskin, there is only the return to White Silence beyond even the fiction of Redemption, and the occasional revisitations of sanity.

JOHN DIXON HUNT

Ut pictura poesis,
the Picturesque, and John Ruskin

As I am always blamed if I approach my subject on any but its picturesque side.

 —RUSKIN, Writing to *The Daily Telegraph,*
 8th October 1870

It was John Ruskin's lifelong conviction that "the greatest thing a human soul ever does in this world is to *see* something, and tell what it *saw* in a plain way." And what he goes on to say is crucial to any understanding of the priorities of his spiritual and intellectual world: "Hundreds of people can talk for one who can think, but thousands can think for one who can see. To see clearly is poetry, prophecy, and religion, — all in one" (5:333). An examination of that triad is the underlying purpose of this essay.

But it is important, by way of preamble, to insist that Ruskin was not a philosopher nor, though he pretended on occasions to be more systematic and logical than his opponents, did he depend much upon the rigours and consistencies of formal thinking. He told a Cambridge audience in 1858:

> Perhaps some of my hearers this evening may occasionally have heard it stated of me that I am rather apt to contradict myself. I hope I am exceedingly apt to do so. I never met with a question yet, of any importance, which did not need, for the right solution of it, at least

From *MLN* 93, no. 5 (December 1978). © 1978 by The Johns Hopkins University Press.

one positive and one negative answer, like an equation of the second degree. Mostly, matters of any consequence are three-sided, or four-sided, or polygonal; and the trotting round a polygon is severe work for people any way stiff in their opinions.

(16:187)

He may well be engaged there in rationalizing his own career as a critic of art and architecture; for in 1858 he was still two years away from completing the already fifteen-year-old project of *Modern Painters,* about which the best of his modern commentators has written that it "would be less perplexing if Ruskin had known more about art when he began it, or learned less in the course of its composition." Such as conviction, which Ruskin may—at least unconsciously—have shared, obviously contributed some personal urgency to his version of the general Romantic faith in organic structure: "All true opinions are living," he wrote in *Modern Painters* (7:9), "and show their life by being capable of nourishment; therefore of change."

But this generally accepted idea that Ruskin knew too little at the start of his career and learned too much during it conceals another equally fundamental truth about him. This is his early established debt to eighteenth-century picturesque aesthetics and his long-held obligation to its ideas about experiencing landscape and reading landscape paintings, all of which can be recognized in *The Poetry of Architecture,* his first formal publication of any consequence, and continued to inform all his work at least until 1860, despite his public renunciations of picturesque taste.

When in *The Poetry of Architecture* he talks of our education by landscape—the "nobler scenery of that earth . . . has been appointed to be the school of . . . minds" (1:132), he is rehearsing his own youth, which his poetry and sketches reveal as being a frequent exposure to the picturesque. Yet that claim for the intellectual and moral benefits of travel is (maybe deliberately) opposed to an assertion by the leading eighteenth-century popularizer, William Gilpin, that "picturesque travel" should not be brought "into competition with any of the more useful ends of travelling." It is typical of Ruskin's mixture of debt and independence, which informs his later treaty with the picturesque, that he adjusts Gilpin's emphasis to suit his own convictions even while writing a series of essays that draw upon much experience of viewing scenery in Gilpin's manner.

It is a commonplace that Ruskin's youth was a substantial education in the picturesque. In 1880 he recalled that one of Samuel Prout's drawings, bought by his grandfather, and which

> hung in the corner of our little dining parlour at Herne Hill as early
> as I can remember . . . had a most fateful and continual power over

my childish mind. In the first place, it taught me generally to like
ruggedness . . . the conditions of joints in moulding, and fitting of
stones in walls which were most weather-worn.

(14:385)

His father's own modest artistic talents were distinctly picturesque, and on his
travels as a sherry merchant securing orders from customers all over Britain his
letters home reported frequent picturesque encounters: "old oak trees . . .
twisted and knotted in the most fantastic manner . . . the Ruins of Kennilworth
a very interesting scene." And the family's annual excursions, ostensibly in search
of further orders, were a progress from one picturesque site to another, with the
young John watching landscape framed "through the panoramic opening of the
four windows of a postchaise" (35:16). And in adult life these experiences con-
tinued, as he toured Europe to view its scenery as Prout and Turner had painted
it. And I think that painting—Turner's certainly, but Carpaccio's and the
Bellinis' also—largely determined his approach to Venetian art; while his study
of illuminated MSS, as much as his researches among the churches of Venice,
determined his ideas on the gothic craftsman.

The three crucial ingredients of picturesque aesthetic and practice that
Ruskin seems most to have adopted—though much also of a more peripheral
nature was borrowed—were its fascination with ruins, its organization of some
fresh alliance of word and image in the wake of the eighteenth-century rejection
of the traditions of *ut pictura poesis,* and its use of mirrors. It cannot be denied
that these adopted picturesque ideas, modes of experience, and methods of
analysis were, inevitably, adapted by Ruskin during his career. The famous re-
formulation of Turnerian or noble picturesque by the fourth volume of *Modern
Painters* would be the most obvious example. Yet the three picturesque ideas or
strategies remained, even while undergoing revision, basic to his whole work.
They are even, I'd want to suggest, the signature of Ruskin's imaginative world.

I

Ruins were an essential ingredient of any picturesque view; a love for their
broken and rough surfaces also determined the central element of the pictur-
esque aesthetic:

in ruins, even of the most regular edifices, the lines are so softened by
decay or interruped by demolition; the stiffness of design is so relieved
by the accidental intrusion of springing shrubs and pendant weeds.

But equally essential was that a ruin should have been "of some grandeur and
elegance" and "should refer to somewhat really interesting" so that the associative

faculty could be brought into play. For what attracts one to ruins is their incompleteness, their instant declaration of loss. From Thomas Burnet, enquiring into the causes of the "broken world" of mountains in *The Sacred Theory of the Earth,* to Turner or Byron, meditating upon the vacancies of Roman remains, ruins have invited the mind to complete their fragments. Whereas the sublime invocation of ruins stressed their inexplicitness, their relieving the spectator of his habitual recourse to precise explanations, the picturesque, the aesthetics of which developed out of a need to label experiences which eluded Burke's definitions for the sublime and the beautiful, chose rather to colonize that emptiness.

One of Ruskin's earliest surviving drawings is of the ruins of Dover Castle, while his juvenile and generally tedious verses establish ruin as a central motif: at the age of eleven he apostrophized the "old walls" of Haddon Hall in a cheerful song, the refrain of which was "Hey, ruination and hey, desolation, — / But created to spoil the creation!" (2:284). Three years later, travelling down the Rhine, this youthful connoisseur of delapidation encountered only a "tiresome repetition of ruins, and ruins too which do not altogether agree with my idea of what ruins ought to be" (2:349). The remark is loftily *un*explained; but from other remarks and reactions on this 1833 journey it is possible to deduce that Ruskin required ruins which he was able to complete with some specificity — thus at Andernacht they were "mighty . . . and majestic in their decay, *but* their Lords are departed and *forgotten*" (2:355, my italics). But it was actually his geological interests that extended his early picturesque preoccupations: in the "ruined universe" (2:373) of the Alps his highest standard of ruin was satisfied:

> before me soared the needles of Mont Blanc, splintered and crashed
> and shivered, the marks of the tempest for three score centuries, yet
> they are here, shooting up red, bare, scarcely even lichened, entirely
> inaccessible, snowless.
>
> (2:382)

His poem on "The Chrystal-Hunter" provided a fresh identity for the picturesque tourist. In the next family tour of 1835 there is an eloquent record of some hours spent beside the Glacier du Trient: a conventional picturesque experience ("a most beautiful ruin, a superb desolation, a most admired disorder") also involves his completion of the ruins of the "veteran crags" ("telling to every traveller a wonderful tale of ancient convulsions").

In his only attempt to write a novel, which survives as the fragment "Velasquez, the Novice," one of the characters is given a speech that was later revised for inclusion in *The Poetry of Architecture*: "the cypress befits the landscape of Italy, because she is a land of tombs, the air is full of death — it is the past in which she lives, the past in which she is glorious — she is beautiful in death, and

her people, her nation, are the dead; and the throne of her pride is the *hic jacet*" (1:542). In *The Poetry of Architecture* this emphasis on ruin is intensified with more picturesque details like a "fallen column" (1:19). Since *The Poetry of Architecture* is largely dedicated to exploring how the mind as well as the eye must be satisfied in both architecture and landscape, a mental and hence verbal response to images of ruin or delapidation is established as ruin's proper complement. When he talked in *Modern Painters* of his early years, which informed the essays contributed to Loudon's *Architectural Magazine,* he spoke of being "never independent of associated thought. Almost as soon as I could see or hear, I had got reading enough to give me associations with all kinds of scenery . . . and thus my pleasure in mountains or ruins was never, even in earliest childhood, free from a certain awe and melancholy, and general sense of the meaning of death" (5:365–66).

By this third volume of *Modern Painters,* however, Ruskin had decided that the modern taste for ruin was excessive (5:319); yet on the other hand ruin was by then established as the theme of all his writings. *Modern Painters* discovers its essential subjects equally in what is elsewhere called "the ruined mountain world" (9:294) of alpine geology and in the Hesperid dragon—"the worm of eternal decay" (7:420)—of Turner's *Garden of the Hesperides.* Inasmuch as his work does focus upon Turner, Ruskin's peroration singles out one all-important fact about his subject—that "through all the remainder of his life, wherever he looked, he saw ruin. Ruin, and twilight . . . And fading of sunset, note also, on ruin" (7:432). And in the midst of his long composition of *Modern Painters,* Ruskin did the research and wrote *The Stones of Venice,* which is constructed, as its first page declares, out of ruin. His Venetian letters, notes and sketches are constantly lamenting and annotating ruin, just as the text of his book is slowly reconstituting it. Even when he collects materials that are not obviously ruined, Ruskin's memoranda themselves choose to fragment gothic buildings.

So that although picturesque ruin and its sentimental associations are derided by the mid-1850s, on another side of the polygon, so to speak, the attraction to decay and incompleteness becomes the foundation of his whole work. The reason, I believe, is that his religious upbringing contrived to make ruin an essential feature of his spiritual landscape. His mother's evangelical training never ceased to insist upon the imperfections of human life and its achievements. The ruination of the Garden of Eden, encountered and adumbrated on each daily Bible reading, became a matter of conviction and accordingly a characteristic image of his adult vision. On the early tours to Switzerland of 1833 and 1835 the Alps from Schaffhausen and the Valley of Chamounix were both close to a "heaven-like dwelling place" (2:392); but the former are

described in *Praeterita* as having been "the seen walls of lost Eden" (35:115). And in *Modern Painters* the valley of the Trient between Valorsine and Martigny, which provides the type and specific location of "Mountain Gloom," is an extended, but by no means isolated, example of ruins discovered in pastoral enclaves:

> The other [i.e. Savoyard] cottage, in the midst of an inconceivable, inexpressible beauty, set on some sloping bank of golden sward, with clear fountains flowing beside it, and wild flowers, and noble trees, and goodly rocks gathered round into a perfection as of Paradise, is itself a dark and plague-like stain in the midst of the gentle landscape. Within a certain distance of its threshold the ground is foul and cattle-trampled; its timbers are black with smoke, its garden choken with weeds and nameless refuse, its chambers empty and joyless, the light and wind gleaming and filtering through the crannies of their stones.
>
> (6:389)

For such a temperament as Ruskin's, the idea of ruin had a vital fascination. It seems furthermore to have permeated his whole psychology long after Ruskin ceased to subscribe to his mother's religious teaching; consequently, we find that he is ready to identify and discuss ruin even in contexts that do not otherwise declare any strong evangelical attitudes. His account of "romantic association," for instance, is based upon its response to ruin:

> It rises eminently out of the contrast of the beautiful past with the frightful and monotonous present; and it depends for its force on the existence of ruins and traditions, on the remains of architecture, the traces of battle-fields, and the precursorship of eventful history. The instinct to which it appeals can hardly be felt in America.
>
> (5:369)

Long before he manoeuvred towards redefining the noble or Turnerian picturesque in *Modern Painters* IV, he defended Samuel Prout's picturesque sketches of buildings by insisting on Prout's

> feeling which results from the influence, among the noble lines of architecture, of the rent and the rust, the fissure, the lichen, and the weed, and from the writing upon the pages of ancient walls of the confused hieroglyphics of human history.
>
> (3:217)

The idea there is characteristically picturesque, and Ruskin goes on rather nervously to defend it from any superficiality by arguing for the "deeper moral" of

Prout's "ideal appreciation of the present active and vital being of the cities" which he depicts; that is to say, Prout successfully images what he sees in delapidated cityscapes and what he can thence deduce of their past. Ruskin's own fascination with ruin, itself partly learnt from Prout, as we saw, has to be defended in similar ways. He is tempted into a brief, but eloquent description of the facade of San Michele at Lucca—

> the mosaics have fallen out of half the columns, and lie in weedy ruin beneath; in many, the frost has torn large masses of the entire coating away, leaving a scarred unsightly surface. Two of the shafts of the upper star window are eaten entirely away by the sea-wind, the rest have lost their proportions; the edges of the arches are hacked into deep hollows, and cast indented shadows on the weed-grown wall. The process has gone too far, and yet I doubt not but that this building is seen to greater advantage now than when first built.
>
> (3:206)

—yet he goes on immediately and severely, as if suddenly aware of his own indulgence, that this "is no pursuit of mere picturesqueness; it is true following out of the ideal character of the building."

II

The ideal building would exist, then, simply in the imagination.

> Let the reader, with such scraps of evidence as may still be gleaned from under the stucco and paint of the Italian committees of taste, and from under the drawing-room innovations of English and German residents, restore Venice in his imagination to some resemblance of what she must have been before her fall.
>
> (3:213)

His obsessional need to "preserve" ruin was probably at the root of his lifelong hostility to the restoration of ancient buildings: "I have never yet seen any restoration or cleaned portion of a building whose effect was not inferior to the weathered parts, even to those of which the design had in some parts almost disappeared" (3:205). So that if architectural restoration was anathema and the fall of Venice could never be redeemed by recovering its buildings (nor, with stucco, re-covering them), their vacancies must be completed while still leaving them ineluctably fragmentary—completed, therefore, in the imagination. This version of the picturesque required verbal elaboration of the visual image.

For these reasons Ruskin insisted upon the necessity of an alliance between image and word. His belief that a human soul does best by telling what it saw

has already been quoted and undoubtedly lies behind his use of "the words painter and poet quite indifferently" (5:221). The example of Turner's own use of elaborate titles and catalogue entries for his pictures was one that Ruskin inevitably took seriously; Constable's recourse to letterpress in the 1830s for *The English Landscape* he chose to ignore, for reasons that presumably have to do with his preferential defence of Turner. But he was convinced that modern artists should attach written statements to their work to complete their meanings and in the Pre-Raphaelites he saw a new union of the sister arts (6:32 and 5:127 respectively).

Yet Ruskin was also often at pains to remind his readers that "Words are not accurate enough, not delicate enough, to express or trace the constant, all pervading influence of the finer and vaguer shadows throughout" Turner's works (3:308). Such admissions, however, are almost inevitably the prelude to one of Ruskin's more strenuous and rhetorical analyses, as he rises to the challenge of translating visual into verbal discourse. But he was not tutored in the picturesque for nothing, and one of its legacies to him was an addiction to formal effects in nature or paint, before which words seem especially inefficacious. Thus he is unusually mute — merely listing the relevant subjects — before Turner's late Swiss water-colours (3:551). He certainly never faces the problem of painting's formal language very steadily in *Modern Painters,* yet there is much scattered attention of a high order dedicated to it. Specifically, the discussion of colour, growing in confidence and scope throughout *Modern Painters* — and fueled by its central role in his appreciation of Venetian architecture — is never brought together into a coherent section, except for the panic admission in a note to volume five that he hasn't got around to doing so (7:414). Yet his random discussions of colour reveal some real feeling for formal elements in visual art, which language may point towards but cannot translate into its own terms. The analysis of scarlet in volume four (6:69ff.) is especially good.

These hesitations about the primacy of the visual over either the joint endeavours of visual and verbal or the verbal *tout simple* obviously derive in part from his own competence with both. Though his parents only encouraged his drawing and painting to the level of gentlemanly accomplishment, he expressed himself fluently with both image and word. As a child he devised his own books where both forms collaborated, a dual enterprise that was given added stimulus after the discovery in 1832 of Roger's *Italy* with its vignettes after Turner. His adult letters will often switch from sentence to sketch and back again to complete his meaning. But God, as we are reminded in the first volume of *Modern Painters* (3:345), was in the still small voice rather than the forms of earthquake, wind and fire. Elsewhere we are told that God is served better with few words than many pictures (5:86), though that is a by-product of Ruskin's endless doubts as to the moral efficacy of landscape painting.

Such inconsistencies, more trotting round the polygon, largely stem from Ruskin's ambivalent feelings towards the picturesque, a movement which contrived as well as inherited certain difficulties which have to do with the relations of word to image. Ruskin points indirectly to some of them when he notes how Turner broke away from the iconographical traditions of pictorial allegory and mythological subjects and learnt to use instead the landscape of natural forms:

> it is one of the most interesting things connected with the study of his art, to watch the way in which his own strength of English instinct breaks gradually through fetter and formalism; how from Egerian wells he steals away to Yorkshire streamlets; how from Homeric rocks, with laurels at the top and caves in the bottom, he climbs, at last, to Alpine precipices fringed with pine, and fortified with the slopes of their own ruins; and how from Temples of Jupiter and Gardens of the Hesperides, a spirit in his feet guides him, at last, to the lonely arches of Whitby, and the bleak sands of Holy Isle.
>
> (5:329)

Ruskin isolates a vital truth there, even while characteristically ignoring other relevant evidence (it is one of the startling omissions from *Modern Painters* that he never treats Turner's early picturesque years). Turner's gradual (though not at all consistent) abandonment of mythical and iconographical imagery through his career — Constable, of course, rarely if ever invoked it — declares the late eighteenth-century loss of confidence in one of the main components of *ut pictura poesis* — namely, imagery that could readily be translated into verbal discourse.

The rise of the picturesque school and the decline of confidence in *ut pictura poesis* during the eighteenth century seem to me closely related. Their respective fortunes can be traced in and I suspect were, if not caused, at least hastened, by the new art form of the English landscape garden. Here, to start with, readable items such as statues, temples, and inscriptions were situated among natural forms of wood, lawn, and water. Gradually, as the taste for allegory and allusion waned, these natural forms by themselves came to assume the central role — either as the constituents of formal visual effects, as in "Capability" Brown's gardens, or, if that abstract appeal to the eye did not suffice, as the new visual language for "meaning" in a landscape. The picturesque movement annexed both those concerns. It promoted the appreciation of aesthetic effects, divorced from moral or religious values. And it sanctioned personal and sentimental discoveries of meaning in landscape. Both were consequences of the disrepute which had overtaken the old iconographical or emblematical syntax, which connected aesthetic to moral and communicated public meaning in a scene. Joseph Spence, whose *Polymetis* of 1747 has been offered by D. J. Gordon as a major text in the history of the English rejection of *ut pictura poesis,* not only declared that he could not

understand paintings which relied on emblematic imagery, but would not bother to invoke Ripa's *Iconologia* or Alciati's *Emblemata* and preferred to rely solely upon what he saw — "the figures of things themselves speak . . . the clearest language."

Ruskin's scepticisims with the extreme manifestations of the picturesque appear early, in *The Poetry of Architecture,* and they centre precisely around this largely eighteenth-century emphasis upon the clear language of things. He shared, as we've seen, the picturesque propensity to treat simply of forms and shapes, as in the variety and roughness of ruins or in geological samples. There things speak for themselves to our eye. But he also shared the rather old-fashioned idea that landscape and architecture should address themselves to our minds as well as to our sight, though what had now been lost from the tradition was any language in which it could be done.

Both in his conservatism and his loss of conventional language Ruskin seems close to the later ideas of Humphry Repton on landscape design. Repton's writings were collected for publication in 1840 by J. C. Loudon, Ruskin's mentor in the late 1830s and the man who accepted the essays on *The Poetry of Architecture* for his *Architectural Magazine* during 1837 and 1838; Loudon even included a piece of Ruskin's ("On the Proper Shapes of Pictures and Engravings" (1:235–45) in the volume of Repton's works. It seems likely, then, that Ruskin would have heard much of Repton's ideas; certain parts of *The Poetry of Architecture* declare this influence quite strongly — notably Ruskin's praise of the formality of terracing introduced around Italian villas as a necessary "link between nature and art" (1:86). But in their general emphasis upon a landscape's appeal to the intellect, especially to the mind's adjudication of proper connections between buildings and surrounding scenery and between that location and the building's ornamentation, Ruskin and Repton have much in common. Thus Ruskin makes fun of what he calls "edificatorial fancies" of contemporary picturesque architects, which he parodies in the style of *Pickwick Papers* that he was just then reading:

> the humour prevailing at the present day among many of our peaceable old gentlemen, who never smelt powder in their lives, to eat their morning muffins in a savage-looking tower, and admit quiet old ladies to a tea-party under the range of twenty-six cannon, which, it is lucky for the china, are all wooden ones, as they are, in all probability, accurately and awfully pointed into the drawing-room windows.
>
> (1:153)

This is comparable to Repton's query whether the picturesque vocabulary of "Salvator Rosa, and our English Mortimer" is fitly copied "for the residence of

man in a polished and civilized state." The appeal to the mind, which is neg-
lected in both examples, involves a lack of consideration for the propriety and
reasonableness of association: "the spirit of the English landscape is simple,
pastoral and mild, devoid, also, of high associations," which the Scottish High-
lands by contrast would possess (1:169).

The problem for both Ruskin and Repton was that "meaning" in a building
or landscape could no longer depend upon a clear iconographical language, in
which objects were readily "translated" according to established allegorical syntax,
which Ruskin had already seen Turner abandon. Yet in order to avoid the mind-
less absorption in either merely formal effects or random fancifulness, Ruskin
thought that landscape needed to be seen as having meanings—he uses variously
the terms, "character," "soul," "animation"—which the spectator could under-
stand. His essays are at times rather confused as to whether these meanings come
"ready-made" in the different landscapes he treats of or whether a properly
educated sensibility registers as elements of a scene what are in fact constituents
of that person's consciousness. But in either case the visual experience has mental
repercussions, which it is the business of verbal discourse to identify and explain.
(In this Ruskin shows, what is never mentioned by his critics, an obvious debt
not just to picturesque paintings but to contemporary landscape gardens, many
examples of which he saw during the family's annual excursions around Britain.)

Ruskin would continue to use the term "picturesque" in a perjorative
fashion, to indicate his disapproval of a "narrow enjoyment of outward forms"
(6:23) and the mere display of the "skill of the artist, and his powers of composi-
tion" (7:255), even while he was relying upon other aspects of the picturesque
aesthetic. He adopted one of the most blatant of picturesque visual enthusiasms,
for example, upon which to base his lifelong attention to architectural orna-
ment, yet at the same time made it the premise for his own re-shaping of the pic-
turesque alliance between words and visual images.

William Gilpin had described how, to "satisfy the eye" before picturesque
objects, there must be a textured surface:

> various surfaces of objects, sometimes turning to the light one way,
> and sometimes in another, . . . give the painter his choice of op-
> portunities in massing, and graduating both his lights, and shades.
> —The *richness* also of the light depends on the breaks, and little
> recesses, which it finds on the surfaces of bodies.

As an example, Gilpin adduced the architect who "break[s] the front of his pile
with ornaments." Now it is these decorations by an architect of his basic structure
that Ruskin, in *The Poetry of Architecture,* argues will obtain "character" for a
building (1:136). And "character," in the terminology of picturesque aesthetics,

means what initiates and guides our associations, which language in its turn artic-
ulates. Ruskin engages, I think, in some circular (rather than polygonal) thinking
at this point: decorations promote "character" which, in its turn, promotes asso-
ciations; associations involve the mind not just the eye; decoration is what dis-
tinguishes human architecture from animal building.

> The mere preparation of convenience, therefore, is not architecture
> in which man can take pride, or ought to take delight; but the high
> and ennobling art of architecture is, that of giving to buildings,
> whose parts are determined by necessity, such forms and colours as
> shall delight the mind, by preparing it for the operations to which it
> is to be subjected in the building.
>
> (1:105)

Hence the insistence, appearing early in *The Poetry of Architecture*, that "the
proper designing of ornament" (1:135) must be an architect's prime concern.

It is, of course, the premise of much of *The Seven Lamps of Architecture*
and *The Stones of Venice*, where gothic ornament becomes the whole object of
his discourse—"fair fronts of variegated mosaic, charged with wild fancies and
dark hosts of imagery" (8:53)—*and* at the same time provides the language for
Ruskin's text—"not a leaflet [in northern Gothic ornament] but speaks, and
speaks far off too" (8:28). In *The Poetry of Architecture* is first heard the character-
istic Ruskinian formulation of a landscape or a building *speaking* to us through its
details: a cottage is "a quiet life-giving voice" (1:12) or a very old forest tree has
its age "written on every spray" and is "always telling us about the past" (1:68).
In later works this emphasis on the mute language of visible things coordinates
three picturesque strategies—the search for textured roughness, for ornament in
Venice or a geological formation in the Alps is generally ruined, or seen
fragmentarily by Ruskin; the picturesque alliance of word with image; and the
address via that fresh language to the mind.

The rich ornamentations of Venetian building, like the "sculptured and
coloured surfaces" of Nature's crags and crystals (8:145), are formal delights
beyond the imagination of any picturesque traveller. They are also "hieroglyphs,"
and the stones of Venice, as of Chamounix, require translation. The gothic
building, Ruskin argues in "The Lamp of Memory,"

> admits of a richness of record altogether unlimited. Its minute and
> multitudinous sculptural decorations afford means of expressing
> either symbolically or literally, all that need be known of national
> feeling or achievement. More decoration will, indeed, be usually re-
> quired than can take so elevated a character; and much, even in the

most thoughtful periods, has been left to the freedom of fancy, or suf-
fered to consist of mere repetitions of some national bearing or sym-
bol. It is, however, generally unwise, even in mere surface ornament,
to surrender the power and privilege of variety which the spirit of
Gothic architecture admits; much more in important features —
capitals of columns or bosses, and string-courses, as of course in all
confessed bas-reliefs. Better the rudest work that tells a story or
records a fact than the richest without meaning.

(8:229–30)

And in discussions of mountain scenery, which he connected to his architectural
studies by emphasising the community of cathedral and Alp, he was equally
alert to visible fact and translatable meaning:

> For a stone, when it is examined, will be found a mountain in min-
> iature. The fineness of Nature's work is so great, that into a single
> block, a foot or two in diameter, she can compress as many changes
> of form and structure, on a small scale, as she needs for her moun-
> tains on a large one; and, taking moss for forests, and grains of
> crystal for crags, the surface of a stone, in by far the plurality of in-
> stances, is more interesting than the surface of an ordinary hill; more
> fantastic in form, and incomparably richer in colour, — the last
> quality being, in fact, so noble in most stones of good birth (that is
> to say, fallen from the crystalline mountain-ranges), that I shall be
> less able to illustrate this part of my subject satisfactorily by means of
> engraving than perhaps any other, except the colour of skies.

And in that significant admission of the uselessness of visual illustration, Ruskin
prepares for his necessary act of literary translation of those facts and meanings.
Such interpretation provides the occasion for most of Ruskin's famous set pieces,
the purple passages so dear to those who select gobbets from his works for us to
peruse. Yet without their context of a criticism which constantly stresses our ob-
ligation to interpret the mute poesy of ornament or mountain structure, those
fine periods are themselves merely picturesque, evidence of *our* "narrow enjoy-
ment" of Ruskin's "merely outward delightfulness" (6:15).

III

The last of the three picturesque procedures which seem central to the func-
tioning of Ruskin's imagination concerns the use of the mirror or Claude glass.
These tinted convex mirrors were carried by most picturesque tourists — thus
Thomas Gray, visiting the ruins of Kirkstall Abbey, tells how

> the gloom of these ancient cells, the shade & verdure of the land-
> scape, the glittering & murmur of the stream, the lofty towers &
> long perspective of the church . . . detain'd me for many hours, &
> were the truest subjects for my glass I have yet met with.

The "glass" had many traditional sanctions for the artist; it acquired fresh ones
for the picturesque traveller, who would often, as amateur artist, transpose its
reflections into sketch and watercolour.

The mirror was the privileged metaphor of artistic representation, authoriz-
ing, according to one's emphasis, either accuracy of vision or the capture of *la
belle nature*. To the picturesque artist it reflected the real world, yet also col-
lected carefully chosen images within the oval (or sometimes square) frame and
coloured them with its one coordinating tint. It was both an objective, cognitive
activity and also a private, creative one, as the user of the mirror turned his back
upon the scene to be studied and withdrew into his own reflections. The reversed
images in the glass, paralleling of course the upside-down images we receive upon
our retinas, were a visible token of that joint world of optical and mental reflec-
tions—otherwise announced in *speculum* and speculation—which is dramatised
in the myth of Narcissus, an extremely popular motif in eighteenth-century des-
criptive poetry. Narcissus' confrontation with his watery mirror had also been, for
Alberti in the second book of his *Treatise on Painting,* the origin and superiority of
painting, as a three-dimensional world is transposed into a two-dimensional image.

Ruskin did not, as far as I know, ever use a Claude glass, though some of his
juvenile verse is composed as if he did. But he nonetheless found that the pictur-
esque obsession with mirrors and reflections answered many of his own beliefs
and even coincided with imagery derived at an early age from his study of the Bi-
ble. Ruskin frequently invokes the traditional artistic metaphor of art holding a
mirror up to nature—not of course a specifically picturesque idea—and, as we
might expect, places contradictory constructions upon it. Sometimes it is simply
the image of unsatisfactory and incomplete imagination:

> And then, lastly, it is another infinite advantage possessed by the
> picture, that in these various differences from reality it becomes the
> expression of the power and intelligence of a companionable human
> soul. In all this choice, arrangement, penetrative sight, and kindly
> guidance, we recognize a supernatural operation, and perceive, not
> merely the landscape or incident as in a mirror.
>
> <div align="right">(5:186–87)</div>

On other occasions the mirror represents the narcissistic arrogance which is dis-
claimed on the title pages of *Modern Painters* via some lines of Wordsworth's
who does not want to be counted among those who only prize

This soul, and the transcendent universe,
No more than as a mirror that reflects
To proud Self-love her own intelligence.

Yet the mirror equally sanctioned Ruskin's requirement of an artist that he carefully delineate the natural world, that he look—at any rate as a preliminary stage of his education—not at what his predecessors have done but at the details of the natural world caught in the glass of his careful private scrutiny. If Alberti saw the Narcissus myth as a translation of three into two dimensions, Ruskin invoked the mirror as the artist's guide back into a proper apprehension and renewed contact with three dimensions:

> Every object, however near the eye, has something about it which you cannot see, and which brings the mystery of distance even into every part and portion of what we suppose ourselves to see most distinctly.
>
> (3:337)

This paradoxical reversal of the mirror's loss of depth is first explored in his —this time specifically picturesque—astonishingly perceptive discussion of the lake as mirror in *The Poetry of Architecture:*

> When a small piece of quiet water reposes in a valley, or lies embosomed among crags, its chief beauty is derived from our perception of crystalline depth, united with excessive slumber. In its limited surface we cannot get the sublimity of extent, but we may have the beauty of peace, and the majesty of depth. The object must therefore be, to get the eye off its surface, and to draw it down, to beguile it into that fairy land underneath, which is more beautiful than what it repeats, because it is all full of dreams unattainable and illimitable. This can only be done by keeping its edge out of sight, and guiding the eye off the land into the reflection, as if it were passing into a mist, until it finds itself swimming into the blue sky, with a thrill of unfathomable falling.
>
> (1:90)

The lake's mirror, better far than any picturesque equipment, because God-given, invites and accommodates the imagination's inward reflections. And because the "surface of water is not a mockery, but a new view of what is above it," as he says in *Modern Painters* (3:542), reflections can be used as the emblem of the highest imagination. For Ruskin this is Turner's, which mirrors the natural world accurately as well as provides a "new view of what is above it." Ruskin defends Turner from hostile contemporary criticism by applying to his work the

basic truth of what watery reflections teach. The whole of *Modern Painters* is an effort to answer the question that is posed by our fascination and puzzlement with mirrors, expressed by another visitor to Italy in 1821:

> Why is the reflection in that canal far more beautiful than the objects it reflects? The colours more vivid yet blended with more harmony; the openings from within into the soft and tender colours of the distant wood and the intersection of the mountain lines surpass and misrepresent truth.

In "misrepresenting" and surpassing truth, Ruskin shows that Turner, who was himself obsessed with reflections in water, especially in his Swiss and Venetian subjects, not only combines all traditional sanctions of the mirror, but becomes in his turn "a mere instrument or mirror, used by a higher power for a reflection to others of a truth which no effort of his could ever have ascertained" (6:44).

The picturesque mirror and the Biblical mirror eventually coincide in the chapter called "The Dark Mirror" in the final volume of *Modern Painters*. In this he is most exercised about whether "it might seem a waste of time to draw landscape at all." He pulls together by way of response many threads from the previous nine interconnected volumes of his work — *The Poetry of Architecture*, *The Seven Lamps*, three volumes of *The Stones of Venice* and the first four of *Modern Painters* itself — and he passes in review most of the concerns that I have tried to elucidate in this paper.

He notes that the picturesque at its lowest is a degradation of the contemplative or reflective faculty. He reaffirms, however, the great artist's attention to the "historical association connected with landscape" and with cities like Venice. He reminds his readers that "in these books of mine, their distinctive character, as essays on art, is their bringing everything to a root in human passion or human hope." He traces "every principle of painting" to "some vital or spiritual fact," which he has used his own verbal skills to translate even when "connections between art and human emotion" were sometimes "slight or local." He then justifies that emphasis upon man's inward rather than outward concerns, even in visual art, by saying that it is in his soul that man resembles the Deity: "the soul of man is still a mirror, wherein may be seen, darkly, the image of the mind of God."

He apologizes at once for these "daring words." Part of the boldness at this point in Ruskin's long endeavour to bring *Modern Painters* and its satellites to completion is perhaps that he finds he still must use an imagery which he encountered first in the picturesque movement, aspects of which he now rejects, and a picturesque imagery that forged strong bonds with religious ideas that he has also found insufficient (he is writing at most twelve months after his famous

"unconversion" in 1858 before Veronese's *Solomon and the Queen of Sheba* in Turin). Continuity and contradiction are the twin hallmarks of Ruskin's mind. So the reliance upon ideas still drawn from modes of thought now rejected must be no surprise, except to those who need to make Ruskin into a systematic thinker. The "soul of man is a mirror of the mind of God" is quickly restated, after a brief defence of the original bold words, and in ways that are even more revealing of Ruskin's debts:

> A mirror, dark, distorted, broken, use what blameful words you please of its state; yet in the main, a true mirror, out of which alone, and by which alone, we can know anything of God at all.
>
> (7:260)

The human ruin, blemished and rough like any picturesque object — has in its turn to be interpreted and articulated as the hieroglyph of spiritual and divine history.

IV

Ruskin's early schooling in the picturesque joined his mother's constant instruction of him in the Bible to shape his most characteristic ideas. At times he needed to insist that he had grown out of both disciplines; while it is certainly true that he re-modelled them, I do not think they ever ceased to determine the ways of his imagination and even the odd fashion in which his *oeuvre* (at least until 1860) was built up.

The love of ruin, of fragments, gave Ruskin, as it had given Thomas Gray, the "truest subjects for his glass." They offered him opportunities for exact delineation, a loving response to shape, form, colour and light. But they also provided occasions for interpretation. For even in what Ruskin calls "lovely nature," though there is "an excellent degree of simple beauty, addressed to the eye alone, yet often what impresses us most will form but a very small portion of that visible beauty" (5:355–56). The key word there is *impress;* elsewhere in the first volume of *Modern Painters* (3:201) the picturesque is specifically contrasted with the "impressive." I suspect what we have here is some fossilized jargon from the Lockean and associational traditions; it serves, however, to distinguish the merely visual from the visible's address to the mind. The impression upon that mind of beauty or truth in visual objects, however, needed fresh languages for its interpretation. Picturesque skill at recording formal delights was not a sufficient syntax; old allegorical and emblematic languages were in disrepute as being both too arcane and too public and general, not tailored for the individual sensibility. Fresh alliances of word and image must be forged to treat of truths which

may be stated by any signs or symbols which have a definite signif-
ication in the minds of those to whom they are addressed, although
such signs be themselves no image nor likeness of anything.

(3:104)

What he strove, therefore, to do was to honour in the same object both truths
that he saw and truths that he deduced, for which a language traditionally ex-
isted in his own evangelical background: that of typology. "I have throughout
the examination of Typical beauty, asserted our instinctive sense of it; the moral
meaning of it being only discoverable by reflection" (4:211). Reflection is thought
and, as he claimed for Turner, our readiness to act as God's mirror.

The attention to fragments, which could be found to speak volumes, may
also, we would be not uncharitable in thinking, serve as an analogy for Ruskin's
own work. He talks frequently of its "warped and broken" text (7:257). But in it
he could reveal by many images and even more words how ruin was of the essence
of God's universe as we find in the Alps and of man's world as we find it in Vene-
tian ornament. He could catalogue and itemise their phenomenal as well as their
noumenal significance. In his mirror he could keep, perhaps, the whole image
steady for himself; it is not always so coherent when we try to peer over his
shoulder. We can from time to time feel confident that we see him steadily and
see him whole; but it would be just as fair to those other moments of our be-
wilderment, trotting round his polygon, to end by quoting his father's panic in
face of the son's frenetic quest among the ruins of Venice on 25 May 1846, an ac-
tivity that the old man seems to intuit, for he was no fool, as a strange revision of
the picturesque:

He is cultivating art at present, searching for real knowledge, but to
you [W. H. Harrison, an old friend] and me this is at present a sealed
book. It will neither take the shape of picture nor poetry. It is
gathered in scraps hardly wrought, for he is drawing perpetually,
but no drawing such as in former days you or I might compliment in
the usual way by saying it deserved a frame; but fragments of every-
thing from a Cupola to a Cart-wheel, but in such bits that it is to the
common eye a mass of Hieroglyphics — all true — truth itself, but
Truth in mosaic.

(8:xxiii)

WILLIAM ARROWSMITH

Ruskin's Fireflies

There is in every word set down by the imaginative mind an awful under-current of meaning, and evidence and shadow upon it of the deep places out of which it has come. It is often obscure, often half told, for he who wrote it, in his clear seeings of the things beneath, may have been impatient of detailed interpretation, but if we choose to dwell upon it and trace it, it will lead us always securely back to that metropolis of the soul's dominion from which we may follow out all the ways and tracks . . .

<div align="right">(4:252ff.)</div>

Will you undertake to convey to another person a perfectly distinct idea of any single emotion passing in your own heart?

You cannot — you cannot fathom it yourself — you have no actual expression for the simple idea, and are compelled to have instant recourse to metaphor.

You can say, for instance, you feel cold, or warm, at the heart; you feel depressed, delighted, dark, bright: are any of these expressions competent to illustrate the whole *feeling? If you try to reach it you must heap metaphor after metaphor, and image after image, and you will feel that the most mysterious touch nearest and reach highest, but none will come up to the truth. In short, if you banish obscurity from your language you banish all description of human emotion, beyond such simple notions as that your hero is in a fury or a fright. For all human emotions are obscure, mysterious in their source, their operation, their nature; and how possibly can the* picture *of a mystery be less than a mystery?*

But, farther — were it possible, it is not desirable to banish all obscurity from poetry. If the mind is delighted in the attainment of a new idea, its delight is increased tenfold if it be obtained by its own exertion — if has arisen apparently from its own depths.

From *The Ruskin Polygon: Essays on the Imagination of John Ruskin.* © 1982 by William Arrowsmith. Manchester University Press, 1982.

> *The object in all* art *is not to* inform *but to* suggest, *not to add to the*
> *knowledge but to kindle the imagination. He is the best poet who can by the*
> *fewest words touch the greatest number of secret chords of thought in his*
> *reader's own mind, and set* them *to work in their own way.*
>
> (1:441–42)

My immediate purpose is to examine one of the more prominent instances of a "saturated" image or obsessional metaphor in Ruskin—the famous fireflies. There are, of course, numerous other, often interrelated, clusters or obsessions. One thinks, for instance, of his lifelong fascination with pure-running water, blue water above all, with sinister depths or with undarkened clarity like the Rhone's, water in all its forms, hellish or paradisal—wave gathering for the fall, brook gliding, river rushing. Or his contagious delight in natural or man-made filigree, all the intricate entanglements of *la divina foresta,* from the arabesques of acanthus scrolls drifted by the wind around the capitals from which they rise, to the instinctual textures of birds' nests and the uncurling "Greek life" disclosed by a fern spiral or the curve of a calligrapher's uncial. Or his passion, geological and moral, for fragmentation and formation of stone, stresslines, folds and cleavages in layered rock (and even blancmange), all flawing and growing of crystal, and analogous formations of human virtue. But none of these, except possibily his preoccupation with serpents, is so unmistakably obsessive as the fireflies. Here, in no particular order, are the more striking examples:

> I have just come in from an evening walk among the stars and fire-
> flies. One hardly knows where one has got to between them, for the
> fires flash, as you know, exactly like the stars on the sea, and the im-
> pression to the eye as if one was walking on water. They dazzled me
> like fireworks, and it was very heavenly to see them floating, field
> beyond field, under the shadowy vines.
>
> (35:562)

An account of Orcagna's Fiesole:

> The Dominican convent is situated at the bottom of a slope of olives,
> distinguished only by its narrow and low spire; a cypress avenue re-
> cedes from it towards Florence . . . No extended prospect is open
> to it; though over the low wall, and through the sharp, thickset olive
> leaves, may be seen one silver gleam of the Arno, and, at evening,
> the peaks of the Carrara mountains, purple against the twilight,

dark and calm, while the fire-flies glance beneath, silent and inter-
mittent, like stars upon the rippling of mute, soft sea.

(12:233–34)

A more ominous example, in a letter of 1870 to a friend:

A climate like the loveliest and purest English summer, with only the
somewhat, to me, awful addition of fire-flies innumerable which, as
soon as the sunset is fairly passed into twilight, light up the dark ilex
groves with flitting torches, or at least, lights as large as candles, and
in the sky, larger than the stars. We got to Siena in a heavy thunder-
storm of sheet-lightning in a quiet evening, and the . . . showers
of fire-flies between made the whole scene look anything rather than
celestial. But it was very lovely by morning light . . .

(20:liv)

In a letter to Carlyle (1867) the emphasis is on the splendour of the fireflies by
night:

I hope . . . the weather has found you still in Italy; and that you
will outstay the Firefly time. I always think that nothing in the world
can possibly be so touching, in its own natural sweetness, and in the
association with the pensive and glorious power of the scene, as the
space of spring time in Italy during which the firefly makes the
meadows quiver at midnight.

(36:527)

In a letter to his mother (1870) the fireflies seem, by comparison, almost
threatening:

The stars burning like torches all over the sky, the fireflies flying all
about, literally brighter than the stars. One came into the railroad car-
riage and shone clear in full lamplight, settling above my head . . .

In another letter to his mother (also dated 1870) the sinister spectacle of the fire-
flies is revealingly contrasted with the goodness of the Sienese *contadini:*

The fireflies are almost awful in the twilight, as bright as candles,
flying in and out of the dark cypresses. The people are *so* good too —
I mean the country people.

(37:9)

Ruskin clearly regards the fireflies with something resembling awe; he was visibly
shocked when his friend Charles Eliot Norton invited him to come and "look at

the lightning-bugs" (36:xcii). But the "bracketing" is ambivalent, producing, according to Ruskin's mood or emotional needs, either foreboding or delight.

In *The Ethics of the Dust* (1865) he describes, in manifestly Dantesque terms, an allegorical "Valley of Diamonds." The scene and the symbolism are saturated in Dante. A rough road winds its way beside a river of blood; the river runs over diamond sands, through harsh, rugged ground, a waste of wild vines said to be "the grape of Eshcol," bitter as gall; the spiny brambles are thick with ruby berries; and high in the contorted trees nest crimson-crested serpents. Wherever one looks there are fireflies:

> And the fireflies fly round the edge of the forests all the night long;
> you wade in fireflies, they make the fields look like a lake trembling
> with reflections of stars; but you must take care not to touch them,
> for they are not like Italian fireflies, but burn, like real sparks.
>
> (18:214 ff.)

At the end of this infernal valley — the Earthly Paradise inverted and run wild — one approaches the throne of its king, Mammon, on whose canopy in fiery letters is written *Pape Satan, Pape Satan Aleppe* (18:215).

The Old Lecturer who recites this tale — clearly Ruskin surrounded by the girls of Winnington School, raptly listening — refuses to unpack his own allegory, saying, "I hate explaining myself." But then he adds:

> You girls ought to be little fireflies yourselves, and find your way in
> twilight by your own wits.
> But you said they burned, you know?
> Yes; and you may be fireflies that way too, some of you, before long,
> though I did not mean that . . . You can scarcely guess that I
> meant them for the light, unpursued vanities, which yet blind us,
> confused among the stars. One evening, as I came late into Siena,
> the fire-flies were flying high on a stormy sirocco wind, — the stars
> themselves no brighter, and all their host seeming at moments, to
> fade as the insects faded!
>
> (18:368)

As self-explanation this is less than convincing, as the Old Lecturer suggests. In the slightly deprecatory tone ("You can scarcely guess") Ruskin appears to disavow his own early interpretation of the fireflies as images of his own lost illusions, all those fitfully glimmering "false fires" and "phosphor lights" one finds everywhere in the early poetry and prose. In the youthful drama *Marcolini*, for instance:

Is it then come to such a pass with me
That this undying hope, this dreamy thing
That flickers in a quick and changing fire
Like to a crown about the brow of madness—
That fixes its far gaze on throne and clouds,
And fills the night of misery with stars
Of thought, which mock with their cold quivering
Of light unreachable . . .
<div align="right">I do love that hope—</div>
As I have loved the beautiful in death . . .
<div align="right">(1:505)</div>

The youthful fireflies are simply *ignes fatui,* the traditional images of vanished hopes, cherished illusions. The Old Lecturer dismisses these youthful illusions and nostalgia for unlived life, writing off with something like distaste the "fatuous fires" and "sputtering illusions" by whose feeble light he had once walked. Old associations are stripped away, and the essential details—twilight, stars, storm cloud, the thick-set background of cypress, ilex or vine—are inflected afresh, at a deeper level, saturated with new experience. In *The Ethics of the Dust* we witness the saturation taking place; the fireflies are now saturated with Rose La Touche (the firefly as unattainable love, a love that *burns*) and also Dante, to whose Inferno, human and cultural, Ruskin now sees himself condemned. But there is also a hint of pride in the thought that the damned must find their own way, glow by the inward light of their own courage and mother-wit, in a dark world. Dryden's famous lines (which Ruskin may be echoing here) come pat to the point:

My thoughtless youth was wing'd with vain desires,
My manhood, long misled by wandring fires,
Follow'd false lights; and when their glimps was gone,
My pride struck out new sparkles of her own.
Such was I, such by nature still I am,
Be thine the glory, and be mine the shame.

It is important to stress the ambivalence which Ruskin, like Dryden, implies. The "shame" is mixed with a "glory" in these "new sparkles" struck by pride—the pride of courageous selfhood.

In the overtly Dantesque setting of Ruskin's fable, the fireflies which, unlike Italian fireflies, "burn, like real sparks" are immediately identifiable as the flakes of fire falling on the sinners in hell:

Sovra tutto 'l sabbion, d'un cader lento
 piovean di foco dilatate falde,
 come di neve in alpe sanze vento . . .

tale scendeva l'etternale ardore;
 onde la rena s'accendea, com'esca
 sotto focile, a doppiar lo dolore.

Sanza riposo mai era la tresca
 de le misere mani, or quindi or quinci
 escotendo da sé l'arsura fresca
 (*Inf.* 14, 28ff.)

Per li occhi fora scoppiava lor duolo;
 di qua, di là soccorrien con le mani
 quando a' vapori, e quando al caldo suolo:

non altrimenti fan di state i cani
 or col ceffo or col piè, quando son morsi
 o da pulci o da mosche o da tafani.
 (*Inf.* 17, 43–51)

Over all the sand huge flakes of fire were falling slowly, like snow in
the mountains without a wind . . . so did the eternal burning des-
cend there, and the sand was kindled by it like tinder under the
flint, to redouble the pain. The dance of the wretched hands was
ever without repose, now here, now there, as they beat off the fresh
burning . . . Their grief was bursting forth through their eyes; with
their hands they defended themselves, now here, now there, some-
times from the flames, sometimes from the burning ground; not
other wise do the dogs in summer, now with muzzle, now with paw,
when they are bitten by fleas, or flies, or gadflies.
 (*Trans. Singleton*)

The fire-bitten sinners of Canto 17 are of course Dante's usurers, their pouches
tied around their necks. And Ruskin naturally annexes the figure in the service
of his own anti-industrial allegory of Mammon's ruined world. Through eco-
nomic avarice and usury, industrial greed and natural impiety the Earthly Para-
dise has been transformed into the polluted wasteland of the Fall, wild with
thorn, thistle and serpent, whose rivers run with the blood of wounded Nature
and Man, and whose true Lucifer is Mammon. The gospel task of redeeming this
hellish waste, purifying the polluted rivers of Paradise, and waging war against

thorn and serpent, is unmistakably the great, all-absorbing prophetic mission of Ruskin's later years — the source from which sprang all those furious jeremiads against spoilers and vandals (restorers!) of Europe's cities; which fuels the tirades of *Fors Clavigera* and the frantic energies devoted to the Guild of St George; and which, in *Sesame and Lilies,* with gentle sternness, reproves English womanhood for its religious indolence and, raising the banner of justification through works, adjures women to stir themselves, to work with *their own hands.* It is their duty, their birthright even, he tells the girls of Winnington, to become *fireflies:* to walk through the darkness by their own inner light ("Let your light so shine") until they become, like Dante's poetic tongue, individual sparks of God's glory, transfigured fireflies:

> ch'una favilla sol de la tua gloria.
>
> (*Par.* 33.71)

(. . . but a single spark of Thy glory.)

All this, looming and inchoate, lies within the penumbra of Ruskin's efforts to explain — or rather to *suggest* what he cannot yet, or will not, explain — his metaphor here. But the image is personal as well as cultural and economic; in the figure of the firefly who burns he is alluding, delicately but clearly, to Rose La Touche and his own burning pain. Ruskin's Inferno is the public hell of a world ruled by Mammon, and the private hell of his love for Rose. *Above,* she is, like Beatrice, one with "the Love that moves the stars," a part of Dante's divine Rose. *Below,* she is a flake of falling fire, she *burns;* she is spine and thorn, she *hurts.* These years were, for Ruskin, years of despair and, often intense bitterness; the feeling of having wasted his youth becomes increasingly strong; and his tragic love for Rose coincides with his rejection of his youthful religion. As his world darkens, the image of the firefly changes from celestial to infernal, from *ignis fatuus* to an image of fleetingly incandescent mortality. The cypresses, ilexes and olives become a funeral backdrop — the *selva oscura* of his, and human, life, against which the firefly flickers like felt pain, a hurt that is no longer simply literary. The pain is, if anything, intensified by contrast with the paradisal memories of the past — the sign of something celestial making its brief epiphany in the world below. The firefly season brings with it the sadness and ecstasy of memory, and the ecstasy intensifies the torture, as with Dante's Francesca:

> Nessun maggior dolore
> che ricordarsi del tempo felice
> ne la miseria.
>
> (*Inf.* 5, 121–23)

(There is no greater sorrow than to recall, in wretchedness, the happy time.)

In Ruskin's hell the task is to cope with the darkness, in him and around him; to find within himself the light he needs to make his way out. In short, to strike his own spark and generate his own light; to become autonomous firefly. This at any rate is exactly how he seems to have thought of the matter. In 1875, several months after Rose's death, Ruskin tried via spiritualist seances to make contact with her:

> Heard from Mrs. Ackworth, in the drawing room where I was once so happy, the most overwhelming evidence of the other state of the world that has ever come to me; and am this morning like a flint stone changed into a firefly, and ordered to flutter about — in a bramble thicket.

The imagination, brooding on its material and searching associations, now with the joy of recognition annexes the *flint* (cf. Dante, *Inf.* 14, 39) from which the firefly's proud "new sparkles" will be struck. Ruskin's joy — I paraphrase the passage — transforms him from unfeeling flint into ecstatic, illuminated firefly; which passes in turn, after the revealing dash, into the old feeling of being lost among the brambles (all that's left him of his Rose — Ruskin's own metaphor) of the familiar "dark wood."

Yet, as Ruskin certainly knew, that "dark wood" is, in Dantesque terms, simply the "sign" of "the other state of the world" — the sacred grove of the Earthly Paradise, and the invisible Paradise beyond. Hell and the world are sown with "signs" pointing beyond themselves, towards their own transfiguration in a higher anagogical realm. Demons point to angels, torture to joy, thirst to its slaking, flint to fire. Ruskin's own passion for geology would have supplied the idea of *silex scintillans,* the flint-born spark. At any rate, the idea of the flint gestates and breeds; before long we find him writing:

> the aspect of my life to its outward beholder is of an extremely desultory force — at its best — confusedly iridescent — unexpectedly and wanderingly sparkling or extinct like a ragged bit of tinder. Only by much attention — if any one cares to give it . . . could the spectator of me at all imagine what an obstinate little black powder of adamant the faltering sparks glowed through the grain of.
>
> (35:608–9)

Accretion on accretion, the image complicates.

If Ruskin now stresses not the unfeeling flint but the adamantine toughness of it, it means that he has found in himself the self-reliance he commended to the girls of Winnington when he told them to become fireflies and find their

way by the light of their own wits. *The Ethics of the Dust* is an unabashed moral geology, Ruskin's sermons in stones and primer of the "crystal virtues." *Deucalion*, written in July 1875, just after Rose's death, is a far darker book in the same moral vein. In a chapter revealingly titled "The Iris of the Earth" he discourses on the quality and virtue of flint:

> It is made of brown stuff called silicon, and oxygen, and a little iron; and so any apothecary can tell what you all . . . are made of: — you, and I, and all of us, are made of carbon, nitrogen, lime, and phosphorus, and seventy per cent or rather more of water; but then, that doesn't tell us what we are . . . And so, in knowing only what it is made of, we don't know what a flint is.
>
> To know what it is, we must know what it can do, and *suffer*.
>
> That it can strike *steel into white-hot fire*, but can itself be *melted down like water, if mixed with ashes;* that it is subject to laws of form . . . that *in the fulfilment of these it becomes pure, — in rebellion against them, foul and base;* that it is appointed on our island coast to *endure* for countless ages, fortifying the sea cliff; and on the brow of that very cliff, every spring, *to be dissolved,* that the green blades of corn may drink with the dew; — that *in its noblest forms* it is *still imperfect,* and *in the meanest, still honorable,* — this, if we have rightly learned, we begin to know what a flint is.
>
> (26:167–68)

In the italicised words (my emphases) I mean to suggest the general lines of Ruskin's sub-text, the way in which his imagination confronts his own (and human) suffering and the fact of death, his own sense of "flinty" human nature. The crucial point is the ambivalence of this "flinty virtue": adamantine in endurance and courage, in grief vulnerably soft; lowly, yet capable of celestial fire and "immortal longings"; capable too of radical self-transformation, the highest formal law of its being which, being evinced, becomes (as in the great design of Sophocles' *Oedipus at Colonus*) the life and meaning — intermittently firelit — of the earth itself. Implicit in the figure of flint lies the pattern and hope of recreating the earthly paradise. As always, Ruskin is *teaching.* Teaching himself to become himself, to accept his nature but also purify it, with the hope, through his own self-taught example, of teaching others. As he changes, the obsessive image of the firefly changes, becoming more and more subject to the shaping, controlling imagination, less and less obsessive.

We *see* it happening. Before Rose's death Ruskin wrote to a mutual friend that Rose, in her treatment of him, had *not* acted like a flint:

> Alas, if only she did behave like a flint! My flints *comfort* me. When
> I've said all that's in my mind against religion generally, I shall set-
> tle myself quietly to write the "history of flint" [here is the germ of
> what became *Deucalion*] — long intended, — headed by the species,
> "Achates Rosacea" — I gave her such a pretty piece of rose-quartz
> ages ago — little thinking . . . when I told her laughing — it was a
> type of her (which made her very angry, *then*) that she would ever
> say so with her own lips.

Ruskin means that Rose is quartz because she is hard and beautiful; she *glitters,*
but persistently, not intermittently and humanly, like a struck flint. She is all
crystal, blazing with the love of God and hence unresponsive to her human lover
(who loved God in *her* and later complained to a friend (37:117), "I wanted my
Rosie *here.* In heaven I mean to go and talk to Pythagoras and Socrates . . .
What will grey eyes and red cheeks be good for *there?*"). Hence his desire to
speak his mind "against religion" generally, which had robbed him of Rosie.

The final "firefly" passage is the most renowned, the famous closing words
of *Praeterita,* his last and best book. The passage — the matrix from which the
final image, under intensely converging pressures conveyed by apparently ran-
domly linked associations and happy memories — deserves to be cited entire:

> I draw back to my own home, twenty years ago, permitted to thank
> Heaven once more for the peace, and hope, and loveliness of it, and
> the Elysian walks with Joanie, and Paradisiacal with Rosie, under the
> peach-blossom branches by the little glittering stream which I had
> paved with crystal for them. I had built behind the highest cluster of
> laurels a reservoir, from which, on sunny afternoons, I could let a
> quite rippling film of water run for a couple of hours down behind
> the hayfield, where the grass in spring still grew fresh and deep.
> There used to be always a corncake or two in it. Twilight after twi-
> light I have hunted that bird, and never once got a glimpse of it: the
> voice was always at the other side of the field, or in the inscrutable air
> or earth. And the little stream had its falls, and pools, and imaginary
> lakes. Here and there it lost itself under beads of chalcedony. It wasn't
> the Liffey, nor the Nith, nor the Wandel, but the two girls were
> surely a little cruel to call it "The Gutter"! Happiest times, for all of
> us, that ever were to be; not but that Joanie and her Arthur are giddy
> enough, both of them yet, with their five little ones, but they have
> been sorely anxious about me, and I have been sorrowful enough for
> myself, since ever I lost sight of that peach-blossom avenue. "Eden-
> land" Rosie calls it sometimes in her letters. Whether its tiny river

were of the waters of Abana, or Euphrates, or Thamesis, I know not, but they were sweeter to my thirst than the fountains of Trevi or Branda.

How things bind and blend themselves together! The last time I saw the fountain of Trevi, it was from Arthur's father's room—Joseph Severn's, where we both took Joanie to see him in 1872, and the old man made a sweet drawing of his sweet daughter-in-law, now in her schoolroom; he himself then eager in finishing his last picture of the marriage in Cana, which he had caused to take place under a vine trellis, and delighted himself by painting the crystal and ruby glittering of the changing rivulet of water out of the Greek vase, glowing into wine. Fonte Branda I last saw with Charles Norton, under the same arches where Dante saw it. We drank of it together, and walked together that evening on the hills above, where the fireflies among the scented thickets shone fitfully in the still undarkened air. *How* they shone! moving like fine-broken starlight through the purple leaves. How they shone! through the sunset that faded into thunderous night as I entered Siena three days before, the white edges of the mountainous clouds still lighted from the west, and the openly golden sky calm behind the Gate of Siena's heart, with its still golden words, "Cor magis tibi pandit," and the fireflies everywhere in sky and cloud rising and falling, mixed with the lightning, and more intense than the stars.

(35:560–62)

How things bind and blend themselves together! The intricacy of the binding here, whether these concinnities are deliberate or the work of "dream-gifted" association in a mind nearing madness, is close to miraculous. Ruskin's *things* ("How *things* bind and blend") suggests that here *things*—active memories—*are* in control; that the narrator's mind is merely a chain on which these memories thread themselves and collect, imposing their own apparently adventitious unity on the musing mind whose past they casually glean. This may be artifice, of course, a narrative strategy for this most improbable of autobiographies. But this seems unlikely. Ruskin rather seems—or wants to seem—resigned to writing according to the concerted rush of things crowding into his mind, speaking through him as their chosen vessel. At least, this is the effect: obsessive themes, images, memories appear to lift into a new life of their own, twining uncontrollably into an autonomous new whole, with a texture of its own making.

Memory laps into memory; they coalesce, expand, annex another memory or image. We get, as it were, a montage of paradisal rivers and waters, all converging

into a single celestial Rhone. [The most paradisal of all of Ruskin's many para-
disal rivers, as the power and beauty of (his description in *Praeterita*, 35:326–27)
makes unmistakably clear.] From Nith to Wandel we move with the remem-
berer to the putative rivers of Ruskin's Eden-land, sweeter to the parched throat
than the fountains of Trevi or Branda. Thoughts of the giddy Severns recall the
older Severn in his room, overlooking the Fontana di Trevi, with its Baroque
river gods and splashing waters, all liquid life and exuberance — living water in
the city of the dead. [To Ruskin, who disliked Rome and thought of it as a dead
and polluted city, Fontana di Trevi suggested purity and life: "When I say water, I
mean legitimate Roman springs . . . fresh from the rocks of the Apennines —
bubbling up in every street and marketplace in abundant gushings, or poured in
a roaring torrent under the arches of gigantic fountains; the only thing in Rome
that does not look diseased or cursed — desolate — desecrate — dismal — dull — or
damnable . . ." (1:445)] This in turn recalls Severn's *Marriage in Cana*, the
sculptured scene set beneath the vine trellis (those "purple leaves" of the firefly
passages, the thick-set hedge of shade, olive, ilex, cypress or bramble), and
showing forth, in its own artistic miracle, the natural miracle of water becoming
wine, the miracle happening *now*. *Now* — this is the effect of Ruskin's verbs —
"the *changing* rivulet of water out of the Greek vase *glowing* into wine"; we note
the way in which the present participles indicate the intensity of a continuous
present, the happening now of things of the past, miraculously quickened.
Fontana di Trevi melts into Fonte Branda (associated in Ruskin's mind with
Fonte Gaia), recalling happy days spent with his friend Charles Eliot Norton —
and then Norton, via a footnote, multiplying into five other friends, other
associated memories). But Fonte Branda also recalls Dante's Tuscany and the
events associated by Dante with Fonte Branda — the story of the famous forger of
the *Inferno*, Maestro Adamo. Ruskin's narrative guides, and is in turn guided
by, the Dantesque association. Ruskin and Norton, their thirst quenched, walk
uphill, back to the sources in the hills of Casentino where the waters of Fonte
Branda begin as brooks. Fusing in memory with these brooks are the paradisal
streams and waters of Ruskin's childhood life and later:

> the Tay, Erne, and Wandel, as early familiar rivers — Loch Leven and
> Queen's Ferry, Derwent Water and Coniston Water . . . and later
> . . . Matlock and Bristol . . . the open sea beach at Sangate . . .
>
> (35:609)

In this way Ruskin's lost paradise — the Eden-land he spent his life trying to re-
construct and rescue from pollution, even to the "little glittering stream" where
he walked with Rosie and Joan — glancingly attaches Maestro Adamo's situation
in the polluted ditch. The result is greater depth and dimension, a pathos that is

no longer purely private. The whole Dante episode crowds into Ruskin's memory, and then, by means of further associations, carries him forward to the final image of the fireflies, itself profoundly saturated in Dante, as we shall see.

But here, first, is Master Adam:

> O voi che sanz' alcuna pena siete,
> e non so io perché, nel mondo gramo,'
> diss' elli a noi, 'guardate e attendete
>
> a la miseria del maestro Adamo;
> io ebbi, vivi, assai di quel ch'i volli,
> e ora, lasso!, un gocciol d'acqua bramo.
>
> Li ruscelletti che d'i verdi colli
> del Casentin discendon giuso nel Arno,
> faccendo i lor canali freddi e molli,
>
> sempre me stanno innanzi, e non indarno,
> ché l'imagine lor vie più m'asciuga
> che 'l male ond'io nel volto mi discarno.
>
> La rigida giustizia che mi fruga
> tragge cagion del loco ov'io peccai
> a metter più li miei sospiri in fuga.
>
> Ivi è Romena, là dov'io falsai
> la lega suggellata del Batista;
> per ch'io il corpo sù arso lasciai.
>
> Ma s'io vedessi qui l'anima trista
> di Giudo o d'Alessandro o di lor frate,
> per Fonte Branda non darei la vista
> (*Inf.* 30, 58–78)

"Oh, you who are without any punishment, and I know not why, in this dismal world," he said to us, "behold and consider the misery of Master Adam. Living, I had in plenty all that I wished, and now, alas! I crave one drop of water! The little brooks that from the green hills of Casentino run down into the Arno, making their channels cool and moist, are always before me, and not in vain, for the image of them parches me far more than the malady that wastes my features. The rigid justice that scourges me draws occasion from the place where I sinned, to give my sighs a quicker flight; there is Romena, where I falsified the currency stamped with the Baptist, for which on earth I left my body burnt. But if I could see here the miserable soul

of Guido or of Alessandro or of their brother, I would not give the
sight for Fonte Branda."

<div align="right">(Trans. Singleton)</div>

A few lines later, Master Adam is reviled by his fellow sinner, Sinon the Greek,
and cursed with the curse most appropriate to the sinner who, born among pure
streams, had, by defacing the coinage stamped with the Baptist, desecrated "the
water of life":

> "E te sia rea la sete onde ti crepa,"
> disse 'l Greco, "la lingua, e l'acqua marcia
> che 'l ventre innanzi a li occhi si t'assiepa!"
> [*Inf.* 30, 121–23]

"And to you be torture the thirst that cracks your tongue," said the
Greek, "and the foul water that makes your belly thus a hedge
before your eyes."

That Ruskin perceived himself in these Dantesque terms, and here and
elsewhere has Master Adam constantly in mind, there can be no doubt. [See
23:29–30. "Without engineers' art, the glens which cleave the sand-rock of
Siena flow with living water; and still if there be a hell for the forger in Italy, he
remembers therein the sweet grotto and green wave of Fonte Branda." Also
17:551–52: "But she [Italy] does not need us. Good engineers she has, and has
had many since Leonardo designed the canals of Lombardy . . . Her streams
have learned obedience before now: Fonte Branda and the Fountain of Joy flow
at Siena still; the rivulets that make green the slopes of Casentino may yet satisfy
true men's thirst." See also 5:308; "Ugolino, in his dream, seemed to himself to
be in the mountains, 'by cause of which the Pisan cannot see Lucca'; and it is im-
possible to look up from Pisa to that hoary slope without remembering the awe
there is in the passage; nevertheless, it was as a hunting-ground only that he
remembered those hills. Adam of Brescia, tormented with thirst, remembers
the hills of Romena, but only for the sake of their sweet waters:

> The rills that glitter down the grassy slopes
> Of Casentino, making fresh and soft
> The banks whereby they glide to Arno's stream
> Stand ever in my view"]

Again and again the aging Ruskin sets himself among Dante's damned or living
dead, those who, like Sordello, have never lived at all; a man who has for ever
lost the light and the living water. He stands instead in Master Adam's *acqua
marcia*, or among the sinners on whom the rain of fire-flakes descends. *There* he

remembers the unpolluted streams of his childhood, the radiance and purity of Mont Blanc, and the forbidden fruit of his Herne Hill Eden:

> [a garden] . . . possessing also a strong old mulberry tree, a tall white-heart cherry tree, a black Kentish one, and an almost unbroken hedge, all round, of alternate gooseberry and currant bush; decked, in due season . . . with magical splendour of abundant fruit: fresh green, soft amber, and rough-bristled crimson bending the spinous branches; clustered pearl and pendant ruby joyfully discoverable under the large leaves that looked like vine.
>
> The differences of primal importance which I observed between the nature of this garden, and that of Eden . . . were that, in this one, *all* the fruit was forbidden . . .
>
> (35:36)

Behind Ruskin stands Dante's Master Adam, and, behind both, fallen Adam himself. In 1867 he wrote to Norton:

> Dante's *Vita Nuova* falls in much with my own mind — but, when death or life depends on such things, suppose it should be *morte nuova* day by day.
>
> (36:545)

But, until the last years, *morte nuova* always. On one of his final trips to Venice, looking out on the polluted canals of "the world's most splendid city," he wrote:

> This green tide that eddies by my threshold is full of floating corpses, and I must leave my dinner to bury them, since I cannot save . . . This green sea-tide! — yes, and if you knew it, your black and sulphurous tides also — Yarrow and Teviot and Clyde, and the stream, for ever now drumly and dark as it rolls on its way, at the ford of Melrose. Yes, and the fair lakes and running waters in your English park pleasure-grounds — nay, also the great and wide sea, that gnaws your cliffs — yes, and Death and Hell also, more cruel than cliff or sea.
>
> (28:77–78)

As for his paradisal Alps ("the seen walls of Lost Eden could not have been more beautiful to us"), they were gone for ever. The late Ruskin is full of the melancholy, sometimes the rhetoric but often the rage, of *ubi sunt*. At times his sadness is little more than liverishly brilliant elegy or jeremiad; at others it reaches greatness, as in his 1882 letter to Charles Eliot Norton:

> I couldn't draw the ridge, and there was no Mont Blanc, any more than there was any you; for indeed the Mont Blanc *we* knew is no

more. All the snows are wasted, the lower rocks bare, the luxuriance
of light, the plenitude of power, the Eternity of Being, are all gone
from it — even the purity — for the wasted and thawing snow is grey
in comparison to the fresh-frosted wreaths of new-fallen cloud which
we saw in the morning light — how many mornings ago?

(27:408)

It is this experience of a shared paradise, taken for granted in youth (as Paradise
usually is), followed by expulsion into lonely damnation — and perhaps this very
letter to Norton — that Ruskin is recalling in the final paragraphs of *Praeterita*.
With Norton he shared a consuming passion for Dante; together they had
shared Dante's Tuscany, and in Siena drunk of Fonte Branda together. This
memory of former happiness shared and lost is intensified in the perspective of
Master Adam, alone in the "stinking water," burning with thirst as though
enveloped in fire, remembering.

The perspective is anything but bookish. Ruskin's personal experience ac-
tively attaches the literary text passively acquired in earlier years; Dante's vision
informs his experience. If the early Ruskin was *par excellence* the observer, the
late Ruskin is the prophet of committed action, *himself* committed to action,
working frantically against time, always reminding himself, "I must work the
works of him that sent me, while it is day: the night cometh, when no man can
work." All his innumerable projects — rescuing threatened buildings, rooting
out thistle wastes, saving the Rhone, ditching swamps and rebuilding roads,
cleansing polluted springs and streams, restoring to the routine-numbered
worker of industrial England the true craftsman's joy in his work, resurrecting
the old crafts and the craftsman's virtue, redeeming the selfish economics which
had contaminated the "waters of life" — all these projects, however unpractical
or grandiose, were his conscious effort to recreate the Earthly Paradise. The vir-
tues they required were not primarily intellectual or literary, but rather the
moral virtues he had praised in flint: endurance, the capacity to strike sparks
from one's own inward nature, humility, kindness and compassion, patience.
They also required — what has been too seldom noticed in the late Ruskin's
strangely Nestorian Christianity — a sympathy with the earth, with one's own
animal nature and powers. His symbol for this is St Theodore of Venice, stand-
ing on his crocodile, "the human spirit in true conquest over the inhuman,
because in true sympathy with it . . . being strengthened and pedestalled by
the 'Dragons and all Deeps.'" "The animal gods of Egypt and Assyria," he pro-
ceeds darkly but grandly, "the animal cry that there is *no* God, of the passing
hour, are, both of them, parts of the rudiments of the religion yet to be revealed"

(24:303). This was the Ruskin who wanted his Rosie *"here*," and who, in his last years, worked so hard to reform *himself* as the first step in persuading others to recreate the Garden.

It was too late, of course, and Ruskin knew it. But *Praeterita* deserves to be read as something more than nostalgia, a commemoration of "golden times." It is that, but it is also paradisal autobiography—a life revised backwards in order to create, through Imagination Penetrative, what the hands could no longer accomplish. *Praeterita* shows us how Ruskin—having never lived at all, or having started too late—*might* have lived, *could* have lived, had he only known how, known earlier. There are few sadder or more revealing reflections on his own life than these:

> nothing prevails finally but a steady, worldly-wise labour—comfortable—resolute—fearless—full of animal life—affectionate—compassionate. I think I see how one ought to live, now, but my own life is lost, gone by. I looked for another world, and find there is only this, and that is past for me: what message I have given is all wrong: has to be all resaid, in another way, and is, so said, almost too terrible to be serviceable. For the present, I am dead-silent.
>
> (36:381)

The dead silence was broken by *Praeterita,* his last effort to renew, in a wholly new way, his prophetic ministry by putting to fullest verbal use just those flinty virtues he praises as alone prevailing. These virtues, in others but also implicitly in himself, are what *Praeterita* is so beautifully and compellingly about. In short, a book of deliberate preterition: a disregarding of matters best forgotten or not worth remembering; or a memorial of important matters wrongly neglected in the writer's earlier years. The struck flint strikes new sparks; and these sparks—luminous, iridescent natures shining bravely and fitfully against the leaves of this world, *selva oscura* or darkening Garden as the case may be—are the fireflies the book remembers. But that commemoration is itself a deliberate *act.* The writer rewrites himself by conscious preterition, according to his own "lights," and, by so doing, brightens the darkness himself.

Ruskin's language, when he speaks of the paradisal loveliness of the unpolluted world he once knew, is so powerful that there is real danger of forgetting that this power, at least in the late works, is intended to effect reform. The prose is missionary, but what gives it special urgency is his own involvement in practical (or unpractical) reform. The preacher's text has been blooded by *praxis;* and the text takes on a fresh power and concentration of energy. In the earlier Ruskin the language, for all its splendour, is finally that of the pulpit, of the vicarious

observer. The astonishing power of the late prose—*Fors Clavigera, Praeterita,*
the letters, *The Bible of Amiens,* parts of *Deucalion* and *St Mark's Rest*—has its
source in Ruskin's experience of the depths, in despair and pain, but above all in
his efforts to remake himself, to practise what he preached. The reader who sees
in the allusion to Dante's Master Adam in his dirty ditch, thirsting for the living
water of Fonte Branda, only literary embellishment misses the whole point.
Misses the point that the allusion is governed not by passive or "dream-gifted"
association but by selective memory, itself galvanised by purposive action. The
association has been actualised, is so saturated in ways of feeling, seeing and ac-
ting that it is one thing with them. It is "second nature."

As in this remarkable passage with which *The Crown of Wild Olive* (1873)
begins:

> Twenty years ago, there was no lovelier piece of lowland scenery in
> South England, nor any more pathetic, in the world, by its expression
> of sweet human character and life, than that immediately bordering
> on the sources of the Wandel, and including the low moors of Alding-
> ton, and the villages of Beddington and Carshalton, with all their
> pools and streams . . . The place remains (1870) nearly unchanged
> in its larger features; but with deliberate mind I say, that I have
> never seen anything so ghastly in its inner tragic meaning,—not in
> Pisan Maremma,—not by Campagna tomb—not by the Torcellan
> shore,—as the slow stealing of aspects of reckless, indolent, animal
> neglect, over the delicate sweetness of that English scene . . . Just
> where the welling of stainless water, trembling and pure, like a body
> of light, enters the pool of Carshalton, cutting itself a radiant chan-
> nel down to the gravel, through warp of feathery weeds, all waving,
> which it traverses with its deep thread of clearness, like the chalce-
> dony in moss-agate, starred here and there with the white grenouil-
> lette; just in the very rush and murmur of the first spreading currents,
> the human wretches of the place cast their street and house foulness;
> heaps of dust and slime, and broken shreds of old metal, and rags of
> putrid clothes; which, having neither energy to cart away, nor
> decency to dig into the ground, they thus shed into the stream, to
> diffuse what venom of it will float and melt, far away, in all places
> where God meant those waters to bring joy and health. And, in a lit-
> tle pool behind some houses farther in the village, where another
> spring rises, the shattered stones of the well, and of the little fretted
> channel which was long ago built and traced for it by gentler hands,
> lie scattered, each from each, under a ragged bank of mortar, and

scoria, and bricklayer's refuse, on one side, which the clean water nevertheless chastises to purity; but it cannot conquer the dead earth beyond: and there, circled and coiled under festering scum, the stagnant edge of the pool effaces itself into a slope of black slime, the accumulation of indolent years. Half-a-dozen men, with one day's work, could cleanse those pools, and trim the flowers about their banks, and make every glittering wave medicinal, as if it ran, troubled only of angels, from the porch of Bethesda. But that day's work is never given . . .

(18:2–4)

The art critic's narratively graphic eye recreates as it moves over the scene the unfolding reality of paradisal river in pollution, its frustrated efforts to recreate its purity, to cleanse itself. The prose is especially passionate because it is Ruskin's own childhood Paradise, the springs of Wandel at Carshalton, that are at stake. Disgust and anger jostle memory — memory outraged. Beneath the rising gorge of his anger, we can sense the implied challenge to himself ("one day's work . . . could cleanse those pools . . . But that day's work is never given") and the gathering determination to act. And act he did. In homage to his mother Ruskin repeatedly cleaned the springs and trimmed the weeds of "Margaret's Well" at Carshalton.

As for art and art history, it led, inevitably, to the same effort to "purify the sources" and halt pollution — economic, industrial, moral — that had contaminated the "waters of life":

The beginning of art is *in getting our country clean* . . . How can the artist paint a blue sky, if he cannot see the sky because of the smoke, or how can he paint the harbour at Folkestone, if the harbour is polluted?

(27:159)

I have . . . spoken of the flowing of streams . . . as a partial image of the action of wealth . . . The popular economist . . . declares that the course of demand and supply cannot be forbidden by human laws. Precisely in the same sense . . . the waters of the world go where they are required. But . . . whether the streams shall be a cure or a blessing, depends upon man's labour, and administering intelligence . . . The stream which, rightly directed, would have flowed in soft irrigation from field to field — would have purified the air, given food to man and beast — now overwhelms the plain and poisons the wind; its breath pestilence and its work famine.

No human laws can withstand its flow. They can only guide it: but
this, the leading trench and limiting mound can do so thoroughly,
that it shall become water of life . . . or, by leaving it to its own
lawless flow, they may make it . . . water of Marah—the water
which feeds the roots of all evil.

(17:60–61)

It is because Ruskin is engaged by the actual meanings of his own metaphors,
whether economic or artistic or broadly cultural; because he insists upon living
his text, purifying it by action, that his late prose achieves a power and energy
and clarity that distinguish it from the earlier work.

Having drunk of Fonte Branda, Norton and Ruskin left Siena and "walked
on the hills above." The text of Dante has been so internalised, is so much a part
of Ruskin's mind that he can suppress precisely that one element—the story of
Master Adam—which links Fonte Branda with the stroll in the Tuscan hills. The
suppressed detail controls the narrative sequence; but it can do this only because
it has already been absorbed by his life.

The point is central. Ruskin's intense bookishness in early life meant that
for him literature, the great got-by-heart texts of his childhood—the Bible he
read daily with his mother; Shakespeare; Scott; and, later, Dante—acquired the
authority of real experience, the intensity of unlived life. As Eliot acutely ob-
served, "One feels that the emotional intensity of Ruskin is partly a deflection of
something that was baffled in life." Track Ruskin as far as you can, and you will
almost always come upon a text from one of his major sources, or several over-
lapping and recombined texts, capable of combining in new ways as experience
demands. And this is especially the case with a mind like that of the youthful
Ruskin, with scant knowledge of the world, an over-protected, imaginative boy
of astonishing observational energy, prodigious memory and, not least, a des-
perate and hardly recognised emotional need.

Ruskin's mode of thinking is clearly complex. But the essential component
is association. Typically, an observation roots itself, for enhancement of emo-
tional force or generalising power, in an earlier text, preferably a classic, of ap-
posite form and / or meaning. This text is often concealed. Not for deceptive
reasons, to deny an influence, but because the writer is unaware of the associa-
tions—I speak of the *early* Ruskin—by which he is guided. He may control the
text imperfectly; or he may simply fail to realise that the text has him in its grip;
or because, as with the Master Adam passage, he has made the text so thoroughly
his own that he can no longer tell the difference between it and his own thought.
The dangers of unawareness are obviously compounded when the critical text is
one which, at an early age, has been committed to memory—the deeper kind of

memory which, in music and rhythm, lies *below* the meaning. Such texts govern us more deeply perhaps than those whose meanings we consciously acquire; uncritically acquired, they often assert an authority out of all proportion to their meaning. Ruskin insists, of course, that his Bible was critically acquired. Even so, his acquisition at a very early age of the Bible whole, most of Shakespeare, much of Scott, provided him with an enormous storehouse whose complex textual meanings he could have mastered only *after* committing them to memory. The text, so committed, then returns in later years to inform and, unless the writer is very vigilant, to guide, influence, shape, even control the diction, rhythm and sense of his own "conscious" thought. Elevate this influence or authority of the remembered text to the level of a principle, and you authorise a certain passivity before tradition. For the remembered, the got-by-heart, text is always the traditional text; why otherwise memorise it in childhood? What this means in practice is that the writer who consciously assents to the tradition he has uncritically acquired consents to what may be real confusion or unrecognised multiplicity of purpose. He is, let us assume, intellectually his own man; yet, given the shaping of ear and tongue and even mind in his formative years, he may become the unwitting vehicle of all those potent ghosts still active in him or the acquired tradition. If he believes on theory that the writer is a kind of vessel or voice for all these ghosts, and if his own experience is limited, he may not always know whose hand is guiding his pen, or to what purpose.

His account of Turner's mode of painting is perhaps the most accurate account of Ruskin's own way of thinking and writing, at least for much of his working life. Turner's composition, he asserts, may in fact not be composition at all but *an arrangement of associated memories:*

> It is this very character which appears to me to mark it as so distinctly an act of dream-vision; for in a dream there is just this kind of confused remembrance of the form of things which we have seen long ago, associated by new and strange laws . . . whenever Turner really tried to *compose,* and made modifications of his subjects on principle, he did wrong, and spoiled them; and that he only did right in a kind of passive obedience to his first vision, that vision being composed primarily of the strong memory of the place itself he had to draw; and secondarily of memories of other places . . . with all great inventors I know not, but with all those whom I have carefully studied (Dante, Scott, Turner, and Tintoret) it seems to me to hold absolutely; their imagination consisting, not in a voluntary production of new images, but an involuntary remembrance, exactly at the right moment, of something they had actually seen.

Imagine all that any of these men had seen or heard in the whole course of their lives, laid up accurately in their memories as in vast storehouses, extending, with the poets, even to the slightest intonations of syllables heard in the beginning of their lives, and, with the painters, down to the minute folds of drapery, and shapes of leaves and stones, and over all this unindexed and immeasurable mass of treasure, the imagination brooding and wandering, but dream-gifted, so as to summon at any moment exactly such groups of ideas as shall justly fit each other . . . Turner's mind is not more, in my estimation, distinguished above others by its demonstrable arranging and ruling faculties than by its demonstrably retentive and submissive faculties; and the longer I investigate it, the more this tenderness of perception and grasp of memory seems to me the root of its greatness . . . I am more and more convinced . . . respecting the imagination, that its true force lies in its marvellous insight and foresight . . . and . . . because in *its* work, the vanity and individualism of the man himself are crushed, and he becomes a mere instrument or mirror, used by a higher power for the reflection to others of a truth which no effort of his could ever have ascertained.
(6:41–44)

Elsewhere in *Modern Painters* Ruskin remarks in a way which vividly anticipates, and perhaps influenced, Eliot's doctrine of poetic "impersonality":

The power of the masters is shown by their self-annihilation. It is commensurate with the degree in which they themselves appear not in their work . . . Every great writer may be at once known by his guiding the mind far from himself to the beauty which is not of his own creation, and the knowledge which is past his finding out.
(3:23)

In sum, precisely the aesthetic posture of the Ruskin who asserts in *Praeterita:*

My entire delight was in observing without being myself noticed, —if I could have been invisible, all the better. I was absolutely interested in men and their ways, as I was interested in marmots and chamois, in tomtits and trout. If only they would stay still and let me look at them, and not get into their holes and up their heights! The living inhabitation of the world—the grazing and nesting in it, —the spiritual power of the air, the rocks, the waters, to be in the midst of it, and rejoice and wonder at it, and help it if I could, —happier if it needed no help of mine, —this was the essential love of Nature in

me, this the root of all that I have usefully become and the light of
all that I have rightly learned.

$$(35:166)$$

A tender submissiveness of mind as opposed to the governing intellect,
with the stress on the involuntary combination of memory and dream; the cen-
sure of doctrinal composition and intellectual revision—these precepts tell us a
great deal about Ruskin's perception of his own work, as well as the way in which
that apparently "dream-gifted" book *Praeterita* may have been written. Add to
this his consistent counsel of humility towards the greatest masters, of making
oneself invisible by steeping the mind in the tradition, and we have a set of prin-
ciples which, despite obvious differences, are those advocated by Eliot in "Tradi-
tion and the Individual Talent." There too the poet proposes to divest himself of
his own personality in order to become the continuing voice of "the changing
mind of Europe." The past is crowded with ghostly presences who, through his
voice, recover life but also quicken him into individual fulfilment; tradition is
precisely this living larval inhabitation of the present by the past. The tradition
possesses the poet, who, in turn, struggles to master what possesses him—to
become the active rather than the passive bearer of his tradition, or at least to
balance submission with mastery. What came to Ruskin through daily family
readings of the Bible, Shakespeare and Scott was achieved by Eliot only through
arduous labour. The difference is felt as a difference in control, as a degree of ef-
fort. The traditional text seems at times to possess Ruskin as though he were
unaware of the possession, whereas in Eliot the possession smells at times of the
lamp.

An example of such "possession" in Ruskin. In 1875 he wrote to his friend
Susan Beever about, among other things, Scott's *Waverley:*

> Do you recollect Gibbie [*sic*] Gellatly? I was thinking over that ques-
> tion of yours, "What did I think of the things that shall be hereafter
> —J. R.?" But my dear Susie, you might as well ask Gibbie Gellatly
> what *he* thought. What does it matter what any of us think? We are
> but simpletons, the best of us, and I am a very inconsistent and way-
> ward simpleton. I know how to roast eggs, in the ashes, perhaps—
> but for the next world! Why don't you ask your squirrel what *he*
> thinks too? The great point—the one for all of us—is, not to take
> false words in our mouths, and to crack our nuts innocently through
> winter and rough weather.

$$(37:158)$$

The allusion to Davie Gellatly in Scott's *Waverley,* the feebleminded boy who
could at least roast eggs in the ashes, is here abruptly enjambed, with the last

words from Amiens's song in *As You Like It*. But look again at the Shakespeare text and the abruptness becomes ellipsis. Amiens's song ended, Jacques says, "I can suck melancholy out of a song as a weasel sucks eggs." The weasel turns into Susan Beever's pet squirrel, and Jacques disappears. Not because Ruskin planned it that way, but because his mind associated in this way, with lightning rapidity collapsing the two works together (along with Scott's *Old Mortality*, [Ruskin has, revealingly, confounded the simpleton-boy Davie Gellatly of *Waverly* with the crack-bained Gibbie Goose of *Old Mortality*] and suppressing the pivotal term—Jacques and the image of the egg-sucking weasel—in order to conclude on the squirrel's "steady, worldly-wise" innocence. Ruskin's thought, while concentrated, is simple; it acquires range and power by his talent for finding appropriate "correlatives" in which to embed itself—though in a clear sense the rote mastery of the tradition is the condition of the talent it "possesses." The possessed text bides its time, waiting for the precise moment in which to precipitate itself into the imagination of its possessor. But it may also, as with the firefly image, be precipitated by the active imagination of its engaged possessor.

Look back, from this perspective, at the firefly image. Given the quite incredible degree of Ruskin's immersion in Dante—an immersion matched among English writers only by Eliot—it would, I think, have been quite impossible for him, while musing on the spectacle of the fireflies, there in Dante's Tuscany, *not* to have recalled the great metaphor, in Canto 26, of the peasant and the fireflies, who stand for the fire-enveloped sinners. Here is the passage:

> Quante 'l villan ch'al poggio si riposa,
> nel tempo che colui che 'l mondo schiara
> la faccia sua a noi tien meno ascosa,
>
> come la mosca cede a la zanzara,
> vede lucciole giù per la vallea,
> forse colà dov'e' vendemmia e ara:
>
> di tante fiamme tutta risplendea
> l'ottava bolgia, sì com'io m'accorsi
> tosto che fui là 've 'l fondo parea.
>
> E qual colui che si vengiò con li orsi
> vide 'l carro d'Elia al dipartire,
> quando i cavalli al cielo erti levorsi,
>
> che nol potea sì con li occhi seguire,
> ch'el vedesse altro che la fiamma sola,
> sì come nuvoletta, in sù salire:

tal si move ciascuna per la gola
 del fosso, ché nessuna mostra 'l furto,
 e ogne fiamma un peccatore invola.

Io stava sovra 'l ponte a veder surto,
 sì che s'io non avessi un ronchion preso,
 caduto sarei giù sanz'esser urto.

E'l duca, che mi vide tanto atteso,
 disse: "Dentro dai fuochi son li spirti;
 catun si fascia di quel ch'elli è incesco."
 (*Inf.* 26, 25–48)

As many as the fireflies which the peasant, resting on the hill — in
the season when he that lights the world least hides his face from us,
and at that hour when the fly yields to the mosquito — sees down
along the valley, there perhaps where he gathers grapes and tills:
with so many flames the eighth ditch was all agleam, as I perceived
as soon as I came where the bottom could be seen. And as he who
was avenged by the bears saw Elijah's chariot at its departure, when
the horses rose erect to heaven — for he could not so follow it with his
eyes as to see aught save the flame alone, like a little cloud ascend-
ing: so each flame moves along the gullet of the ditch, for not one
shows its theft, and each steals away a sinner. I was standing on the
bridge, having risen up to see, so that if I had not laid hold of a rock I
should have fallen below without a push; and my leader, who saw
me so intent, said, "Within the fires are the spirits; each swathes
himself with that which burns him."

The figure is extremely vivid, above all in the likening of the seamless flame
enclosing the sinners with the *ascending* blaze of Elijah's cloud-like chariot.
Small wonder that Ruskin, in his own imagination already an inhabitant of the
depths, should find the fireflies in *this* perspective "anything but celestial." The
correspondence between the various firefly passages and the Dantesque image
are simply too close to be coincidental; they are Dante-saturated. Detail for
detail: hills and / or valley at dusk; the glimpse of the vineyards against whose
leaves the fireflies glow; the heat of the summer season; the astonishment of the
spectator, *tanto atteso;* and, most important of all, the revelation of the fireflies
beautifully delayed in Dante, the infernal world improbably unfolding from the
simple pastoral image — as the flame-enveloped sinners. In Canto 17 the usurers
defend themselves from the flakes of falling fire; the image is then intensified,

transformed, in the later canto, with the developed image of the sinner-*as*-flame, the firefly itself.

But not all Ruskin's fireflies are infernal or funereal; in the earliest instance, it was "very heavenly to see them floating, field after field, under the shadowy vines." And the language of the *Praeterita* passage is clearly designed to avoid all sinister suggestion ("*How* they shone! moving like fine-broken starlight through the purple leaves!"). But how, we may reasonably ask, can the same passage—one spectacle repeatedly re-seen, with modest variation of details but drastic differences of feeling-tone—how can the same image indicate moods so antithetical? Clearly, the viewer's mood changes with experience. Still, the ambivalence remains. In part, because Ruskin's sources are multiple. But also, as Ruskin would have known, the "sign" in Dante is inherently polyvalent. The *Commedia* is a vast and intricate structure of exact correspondences between the poem's three realms; sign for sign, image for image, the Inferno is anagogically transformed in Purgatory and Paradise. Take, for instance, the passage in the *Paradiso* which clearly corresponds to the image of the firefly or flaming sinner in the *Inferno*. Beatrice describes in Canto 30 how it is that angelic sparks—glittering angels—rise from, and fall back into, the great river of heavenly light (in which alone the thirsting sinner, like Master Adam, can finally quench his thirst):

> Noi siamo usciti fore
> del maggior corpo al ciel ch'è pura luce:
>
> luce intellectüal, piena d'amore;
> amor di vero ben, pien di letizia;
> letizia che trascende ogne dolzore . . .
>
> e vidi lume in forma di rivera
> fulvido di fulgore, intra due rive
> dipinte di mirabil primavera.
>
> Di tal fiumana uscian faville vive,
> e d'ogne parte si mettien ne'fiori,
> quasi rubin che oro circunscrive;
>
> poi, come inebrïate da li odori,
> riprofondavan sé nel miro gurge,
> e s'una intrava, un'altra n'uscia fori.

[We have issued forth from the greatest body to the heaven which is pure light: light intellectual full of love, love of true good full of joy, joy that transcends every sweetness . . . And I saw a light in a form of a river glowing tawny between two banks painted with marvellous

spring. From out this river issued living sparks and dropped on every
side into the blossoms, like rubies set in gold. Then, as if inebriated
by the odours, they plunged again into the wondrous flood, and as
one was entering, another was issuing forth.]

Beatrice then proceeds to address Dante as one whose desire for the heights and
for heaven has enveloped him in flame and whose thirst for God can be quenched
only in the river of light:

> L'alto disio che mo t'infiamma e urge,
> d'aver notizia di cio che tu vei,
> tanto mi piace più quanto più turge;
>
> ma di quest' acqua convien che tu bei
> prima che tanta sete in te si sazi.
>
> *(Par.* 30, 70ff.)

[The high desire which now inflames and urges you to have knowl-
edge concerning that which you see pleases me the more the more it
swells; but first you must needs drink of this water before so great a
thirst in you be slaked.]

Infernal fireflies and Master Adam here fuse anagogically into the flame-
enveloped Dante, himself an angelic spark by virtue of his poet's tongue (*una
favilla sol de la tua gloria*) about to plunge into the great stream of light from
which he came, to quench the thirst that can be assuaged only in God. That it is
this image that Ruskin has, among others, in mind in *Praeterita* seems probable
if we simply set Beatrice's account of the sparks rising and falling back into the
great flood of light against Ruskin's final clause, with its skyscape of heaven and
cloud, "and the fireflies everywhere . . . rising and falling, mixed with the
lightning, and more intense than the stars."

Behind Dante, of course, stands the Bible, in which Ruskin's mind was
even more saturated than it was in Dante. Hence it is not surprising that
Ruskin's fireflies should have biblical origins also. In the apocryphal *Wisdom of
Solomon* (3:1), for instance, the godly are compared to sparks in the stubble:

> And in the time of their visitation they shall shine and run to and fro
> like sparks among the stubble.

Godly and *good* because tested by the fire of suffering. These sparks, in turn,
derive from the great image of suffering mankind in Job (5:7): "Yet man is born
unto trouble, as the sparks fly upward." Ruskin, citing this figure elsewhere, im-
mediately links it with Dante:

I know that there are many who think the atmosphere of rapine, rebellion, and misery which wraps the lower orders of Europe more closely every day, is as natural a phenomenon as a hot summer. But God forbid! There are ills which flesh is heir to, and troubles to which man is born; but the troubles which he is born to are as sparks which fly *upward,* not as flames burning to the nethermost Hell.

(11:261)

The intricate linking of association here — from "hot summer" to the fireflies seen at Siena, to the *upward*-rising sparks of Job, which are contrasted with the *falling* rain of fire in Canto 17 — is wholly typical of Ruskin's metaphorical habits.

Even more impressively remembered, I believe, is the great passage from Isaiah (50:2–3, 10–11), which combines a number of Ruskin's most obsessive themes, from the desecration and pollution of the earth at the last Judgement, to Jehovah's awful anger with those spiritual leaders who have led their followers astray, preferring their own illumination and refusing God's light — and who are therefore condemned to walk for ever in the light of the fires they have kindled:

Wherefore, when I came, was there no man? when I called, was there none to answer . . . ? Have I no power to deliver? Behold, at my rebuke, I dry up the sea, I make the rivers a wilderness: their fish stinketh, because there is no water, and dieth for thirst.

I clothe the heavens with blackness, and I make sackcloth their covering.

Who is among you that feareth the Lord, that obeyeth the voice of the servant, that walketh in darkness, and hath no light? let him trust in the name of the Lord, and stay upon his God.

Behold, all ye that kindle a fire, that compass yourselves about with sparks: walk in the light of your fire, and in the sparks that ye have kindled. This shall ye have of mine hand: ye shall lie down in sorrow.

Ruskin took his role as prophet seriously, and also his Guild of St George, of which he was founder and spiritual leader. Increasingly he came to feel that he had failed those who had looked to him to lead them out of the wilderness; that he had neither solace nor wisdom to offer. In this mood he wrote to a friend:

You say, in losing the delight I once had in nature, I am coming down more to fellowship with others. Yes, but I feel it a fellowship of blindness. I may be able to get hold of people's hands better in

the dark, but of what use is that, when I have nowhere to lead them, but into the ditch?

<div align="right">(36:83)</div>

The ditch here is Inferno itself, Master Adam's polluted *fosso;* and Dante's fire-cloaked sinners are, in fact, the Evil Counsellors—those who, by unwise advice, had like Ulysses destroyed themselves and those they led. Ruskin too had failed, walking by the sparks he had kindled; but the failed prophet refuses to abandon his own inner light. Determined to strike new sparks from his own flinty nature, he rejects the biblical text while annexing the image. To a young girl he loved he wrote:

> surely your statement of the things that torment me is just as terrible as my own. It is just because I am one of those flakes of chaff who "with all light and all vision *will* not strive to the ideal set before them"—that I fear the winnowing.

His flinty nature, he knew, was ambivalent. At one moment it was outwardly desultory and unreliably iridescent; but the gleams rose from "an obstinate little black powder of adamant the faltering sparks glowed through the grain of" (35:609). In love, he said, he was all adamant:

> When I have once loved any creature, I am true to them to the death —theirs or mine—through whatever decay of body or soul . . . *I* change not.

He could praise, but also *be,* the crystal virtues he commended: hard work, dogged courage, loyalty. There was genuine pride and self-knowledge in this. "Man is born to trouble, as the sparks fly upward." But *upward*—hellfires no longer—towards the light and the stars which they resembled and, in the *Praeterita* passage, outshone. Pain had ripened him; he knew the darkness now; he could assess with something like pleasure his ability to strike a spark against the cold and the darkness:

> perhaps one use of all that I most mourn, is to fit me to see the darks in things that *are* dark—and of which others forget the existence— in the joy of their own quiet lamp and light of their room by its suffi-cient love—though all around—without—*is*—the "outer dark-ness," and the cold.

If he was not a *fixed* star, like Shakespeare's Caesar, he could claim nonetheless that his own sparks, no less than those of others—Joanie, Arthur, Rose, etc.— still shone star-like against the dark sky and the gathering storm to the west of

Siena. Ruskin knows now where the light rises and sets, and what it means: "I shall not mistake light in the West for light in the East — now. I know the Evening and the Morning."

Knowing his nature, its weaknesses and strengths, he could now devote his remaining light and time to the project most fitted to his nature, art and convictions — the effort to recreate here on earth, with whatever light he could strike from his mixed nature, the only paradise to which he thought human nature could practically aspire. He had wanted his Rosie *here;* and his paradise too was here and now — under threat of imminent destruction, but still miraculously *there,* suspended in the precarious present.

This, at any rate, is how Ruskin puts it in one of his most remarkable letters:

> It is impossible for me ever to be as I was in the days of my youth again, — and, I believe me, I am better — as I am, for all *I* have to do, *now*. But that is so with many men's lives. They lose the best that was in them, but another good of an opposite kind — equally theirs, take its place, or may take it if they do their best. Meantime — be as religious as you please — but do not let yourself be lulled into the great heresy of this age — that God will put things right — though He lets little things go wrong — if only we trust in Him. The great things — like the little — will turn out finally ill — or well according to our own human care — and are properly to be called "ill" or "well" according to human perceptions. If the Cook makes the Pudding heavy — through her trust in Providence — she is even a more capable Cook than if she had done her poor impious best — and failed. And a Heavy Pudding is a Bad and not a Good Pudding, and there an end — and that's what *I've* got to preach — *now*.

Combining in different ways, with different emphases, certain elements in his firefly passages constantly, obsessively recur. A Tuscan twilight, hills and valley, a vineyard (or ilexes, olives, or cypresses), the quivering pulsation of fireflies constantly likened to starlight; and the sense of buoyance, of walking on water; a thunderstorm gathering; sheet lightning, celestial or infernal as the case may be — we recognise the feeling of meaning in possible excess of the situation, the obsessional overload; or, alternatively, the combination of unconscious memory and consciously controlled recall in the effort — the effort of all art, according to Ruskin — to *suggest* the mysterious quality of human feeling and life. What is he finally getting at?

I suggested earlier that the *Praeterita* passage seems devoted to eternising, or at least suggesting the indefinite suspension of the present. *Something* is about to happen; the moment is pregnant with looming change. But the change

is suspended; Ruskin keeps the focus of his gaze on the eternity of the moment: *now*. We feel this ephemeral eternal as a vibration or oscillation — the trembling of the present, suggested by the shimmering and pulsing of the fireflies. The dusk is poised precisely at the intersection time: *twilight*. An interim world: the white masses of Alpine clouds piled up in the thunderous but still illuminated night building in the west, the golden afternoon behind the Gate with its words of golden welcome, *Cor magis tibi Sena pandit* (More and more does Siena open her heart to you). The sky is calm, "openly golden," as expansive as the Latin words. (Everywhere in Ruskin, except in the economic tracts, "golden" is paradisal, *good*). Golden, because this *now*, this poised and hovering present, is also good. The visual image of this golden present is of course Severn's "Marriage in Cana." His last painting, it is itself a miracle, made more miraculous because the subject is suspended in time, that "instant of forever" when a sacred order intersects with a temporal one. Past and present are fused, in perfect balance, one simultaneous thing. The tense is all preterita-present. The fireflies *shone* fitfully in the *still undarkened* air; the fireflies shining *now* fuse with those of three days past, just as all the waters, paradisal brooks and streams, and the fountains of Trevi and Branda converge in the single goodness of water — water of life — drunk in the light of the fireflies, hinting, in their Dantesque way, of paradise lost and infernal pain, but also of pain overcome, transcended, moving upward, like sparks or self-ignited light, brighter than the stars. A time, a place, of looming meaning. "Still undarkened" hints of darkness to come; "still golden" is faintly ominous, the language of a man who has seen golden times, golden times vanish. The *mountainous* clouds — those same cloud-like paradisal Alps the youthful Ruskin first glimpsed, in ecstasy, from Schaffhausen — are still lit with the last light of the westering sun. Three "stills" in as many lines, and then, capping them, the delicate vibration of the crystal-fragile present in the participles closing the passage, confounding the fireflies with lightning and starlight. "How things bind and blend themselves together!" The fireflies flicker like "fine-broken starlight." The idea is fragmented eternity — the pulsing, iridescent, transient life-lights against a background of advancing darkness. And finally the fireflies move, rising and falling, like Dante's angelic *faville*, towards the floodstream of heavenly light, fireflies everywhere, eclipsing even the stars in their bright intensity.

Intensity: the precariousness and fragility of present joy; the image of the present as doomed but vivid iridescence; the shining and warmth of human courage and love against the "cold" and the "outer darkness" as against the warmer darkness of the Earthly Paradise with its "scented thickets." The evoking of these things, of the Edenic world, *this* world with its ordinary *daily* miracle — water into wine — in rapt, partly "dream-gifted," but mostly composed, temporal

montage and miraculous prose, is, I believe, the main purpose and astonishing achievement of this passage in which the whole book converges. [In *Fors Clavigera* (29:343–45) Ruskin cites a long letter from a correspondent dealing with the real meaning of the miracle at Cana. In an earlier Fors [29:285] he had written, "They have no wine? and the command is, 'Fill the water-pots with water.'" His correspondent comments by observing, "I am greatly averse to what is called improving, spiritualizing — i.e. applying the sacred text in a manner other than the simple and literal one . . . In every grape that hangs upon the vine, water is changed into wine, as the sap ripens into rich juice. *He* had been doing that all along, in every vineyard and orchard; and that was His glory." On which Ruskin remarks approvingly, "Seldom shall you read more accurate or more noble words . . ."] A fallen man if ever there was one, Ruskin here writes in secure possession, for the first time, of the Garden he has recovered by remaking himself. He writes, as I suggested, in manifest control of the images which had for so many years obsessed and, to that degree, controlled him. He writes at last, on his own, echoing the Bible and Dante, not to annex their authority and experience, but in the service of his own vision. *These* fireflies may borrow the language and ideas of their biblical and Dantesque contexts; but, unlike the earlier fireflies, they are Ruskin's own possession. The great texts speak through him and guide his associative memory still; but they are finally subject to his own Imagination Penetrative.

Even more remarkable perhaps is the new moral and human control the book reveals. Above all in its *charity,* its manifest love for other human beings. Late in life, very late, Ruskin had learned to love. "I find myself totally changed," he wrote to a dear friend, "and that living people are now everything to me." In this respect *Praeterita* is not an autobiography at all but an exemplary memorial, commemoration, of those he had come to love. Ruskin proposes to remember both the past and the persons omitted or scanted elsewhere —*personae praeteritae* — and, in the course of so doing, to recreate himself. To revise himself: not perhaps as he was, but as he is, *now.* To be reborn; to memorialise the Severns who were good to him; to make amends to the past he has not lived, for the virtues he has lacked or failed to evince — this is the heart of his project. The charity is not indiscriminate; of his wife, Effie, there is not a word. Ruskin's charity was human, not divine. But it is an impressive charity, all the same, especially if his age and mental condition are taken into account. How many men in their late sixties propose to remake themselves completely and succeed so well — if I understand *Praeterita* rightly — as Ruskin did? The effort was wholly conscious. To his friend Susan Beever he wrote:

And we will make more and more of all the days, won't we, and we will burn our candles at both beginnings instead of both ends, every

day beginning two worlds—the old one to be lived over again, the new to learn our golden letters in. Not that I mean to write books in that world. I hope to be set to do something, there.

(37:545)

But *here*? Here he means to write books. Books like *Praeterita:* "the old [life] to be lived over again, the new one to learn our golden letters in." He had dreamt his first life badly; now he would dream it well. Charitably, truthfully. In a sense *Praeterita* is a golden dream, a real dream; the memory, wandering "dream-gifted," re-enacts the past as present, the present as past. Ruskin never came closer to writing poetry than in this book. So far as I can judge, its compositional principles belong not to prose but to poetry. If Ruskin lacked, as Matthew Arnold thought, the *ordo concatenatioque veri,* it is because Arnold's criterion is that of discursive prose.

Look one last time at the final firefly passage. Here everything converges. The tangible subject is an enclosed garden, the *hortus inclusus* of the present. Over the wall, in the background, we can see what the garden excludes—everything which impends upon, which threatens, the precarious present implied in those three "stills," in the evanescent fireflies, the lingering of the golden afternoon. Excluded, barely excluded, are the night and the storm, surely "the great storm-cloud of the nineteenth century," with its devil winds and wrath-scourged skies. This, I hardly need to add, is also the storm cloud of Ruskin's most dreaded nightmare, the "serpent-dream," the Last Judgement of a God who, for a while at least, became for Ruskin "a raging enemy":

> I am driven more and more to think that there is to be no more good for a time, but a Reign of Terror, of men and the elements alike; and yet it is so like what is foretold before the coming of the Son of Man that perhaps in the extremest evil of it, I may some day read the sign that our redemption draws nigh . . .
>
> (37:127)

One has merely to glance through the standard biblical accounts of the Judgement or God's Wrath to recognise that the whole idea and vocabulary of Ruskin's lunatic clarity in "The Great Storm-Cloud of the Nineteenth Century" are firmly traditional. Ruskin's night, here and elsewhere, echoes the languages of the prophets and the gospels:

> I clothe the heavens with blackness, and I make sackcloth their covering.
>
> (Isa. 50:3)

The sun shall be turned into darkness, and the moon into blood, before the great and notable day of the Lord come.

(Acts 2:20)

Multitudes, multitudes in the valley of decision: for the day of the Lord is near in the valley of decision. The sun and the moon shall be darkened, and the stars shall withdraw their shining.

(Joel 3:14–15)

For as the lightning cometh out of the east, and shineth even unto the west: so shall also the coming of the Son of Man be.

(Matt. 24:27)

No need to labour the point. Ruskin's "storm cloud" in the *Praeterita* passage and the famous "Storm cloud" lectures is simply the worldly or secular form of the great thunder cloud on which the Lord comes to judge the world. In the last poised enchantment of the dusk—the day-world still visible, the night-world moving in—the fireflies shine in the darkening, but "still undarkened," air. The stess is on their shining: "*How* they shone!" Intense evanescence is in that shining: what is more ephemeral than the glimmering of the firefly? The fireflies' dance—like broken starlight—fills the foreground, brighter than the stars. Who are these fireflies if they are not simply Dante's sinners? Surely the "shining" firefly-girls of Winnington; Rose too, once in death she had lost her hard living glitter; and other girls of his childhood who had died or disappeared, "glittering" in memory; and Giorgione's nudes moving "among the trees like fiery pillars, lying on the grass like flakes of sunshine" (4:195–96); and Carlyle; and Adèle Domecq; and little Constance Hilliard, who "glittered about the place"; and many, many more. But above all the Severns, Joan in particular. Joan and Arthur, wrote Ruskin, were "giddy enough"—and by "giddy" he meant, as the context shows, giddy with happiness and gaiety. ("Happiest times, for all of us, that ever were to be"). And this giddiness of joy—contrasted with the Severns' sorrow and Ruskin's own—dissolves into the account of Joseph Severn, another firefly, with a gift for gaiety, gaiety wherever he was (a gaiety Ruskin associated with Mozart's Papageno), shining with "delight" in his painting of *The Marriage in Cana,* which then, by association with miraculous water, melts into the happiness of Ruskin and Norton, drinking together of Fonte Branda. A characteristic Ruskin footnote—born of the sense of time running out, the need to get everything down, *now*—adds more names, more happy days spent with all "these friends, tutors, or enchantresses." Can there be any doubt that it is these happy, giddy spirits, each enveloped in his vital flame ("Within the fires are

the spirits"), dancing, rising and falling, brave and good people, whom he writes to commemorate while he still can, in the short interval between the last afternoon light and the coming night? It was Ruskin's achievement here, in his last words, to have confronted his obsessions and tamed them into art: an intricately simple and powerful image of human courage, warmth, transience, pain transcended in joy, and daily decency, confronting the dark blank of eternity.

STEPHEN BANN

The Colour in the Text:
Ruskin's Basket of Strawberries

This [essay] does not attempt anything so ambitious (or dubious) as a demonstration of Ruskin's theory of colour. It will, on the contrary, develop the argument that his frequent and suggestive references to colour are an indication of failure to develop a coherent theory of representation within which the powerful stimulus of colour would have its allotted and determined place. But such a failure might be seen, from another point of view, as one of the most interesting aspects of Ruskin's criticism. It will be argued that the problem of colour, as it exists for Ruskin the writer and critic, is a remarkably telling index of the equivocal role which colour has played in the theoretical and practical development of post-Renaissance art in Europe. Ruskin's text is a litmus paper which records, not the state of colour theory in the nineteenth century, but the resistance of prevalent views of representation to the concrete *experience* of colour in the visual arts. Moreover, in its very theoretical confusion, Ruskin's writing on colour points towards the specific field of practice within which the artists of the Modern Movement were to seek to close this gap between experience and theory.

Such a claim is not easy to sustain in a short space. But it is surely supported by the evidence of one of the most original of recent writings on Ruskin: John Unrau's *Looking at Architecture with Ruskin.* In the last chapter of his study Unrau tackles the question of colour with an initial, frank admission:

> Colour has proved a continual embarrassment to architectural writers concerned that their study of buildings should be strictly accurate and systematic, for it is difficult — perhaps ultimately impossible —

From *The Ruskin Polygon: Essays on the Imagination of John Ruskin.* © 1982 by Manchester University Press.

to reduce the visual complexities introduced by colour to categories
that lend themselves to analysis.

Such a statement is indeed strongly supported by the succeeding quotation
which Unrau takes from a leading architectural writer of Ruskin's day, who is "not
inclined to assert that the colour of a building in a landscape is unimportant to the
general effect of that landscape" but does not hesitate to say that colours are "of
minor consequence in relation to our art." Against these uneasy double negatives
Ruskin does indeed, as Unrau emphasises, make an unequivocal assertion:

> The perception of colour is a gift just as definitely granted to one
> person, and denied to another, as an ear for music; and the very first
> requisite for true judgment of St Mark's, is the perfection of that
> colour-faculty which few people ever set themselves seriously to find
> out whether they possess or not. For it is on its value as a piece of per-
> fect and unchangeable colouring, that the claims of this edifice to
> our respect are finally rested.
>
> (10:97–98)

Yet Ruskin perhaps leads his sympathetic exegete astray when he writes of the
"colour-faculty" and places the issue squarely on the ground of "perception of
colour." As Unrau himself admits, the study of colour perception as a branch of
experimental aesthetics has made very little progress between Ruskin's time and
our own. But this fact may not be strictly relevant to the "embarrassment" of
successive architectural writers, or to the determined stand which Ruskin makes
upon the principle of colour. In order to appreciate Ruskin's originality (and no
doubt to add a small piece to the jigsaw of modern art), we should recognise that
the denial of colour is itself an important aspect of the economy of post-Renais-
sance representation. In other words, it is not our inability to theorise about the
experimental data of colour perception that is of significance here. It is the role
of colour within a representational system, its uneasy role, that determines the
originality, and indeed the excess, of Ruskin's text.

Two extracts from contemporary French critics, both closely concerned with
the problem of colour, will help to clarify the distinction that I am making. In
his essay "Split colour / blur" Jean-Louis Schefer draws a broad distinction be-
tween Western attitudes to colour and those of other civilisations:

> The West can perceive colour but (contrary to India, China, Africa,
> South American Indians, etc.) cannot think in colour; and for another
> reason, that because of its closed economics the figurative system can
> never introduce elements that it is not capable of engendering. Plato,
> Aristotle, Malebranche . . . all engender colour for perception,

that is to say, in the general economics of "reasonable" cost to the subject — which guarantees the subject / the world / philosophy.

Schefer is here referring to the subordinate role which colour perception has played within the dominant tradition of Western philosphy — a point which is perhaps curiously echoed by Ruskin himself when he accuses the "metaphysical Germans" of being prone "to see things without colour" (6:67). But he clearly views the development of theory of perspective at the time of the Renaissance as the most telling sign of the primacy of "figure" over "colour" — a primacy which Leonardo celebrates by stressing that colour differences are merely an aid to the correct definition of receding bodies in perspectival space. For Schefer, the Western tradition locates colour only as an attribute or accident of the figurative system: "what is unthinkable in all this is the fact that objects might be seen as attributes or accidents of pure colour (which Leonardo only ever refers to as a fog): that is, that these things should be produced within the picture is unthinkable." A necessary corollary of this position, however, is the assertion that contemporary art, at least since Cézanne, has made the unthinkable something to be contemplated and achieved. Marcelin Pleynet draws the two threads succinctly in his critical and theoretical programme:

> As opposed to the metaphysical role of the sign which, for the humanist of the Renaissance, overdetermines line as the bearer of a meaning which colour succeeds in filling out (and the impossibility of moving from there to the investigation of subjective or sexual positions), I shall emphasize Cézanne's "mad" obstinacy in the face of the motif, Matisse's "drawing with scissors, cutting directly into colour," the insistence with which some contemporary artists consider the "problem" of colour, and . . . the wish for "colour" no longer to colour in between lines, or to be cut out in colour, but for colour to produce line.

What place has Ruskin in this grand design? I suggest that in many important respects he anticipates the "spilling" of colour out of its Renaissance straitjacket. Even if, as is inevitable, he is continually drawn back within the "economics" of the perspectival system, he is nonetheless able to discern and promote the *productivity* of colour, as opposed to its merely distinctive and differential properties. Yet this conspicuous prescience is most of all observable in the texts where Ruskin comes closest to incoherence: in the texts where Pleynet's "subjective or sexual positions" come most clearly into view. Cézanne's "'mad' obstinacy" has its correlative in the manic eruptions of Ruskin's late prose.

An extraordinary footnote to the chapter on "The Hesperid Aeglé," in the last volume of *Modern Painters*, makes the intense contradictions in his position

only too apparent. The note unequivocally dismisses the pretensions of colour, as exemplified in the Roman school: "Its colour is not subordinate. It is BAD." Nevertheless, Ruskin hastens to add, the perfection of colour improves even the most excellent achievements of form and figure: "Had Leonardo and Raphael coloured like Giorgione, their work would have been greater, not less, than it is now" (7:415). A certain amount of further equilibration between the claims of colour and of form, with particular reference to Turner, leads to a further and firmer restatement of the issue — as if colour had simply refused to lie down:

> Colour, as stated in the text, is the purifying or sanctifying element of material beauty.
>
> If so, how less important than form? Because, on form depends existence; on colour, only purity. Under the Levitical law, neither scarlet nor hyssop could purify the deformed. So, under all natural law, there must be rightly shaped members first; then sanctifying colour and fire in them.
>
> Nevertheless, there are several great difficulties and oppositions of aspect in this matter, which I must try to reconcile now clearly and finally. As colour is the type of Love, it resembles it in all its modes of operation; and in practical work of human hands, it sustains changes of worthiness precisely like those of human sexual love. That love, when true, faithful, well-fixed, is eminently the sanctifying element of human life: without it, the soul cannot reach its fullest height or holiness. But if shallow, faithless, misdirected, it is also one of the strongest corrupting and degrading elements of life. . . .
>
> So it is with the type of Love — colour. Followed rashly, coarsely, untruly, for the mere pleasure of it, with no reverence, it becomes a temptation, and leads to corruption. Followed faithfully, with intense but reverent passion, it is the holiest of all aspects of material things.
>
> (7:417)

The modern reader can scarcely fail to note the tensions within this passage — within this inordinately prolonged footnote, which dramatises the return of the repressed. Ruskin salvages the idealist viewpoint only at the expense of indicating the libidinal bases of colour perception. Not surprisingly, the same chapter concludes with a paean to colour which is intended to stress, once again, the primacy of the ideal over the material:

> But ten years ago, I saw the last traces of the greatest works of Giorgione yet glowing like a scarlet cloud, on the Fondaco de' Tedeschi. And though that scarlet cloud (sanguigna e fiammeggiante, per cui

le pitture cominciarono con dolce violenza a rapire il cuore delli genti) may, indeed, melt away into paleness of night, and Venice herself waste from her islands as a wreath of wind-driven foam fades from their weedy beach; — that which she won of faithful light and truth shall never pass away.

(7:438–39)

It is worth mentioning here that Ruskin's initial reaciton to the Giorgione frescoes on the Fondaco dei Tedeschi was a more muted one. On 4 October 1845 he wrote to his father from Venice that he regretted the passing of fresco painting from the exteriors of the buildings in most cases, but mentioned the persistence of "a fragment or two of Giorgione . . . purple and scarlet, more like a sunset than a painting." In the passage of time such vestiges were thus claimed, inexplicably, for Giorgione's "greatest works," while the deprecatory smile of the sunset became converted into a powerful metaphor of the decline of the great maritime city. But there are other things, as well, at work in the text. Just as Ruskin confines the discussion of colour and "sexual love" to a footnote, so he here restricts Zanetti's powerful evocation of the "soft violence" of colour to a bracketed section — and to the relative obscurity of a foreign language. And he reserves for a final footnote the "impression that the ground of the flesh in these Giorgione frescoes had been pure vermilion."

Purple . . . scarlet . . . vermilion . . . What exactly is involved in this shifting of colour descriptions? Before this question is answered, it is worth adding yet another qualification of the vanishing frescoes which appears in Walter Pater's essay on "The School of Giorgione," published for the first time in 1877. Pater asserts, in sharp contrast to Ruskin:

Much of the work on which Giorgione's immediate fame depended, work done for instantaneous effect, in all probability passed away almost within his own age, like the frescoes on the facade of the *Fondaco dei Tedeschi* at Venice, some crimson traces of which, however, still give a strange additional touch of splendour to the scene of the *Rialto.*

One suspects, with regard to this passage, that the confutation of Ruskin is Pater's primary though unstated purpose. Ruskin makes the imaginative leap of proclaiming these vanished frescoes to have been Giorgione's "greatest works." Pater dismisses them as "done for immediate effect." Ruskin speaks of a "scarlet cloud" (rejecting his earlier alternative of "purple"), and hypothesises that the ground was once "pure vermilion." Pater prefers "crimson traces." The nuances of discrimination used in relation to this vestigial work should alert us to some of

the paradoxes of colour attribution in art criticism. For—quite apart from the
weight that might be placed on Pater's need to modify Ruskin's original colour
description—we must reckon with the fact that the two alternative colour adjec-
tives are in fact derived from the same root! The word "crimson" is a variant of
the Arab "kermes," which denotes a small insect whose shell once served in the
processes of dyeing. And "scarlet" also relates to this insect, being the word
which describes the shell itself. Of course the fact that scarlet is originally a kind
of metonymy of crimson need not lead us to dismiss the difference which usage
has conferred upon the two types of red. But the very scantiness of the evidence
on which the colour descriptions are based in this case leads us to press further
than the conventions of usage would normally allow. We begin to see the opera-
tion in Ruskin's text—and, *a contrario,* in that of Pater—of a kind of colour code
whose terms are not conventional but hermetic. Colour is not so much denotative
as richly connotative, and the field of connotation is within the Ruskin text.

This being so, we might frame an answer to the question "Why does Ruskin
pick scarlet rather than crimson?" in the following way. Colour, for Ruskin, is
mediated by the particular use which the great painters, and pre-eminently
Turner, have made of it. And crimson, in the work of Turner, has an extremely
specific connotative charge: "He was very definitely in the habit of indicating the
association of any subject with circumstances of death, especially the death of
multitudes, by placing it under one of his most deeply *crimsoned* sunset skies.
The colour of blood is thus taken for the leading tone in the storm-clouds above
the 'Slave Ship'" (6:381). This connotative chain of crimson / sunset / blood /
death, which Ruskin also identifies with the "setting sun, red 'like the colour he
predicts'" in Byron's *Sardanapalus,* becomes additionally charged in the ref-
erences to scarlet in *Modern Painters* V:

> Note with respect to this matter, that the peculiar innovation of
> Turner was the perfection of the colour chord by means of *scarlet*
> . . . Now, this scarlet colour,—or pure red, intensified by expres-
> sion of light,—is, of all the three primitive colours, that which is
> most distinctive . . . Observe, farther, that it is this colour which
> the sunbeams take in passing through the *earth's atmosphere.* The
> rose of dawn and sunset is the hue of the rays passing close over the
> earth. It is also concentrated in the blood of man.
>
> (7:413–14)

Scarlet, therefore, the "pure red," both subsumes and exceeds crimson. To
the chain of connotations already cited it adds additonal, ambivalent terms: not
sunset / blood / death but "rose of dawn and sunset" / blood and *life.* To refer to
Giorgione's frescoes as a "scarlet cloud" is thus to pick up the Turner motif ("No

man hitherto had painted the clouds scarlet"), and implicitly to deny the deathly connotations of crimson. But here we may have to reckon with a definite shift in usage between the writing of volumes IV and V of *Modern Painters* (a shift whose significance is emphasised by the appearance of "rose" in the later text, as we shall shortly see). In the earlier volume Ruskin quite evidently maintains a working distinction between scarlet and crimson, referring for example to the presence of both colours in Turner's drawing of Goldau (6:381). In the later volume, however, he writes at one point as if the two terms were synonymous. We should expect the term scarlet to be picked up at the moment when he records—ironically, of course—"Crimson is impure and vile; let us paint in black if we would be virtuous" (7:413). Is it that Ruskin could not bring himself to refer, even ironically, to scarlet as "impure and vile"? Certainly our impression is that he has been labouring to set up, within the terms of colour differentiation, a good red and a bad red—a paradigm of purity against the threat of impurity. Such an aim predominates, by this point at any rate, over any more objective purpose of description.

Furthermore, there is the question of "pure vermilion." Here we are dealing not simply with a descriptive term but with a chemically fixed pigment. Consequently, the word vermilion is not so much an alternative within the register of crimson / scarlet as a supplement: the colour effect brought down to the material determinants of the painter's practice. After writing of the effect of scarlet reflection, Ruskin adds the gloss: "Turner habitually, in his later sketches, used vermilion for his pen outline in effects of sun." In relation to the Giorgione frescoes, the impression conveyed in the footnote that "the ground of the flesh . . . had been pure vermilion" is thus an intriguing link between Turner and the Venetian painter. Giorgione is retrospectively associated, on the faith of Ruskin's "impression," with the supreme colourist of modern times. Small wonder that, in this not unimportant detail, Pater makes his second decisive shift from Ruskin's essay, associating the "flesh" of Giorgione's painting with an idealised landscape effect quite contrary to Ruskin's advocacy:

> Only, in Italy all natural things are as it were woven through and through with gold thread, even the cypress revealing it among the folds of its blackness. And it is with gold dust, or gold thread, that these Venetian painters seem to work, spinning its fine filaments, through the solemn human flesh, away into the white plastered walls of the thatched huts.

The contrast between this carefully colour-coded passage and those which have been drawn from Ruskin shows that colour is indeed the bearer of a burden beyond description. Pater has produced an effect of total sublimation, in which

the gold "filaments" permeate and dematerialise that "solemn human flesh."
Ruskin has allowed the almost vanished frescoes to serve as a pretext for the res-
urrection of that flesh (we might almost say)—through the insistent chain of
meaning which carries us from scarlet to vermilion. One further term requires to
be placed within this chain, if we are to appreciate the full psychological dimen-
sion of his use of colour terms, particularly within the register of reds. In the
following passage all the connotations are taken from the field which has already
been explored. But the apparently casual reference to the "rose of dawn" is sup-
planted by a much stronger equation between the colour and the flower:

> Perhaps few people have ever asked themselves why they admire a
> rose so much more than all other flowers. If they consider, they will
> find, first, that red is, in a delicately gradated state, the loveliest of
> all pure colours; and secondly, that in the rose there is *no shadow,*
> except what is composed of colour.
>
> (6:62)

The purest of reds (which is, we remember, scarlet) is thus exemplified by the
rose. (And the fact that there are roses of other colours is curiously suppressed in
the confident equation!) Despite Ruskin's later assertion that "neither scarlet
nor hyssop could purify the deformed," we seem to glimpse here, in the rose
which has "*no shadow,*" an absolute and purifying principle. Yet the guarantee
of this principle lies ultimately elsewhere than in Ruskin's text, or rather it lies in
what the French psychiatrist André Green has called the "text of the life." Rose
La Touche, the young girl to whom Ruskin formed his most passionate attach-
ment, cannot be seen as merely external to his life as a writer, so numerous are
the instances where the name "Rose" is overdetermined in these later years by
the sad history of their liaison. "Rose" is the signifier which (like the "pure ver-
milion" ground of the Giorgione frescoes) promises love as the "sanctifying ele-
ment of human life"; love as the purification of the material world and the
material body. But if "Rose" is therefore the final condensation of Ruskin's
desire, the equation within the text which draws together the manifold mean-
ings of red, it points back at the same time to a biographical history which pre-
pares and prefigures the eventual result. Adrian Stokes has sympathetically
retraced the story in part 2 of *The Painting of our Time.* Ruskin is first of all por-
trayed in his youth, taken away from his Oxford college because of an illness in
which he spat blood, and seeking to restore his health through a trip to the Con-
tinent. In *Praeterita* he recounts how this period of illness and depression was
terminated by a series of incidents, the first being the present of "a little basket
of wild strawberries" (35:313) which was brought to him in the inn at Fontaine-
bleau. As Stokes puts it, his immediately subsequent success in drawing a "a
little aspen tree" was prepared by this innocent gift:

in the forms of an exterior perception Ruskin regained the measure
of a good incorporated object and of potency feeling, focused by the
integrated body of the aspen tree. The occasion was nearest prepared
by the manic impact upon him of the basket of strawberries: we can-
not doubt it.

Nearly thirty years later, on the night of 11–12 November 1869, Ruskin was to
record a dream of "'a friend of mine' running a race, who asked for a basket of
strawberries from a girl walking in front. 'So I ran and caught her, and she had
four little baskets of strawberries, all stuck together and I couldn't choose which
basket to take.'" Stokes explains: "Poor Ruskin's good objects, at that time, par-
ticularly the wild strawberries of the child, Rose La Touche, were the centre of
unceasing conflict."

Even in the bare lineaments of this biographical sketch, which establishes
the link between the youthful illness (and cure) and the conflict of old age, we
have the deep underpinning—so it would seem—of the colour vocabulary
which we have been considering. On the one hand there is the gift of straw-
berries, a gift which counteracts the (perhaps delayed) effects of a state of illness
characterised by spitting of blood, and enables Ruskin to rehabilitate the "in-
tegrated body" of the aspen tree. (It is worth noting that the incident takes place
in the early stages of a journey to Switzerland. No doubt Switzerland, rather
than Italy, represented for Ruskin the "rested mother" of Stoke's autobiography.
Nevertheless Venice, like Siena at the close of *Praeterita,* seems to have prefig-
ured intermittently the possibility of that maternal identification, and never
more so than in the evocation of the Hesperid Aeglé). On the other hand—
towards the other end of his life—there is the dream of strawberries: both a
recurrence of the earlier experience and an indication of how much his
equilibrium was bound up, by this time, in the passionate futility of his love for
Rose. But in the dream Ruskin is no longer the receiver of the basket of straw-
berries; on the contrary, he is asked to make a present of them to Rose, and can-
not choose between four baskets "all stuck together." Is it too fanciful to see in
Ruskin's gift to Rose—the gift which he cannot make up his mind to choose—
the same ambiguity as resides in the colour coding of the reds, in *Modern
Painters* V particularly? The four alternative baskets might almost be seen as the
four variants of red which Ruskin brings into play: purple, scarlet, crimson, ver-
milion. To be unable to choose between them would be to represent symbolically
the conflict which we have seen to be implicit in his usage of colour terms: to be
fixated upon the "changes of worthiness precisely like those of human sexual
love" in which his maimed desires could find their correlative.

I have said little, up to this point, of the fourth variety of red: purple.
Ruskin uses it as an alternative to scarlet in the letter of 1845. In the later texts

which have been cited he does not allow it to bear the same weight as scarlet or crimson. Nevertheless, in the very year of the dream of baskets of strawberries, he published a series of lectures entitled *The Queen of the Air* in which the colour purple became the pretext for an astonishing display of subtlety and erudition. *The Queen of the Air* reverberates from the start with the anxiety of definition; Ruskin rebels against the linearity of writing which compels him to represent plurality of meanings through strict succession: "I am compelled, for clearness' sake, to mark only one meaning at a time. Athena's helmet is sometimes a mask —sometimes a sign of anger—sometimes of the highest light of aether: but I cannot speak of all this at once" (19:307). Seen in relation to this *cri de coeur,* the passage on purple is indeed a prodigy of compression, in which "clearness" is all but sacrificed to the principle of plural meaning; in which almost all the images and aspects of the discussion up to this point recur as incidents in the connotative chain of this one colour. The passage is long, but can only be quoted *in extenso:*

> As far as I can trace the colour perception of the Greeks, I find it all founded primarily on the degree of connection between colour and light; the most important fact to them in the colour of red being its connection with fire and sunshine; so that "purple" is, in its original sense, "fire-colour," and the scarlet, or orange, of dawn, more than any other, fire-colour. I was long puzzled by Homer's calling the sea purple; and misled into thinking he meant the colour of cloud shadows on green sea; whereas he really means the gleaming blaze of the waves under wide light. Aristotle's idea (partly true) is that light, subdued by blackness, becomes red; and blackness heated or lighted, also becomes red. Thus, a colour may be called purple because it is light subdued (and so death is called "purple" or "shadowy" death); or else it may be called purple as being shade kindled by fire, and thus said of the lighted sea; or even of the sun itself, when it is thought of as a red luminary opposed to the whiteness of the moon; "purpureos inter soles, et candida lunae sidera"; or of golden hair: "pro purpureo poenam solvens scelerata capillo"; while both ideas are modified by the influence of an earlier form of the word, which has nothing to do with fire at all, but only with mixing or staining; and then, to make the whole group of thoughts inextricably complex, yet rich and subtle in proportion to their intricacy, the various rose and crimson colours of the murex-dye, — the crimson and purple of the poppy, and fruit of the palm—and the association of all these with the hue of blood; —partly direct, partly through a confusion between the word signifying "slaughter" and "palm-fruit colour,"

mingle themselves in, and renew the whole nature of the old word; so that, in later literature, it means a different colour, or emotion of colour, in almost every place where it occurs; and casts around for ever the reflection of all that has been dipped in its dyes.

So that the word is really a liquid prism, and stream of opal. And then, last of all, to keep the whole history of it in the fantastic course of a dream, warped here and there into wild grotesque, we moderns, who have preferred to rule over coal-mines instead of the sea . . . have actually got our purple out of coal instead of the sea! And thus, grotesquely, we have had enforced on us the doubt that held the old word between blackness and fire, and have completed the shadow, and the fear of it, by giving it a name from battle, "Magenta."

(19:379–80)

Ruskin's fantasia on the etymology of purple indeed retains and multiplies the ambiguities which we have noted in the case of the other colour variants of red: purple is either "light subdued" ("shadowy" death) or "shade kindled with fire"; from "fire-colour," the colour of dawn, it has descended to the base and terrifying role of canalising the blood spilt at the battle of Magenta. If we are to argue that it is this disturbance of the colour signifier—precisely its oscillation between high and low, noble and base, life and death—that betrays its suppressed links with sexuality, then we shall have an unexpected confirmation in the poetry of Thomas Hardy. Strangely enough, Donald Davie does not mention, in his brilliant article on "Hardy's Virgilian Purples," the possible influence of *The Queen of the Air*. But what he writes after pursuing his own etymological and poetic investigation through the uses of the word purple might almost serve for Ruskin himself: "This clinches it: the purples which prink the main as seen from Beeny Cliff are the spiritual light of sexual love—as indeed we should have guessed, for what but sexual passion is so likely to terrify and irradiate alternately or at the same time?"

The foregoing passages may seem to have brought the issue of Ruskin's colour vocabulary unequivocally on to the territory of biography. But such is not my primary intention. In order to understand the obsessional recurrence of these colour terms, we must, I believe, explore the determinations exercised by the images of Ruskin's life: the spitting of blood, the basket of strawberries and the rose with no shadow. But such a strategy does not simply abandon the issues of art criticism for the lusher pastures of psycho-sexual exploration. As I explained at the outset, Ruskin's problematic use of colour adjectives should be seen against the background of post-Renaissance representational norms: if, in Pleynet's terms, the sign "for the humanist of the Renaissance overdetermines line as the bearer of a meaning which colour succeeds in filling out," then Ruskin is the

anti-humanist who precisely "overdetermines" colour as the bearer of meaning. If the Renaissance position prevents any recourse "to the investigation of subjective or sexual positions," then Ruskin, through his reiterated use of the variants of red, brings the issue of these positions uncomfortably, but undeniably, into the foreground. The general point can therefore be made without equivocation. Ruskin's colour in the text is not a contribution to the dissipation of the "complexities of colour" through the solvent of experimental aesthetics. It is an index of the way in which the "problem" of colour continues to arise in modern art, indissolubly linked as it is with the oral and libidinal bases of perception.

I should finally anticipate the accusation of having imported into this study of Ruskin concepts from the psycho-analytic arsenal of Freud and Melanie Klein, to which the name of Adrian Stokes may have alerted the reader. Indeed, it would be absurd to claim that the general position which I have associated with the names of Schefer and Pleynet is not heavily indebted to psychoanalysis in its reading of the history of representation. Colour as the return of the repressed in modern painting may appear a crude and overtly ideological slogan. But its possible contribution to the imperfect state of our knowledge, not least in the matter of our hopelessly banal distinction between the "abstract" and the "figurative," is in my opinion very considerable. Ruskin wrote *The Queen of the Air* over thirty years before Freud published *The Interpretation of Dreams*. Yet Ruskin's tracing of the history of purple through "the fantastic course of a dream" shows to what extent he anticipated the discovery of the mechanisms of condensation and displacement, and how lightly he is able to dispense with the logic of non-contradiction. Similarly, his very equivocations in the discussion of colour and "love" help us to identify and understand the historical bases of figuration in the post-Renaissance tradition. Jean-Louis Schefer, in his study of Uccello, shows how colour may override the supposed abstract / figurative dichotomy in an important way—he writes of "bodies . . . cut out in colour" and colour as "a fundamental prerequisite of figure." It is the force of this inversion of customary strategies which Ruskin faithfully indicates through the very excessiveness of colour in the text.

ELIZABETH HELSINGER

The Ruskinian Sublime

More than any other Victorian, Ruskin retained a romantic taste for sublimity. Yet the "beholding imagination" he described is not well suited to cope with the romantic or Burkean sublime. His beholders have the picturesque traveler's limitations: they must gather and compare many partial views before they can comprehend or fully respond to what they see. Have these beholders any access to the emotional intensity of the romantic sublime? The beholder's limitations of sight and understanding govern two kinds of aesthetic response which Ruskin discusses at length, the "grotesque" and the "noble picturesque." The noble picturesque uses excursive exploration to evoke strong feelings, while the grotesque, though it is a response to a single impression, consists of fragmented images like those acquired by excursive seeing. The grotesque and the noble picturesque are nonetheless versions of sublime experience. Both the fantasy or fearful symbolism of the grotesque and the active sympathy of the noble picturesque are equal in emotional force to the experience of the Burkean sublime. Ruskin presents them, moreover, as alternative responses to sublime situations. In point of view or mode of comprehension and composition, they are closer to an ordinary way of seeing, the excursive and not the sublime. But in feeling and imagination, they lay claim to the power, and hence presumably the satisfaction, associated with extraordinary, sublime vision. Both responses are carefully distinguished from the full imaginative grasp of the artist or poet. We might call these categories of aesthetic response a spectator's or reader's sublime.

The significance of the two Ruskinian categories may be clearer if we look again at the usual meaning of the sublime for the traveler. Sublimity may have

From *Ruskin and the Art of the Beholder.* © 1982 by the President and the Fellows of Harvard College. Harvard University Press, 1982.

117

been increasingly associated with poetic vision, but this did not mean that it was inaccessible to the ordinary viewer. Quite the opposite, as writers from Gilpin through Wordsworth agree. Sublimity was a challenge, requiring a sudden, difficult, but rewarding shift in the mode of perception. The example of the poet's response was a model for imitation by less privileged spectators. The results might sometimes be more ridiculous than sublime, but the challenge of a poetic way of seeing, to feel an immediate impression of sublimity before the Alps or St. Peter's, was widely felt by the most ordinary of picturesque travelers. Ruskin too defines a sublime mode of seeing that poets and artists exemplify. But that mode of seeing, the inventive or imaginative, is, he insists, not imitable by every spectator. Poetry and art command awe but not imitation. The artist's sublime grasp of total form and meaning cannot be a model for the spectator's experience. Ruskin's grotesque and noble picturesque can best be taken as different responses to the challenge — or burden — of sublimity, to what Byron earlier called "All that expands the spirit, yet appals." They describe other ways of attaining comprehension, based on the spectator's own habits of perception and not on an assumed identification with the artist's privileged way of seeing.

In this respect the Ruskinian sublime is a major departure from the romantic sublime and its imperatives. Although Ruskin may well have found suggestions for his antipoetic approach to sublimity among the romantics themselves, particularly the later Wordsworth and Byron and Turner, his rejection of the poetic sublime as a model for spectators is both more explicit and more sweeping. The spectator's leisurely way of seeing and partial, fragmented views become in Ruskin's criticism a representative human experience, as the sublime grasp of the artist, though it does and should continue to command awe, is not. In a significant alteration of romantic priorities, Ruskin puts the beholder before the artist as his model for the reform of perception that he saw as essential for the nineteenth century. The beholder's share and, particularly, the beholder's sublime are at once a description of and a prescription for a new way of seeing.

Most Romantic examples of sublime experience provide a sense of exaltation derived from the confrontation with greatness. We might distinguish two kinds of sublimity in romantic landscape experience, a positive and a negative, according to the absence or presence of terror and difficulty in the confrontation with awesome natural power. To each kind of sublime experience there are several possible resolutions. When the confrontation with greatness is not very terrifying or difficult, the experience may conclude either with an unselfconscious participation in that greatness or with a self-conscious identification of the admired greatness as (or as like) our own. The passage from Book IV of *The Excursion* [discussed elsewhere] is an example of unselfconscious participation concluding a positive experience of sublimity. This seems also to have been Ruskin's

characteristic response to mountain sublimity in his youth, as we shall see later. Wordsworth's ascent of Snowden (in *The Prelude*) is an example of the second resolution to positive sublimity. The poet discovers in the natural landscape an image of the power of his own imagination.

In the negative or terrible sublime, we may move from fear to exaltation by several routes. We may successfully resist the felt threat of an external power. Resistance brings a sense of our own mental and emotional strength. Or we may do no more than recognize the feared power. The recognition, especially when it involves naming or articulating that power, is also a form of mental mastery. The Burkean sublime is a negative sublime: terror and fear are indispensable parts of the experience. The notion of resistance is also implied in the connection Burke draws between sublime response and the instinct of self-preservation. Wordsworth's passage through Gondo Gorge is another example of the negative sublime. Wordsworth, however, gives two resolutions to this experience: that of simple recognition or naming (the fearful shapes and sounds as types and symbols of apocalypse) and a second, in the preceding apostrophe to his imagination, in which successful resistance is implied and the types and symbols very nearly appropriated as an image of imaginative power. To the extent that we believe the appropriation, the experience seems positive — though terror remains in other aspects of the account. Despite Wordsworth's efforts to transform this particular experience of the negative sublime, however, the difficult or terrible sublime is probably the most common form of romantic sublimity.

My simplified account is partly designed to bring out one common assumption, shared even by recent writers on the subject: the only alternative to a successful attempt to comprehend greatness at the moment of confrontation is failure. When we cannot identify with natural power, or fail to subdue or comprehend it through resistance or recognition, we must give up the challenge. We return to an ordinary mode of perception and feeling without the sense of exaltation that comes from the successful attempt at comprehension. The sublime experience has not occurred. Actually, neither Wordsworth nor Byron nor Turner accepted this restricting view of sublime experience. Turner provides access to his sublime landscapes through figures of ordinary beholders with limited or partial comprehension. In *The Prelude* Wordsworth portrays fearful confrontations as sublime even when comprehension is delayed. Imagination works in and through memory to master natural power. More important for Ruskin, however, is the apparent lesson of *The Excursion*. Terrible or negative sublimity is not an issue for the wandering spectators in that poem. Positive sublimity, resolved by unselfconscious participation, remains a possible experience, but it is far less important than the reformed picturesque or scientific sight of Books I and IV. Wordsworth seems to offer these modes of experience as alternatives

to the emotional satisfactions of sublimity, replacing the more difficult achievements of the negative sublime. . . .

[In *The Stones of Venice* III] Ruskin describes the terror of natural imagery of sin and death in order to distinguish from it what he treats as a far more common and important response to awesome or fearful subjects, the state of mind that produces the grotesque. Here we find an alternative, effective resolution of the terrible sublime. The grotesque is an elastic category that seems, in the course of Ruskin's discussion, to be continually expanding until in retrospect it may even include his own illustration of the terrible sublime. The true sublime, by contrast, shrinks to a hypothetical point, a limiting term for the expanding category of the grotesque. Thus, although Ruskin begins by defining the grotesque as inferior to sublime perception, he ends by exalting it until it becomes the highest humanly possible response to sublimity. "And thus in all ages and among all nations, grotesque idealism has been the element through which the most appalling and eventful truth has been wisely conveyed . . . No element of imagination has a wider range, a more magnificent use, or so colossal a grasp of sacred truth" (5:134). If we look closely at the terms by which Ruskin distinguishes between the grotesque and the sublime, and at those he describes as the perceivers in each category, we can connect Ruskin's personal reaction to sublimity to his attempt to reform nineteenth-century habits of viewing art and landscape.

Ruskin defines grotesque art in terms of the state or condition of mind that produces it: he recognizes what he had denied in *Modern Painters* I, the importance of point of view. The opposed states of mind that produce grotesque or sublime art are described in phrases remarkably similar to those used to make the contrasts between excursive and sublime modes of seeing, or between the beholder's and artist's approaches to art. Ruskin attributes to the grotesque state of mind such positive qualities as curiosity, capability of surprise, delight in variety, and a certain waywardness (11:154, 157). Minds in such a state "gather, as best they may . . . various nourishment." They exhibit partial attention, making a "playful and recreative" application of fancy and imagination to serious subjects. Leisurely recreation, curiosity, expectation of surprise, pleasure in variety, gathering or collecting with no fixed plan or design — in all of these characteristics of the grotesque we can recognize the traveling spectator's pleasures as described in landscape literature. The connection becomes at one point explicit: Ruskin names this playful grotesque "the art which we may call generally art of the wayside, as opposed to that which is the business of men's lives." Such art is a "stretching of the mental limbs," a "leaping and dancing of the heart and intellect, when they are restored to the fresh air of heaven" from the imprisonment of work. The common identification between leisure and travel persists in Ruskin's metaphors.

The grotesque, then, is produced by a condition of mind closer to that of the ordinary contemporary viewer than to that of the imaginative artist. The negative aspects of this state of mind, brought out through comparison with the mind that produces a really sublime art, make clearer the presence of a familiar distinction. The sublime state of mind is notable for "the scope of its glance," the breadth or depth of its grasp, its apprehension of highest truths, its compass of human sorrow, its power of contemplating things in their true light, as if reflected in a mirror; such a mind is raised above the playful distraction of the grotesque mind. It presents truths seen in wholeness (11:152, 156, 178–81). The grotesque mind by comparison exhibits a narrowed vision, some shortening of the power of contemplation, a failure to grasp the highest truths; it does not "enter into the depth of things"; it is "imperfect, childish, fatigable" (like the "eminently weariable" imagination of the spectator). Its imagery is like that seen through a broken, distorted, and dim mirror—which seems partial, fragmented, with parts separated and out of proportion, apparently the product of no overall imaginative design (11.178–181). Thus the state of mind that produces the grotesque is not only connected with that of the picturesque traveler; it is also specifically described as inferior to another state of mind: the raised and fixed perception of contemplation, where large design or meaning is grasped or comprehended by the imagination.

Though the grotesque is associated with the leisurely and limited perception of the beholder, it is nonetheless different from what the spectator ordinarily perceives in the course of excursive looking. The grotesque *is* an attempt to see and express a large whole in a single image. In this sense it is the spectator's sublime: it is what one sees when one is arrested by an encounter with something that exceeds ordinary comprehension. It is a reduced or partial version of its subject. The relationship between grotesque image and sublime subject may be playful, witty, satiric, or seriously symbolic, but there is always an obvious disproportion between the grotesque image and what it stands for. Despite the inadequacy of the image, measured against the standard of a full imaginative grasp, the grotesque is a valued perception. Furthermore, the reduced sublimity of grotesque perception has one great advantage: it can be subsequently expanded by excursive methods. The imagery of wild dream or biblical prophecy, or of satiric or humorous grotesques, can be interpreted. The connections between grotesque image and sublime subject are there to be discovered by readers and critics. The possibility of interpretation brings the grotesque a step closer to the true sublime. Thus Ruskin can introduce the grotesque as a lesser sublimity. Just as "there is a Divine beauty, and a terribleness of sublimity coequal with it in rank, which are the subjects of the highest art," so there is also

an inferior or ornamental beauty, and an inferior terribleness coequal with it in rank, which are the subjects of grotesque art. And

> the state of mind in which the terrible form of the grotesque is developed is that which, in some irregular manner, dwells upon certain conditions of terribleness, into the complete depth of which it does not enter for the time.
>
> (11.165–66)

When the beholding imagination pauses and "dwells upon certain conditions of terribleness," it produces grotesque perceptions. The complete depth of the terrible greatness it confronts may be drawn out of the partial image at some later time.

Ruskin extends the meaning of grotesque along lines already laid down by romantic writers, but his grotesque has finally a very different relation to sublimity. Burke paired the sublime and the grotesque for purposes of contrast: the serious with the trivial. The same pairing was also used in the mid-eighteenth century to contrast the serious with the comic. Hogarth begins the growing tendency to take the grotesque more seriously. For him, caricature, a bridge between the grotesque and the sublime, was a serious comic art. German romantic writers like Friedrich Schlegel and Jean Paul Richter stressed the common ground between the grotesque and the sublime while maintaining their opposition. The distorted and hieroglyphic imagery of the grotesque possessed both the terrifying power and the obscure significance of the sublime, but the grotesque alone was diabolic. Some continental romantics discovered a connection between the somber, comic-tragic deformities or limitations of the grotesque and a general modern or human condition. Victor Hugo, for example, paired the grotesque with the sublime as the two great poles of human experience: the grotesque, bestial, infernal, and inhuman at one end, the spiritual or sublime at the other. But Walter Scott, reviewing E. T. A. Hoffmann's stories, objected to the link between the grotesque and the diabolic. Hoffman's grotesque tales, he complained, were too horribly fantastic, the wild imaginings of an uncontrolled or diseased imagination, without moral point. Ruskin's grotesque preserves the association with the sublime and exhibits all of the romantic tendency to take the grotesque seriously, especially to take the grotesque as representative of human limitations. But his discussion of the grotesque might be read as a response to Scott's objections, for Ruskin deliberately strips the "true" grotesque of its connection with the bestial, the satanic, the inhuman, and the immoral. His grotesque is the attempt of the limited imagination to come to grips with sin and death, but if it is true grotesque it reveals not moral corruption but moral aspiration in the perceiver. In this sense too Ruskin's grotesque is a version of the sublime.

Ruskin's elevation of the romantic grotesque toward the sublime should remind us that the relation he posits between beholder and artist is not a simple

opposition either. The grotesque is not a category of aesthetic consumption. It embraces a range of productive activity, from the rough humor of the working man at play, through the witty, ornamental, and often amateur art of a more educated and leisured class, to the fantasies of Shakespeare; or from the dreams of ordinary people to the symbolical imagery of Dante and the apocalyptic visions of the biblical prophets. The true sublime, by contrast, is a class that may have no members at all. Ruskin gives no examples. It is, at any rate, a very rare state of mind, the condition of completely clear and comprehensive vision, of absolutely governed imagination, of an obviously godlike grasp of visual design and metaphysical order. What is important, though, is not so much the shrinking sublime as the expanding grotesque. Ruskin's intent here seems to be to establish a continuity between crude humor and visionary art — and to place the amateur art of the middle-class excursive spectator within that spectrum of active imaginative response.

In this effort Ruskin sets himself against the tendency to regard art and aesthetics as exclusively constituted by two sharply divided groups: imaginative artists and middle-class consumers, those who can create and those who can "taste." I do not mean to suggest that Ruskin is advocating a democratic art. He continues to be concerned principally with middle-class spectators and with artists, and to insist on maintaining some absolute distinctions between them. He describes the activity that produces the grotesque, as we have seen, quite traditionally in terms of the leisure activities of a middle class: travel. The comprehensive grasp associated with the true sublime in this chapter is identified as the exclusively artistic power of invention in the later volumes of *Modern Painters*. The unlettered worker is represented only by a figure from the past, the medieval stone carver (though that, Ruskin argues, indicates a larger problem in contemporary art). Ruskin's emphasis on the grotesque does not indicate any desire to abolish a hierarchy of vision based both on imaginative ability and on social class. It does, however, put a new stress on the active, imaginative nature of the response possible from, and indeed required of, the spectator. Taste, acquired passively through traveling and reading, is not enough. Ruskin is interested in a response to landscape and art somewhere between picturesque taste and sublime comprehension or poetic invention. Failure to rise immediately to the challenge of the sublime in art or nature need not mean spectators must give up — or reduce what they see to a superficial collection of interesting textures and shapes. Artists and poets and those of *no* taste as well as ordinary educated spectator-amateurs employ an alternative mode of seeing. This mode is not a function of social class and imaginative ability, although Ruskin is primarily concerned that it be adopted by his middle-class readers. Dreams, visions, fantasy, wit, humor, satire, Gothic grotesques — all are examples of this alternative way of seeing,

given concrete expression as a form of art. The picturesque landscape sketching of amateurs, one might argue, could be another—if, as in some of Ruskin's own later drawings, it suggests the visual exploration, by a narrowed and broken vision, of what is sensed but not fully seen as vast, significant, and complexly ordered. It is tempting to see Ruskin's own criticism as a form of grotesque art: the concrete expression of an active and imaginative mind approaching the difficulties of landscape or great art by suggesting, and then expanding, partial images. . . .

[I offer as an example] of what could be called Ruskin's grotesque art a passage from Ruskin's manuscript chapter on the terrible sublime, probably written between 1856 and 1860, when its closing sentence was incorporated into a different passage in the published version of *Modern Painters* V. The manuscript version is appropriate here because it introduces the impressive imagery of the last sentence at the end of a paragraph confessing an inability to see and understand. Terrifying description is offered not as imaginative grasp but as an expression of a partial and distorted vision, as terrible facts described but not mastered. Such vision, though not ordinary, is not privileged either. It is a mode of seeing in which the ordinary spectator can and should sometimes share, an alternative to the comprehensive grasp of a hypothetical true sublime.

> I pause as I write—long and resultless. Unless one were oneself all that one should be, how can one say, or imagine, what the thoughts of others should be? I cannot tell, of any pain that I have felt, of any delight that I have enjoyed, how far I grieved or rejoiced rightly. But this at least I know,—that whether we rejoice or grieve, we ought all of us to strive more and more to gain insight into the facts of the life around us; and that those facts are, to our human sight, more than terrible. Assume what theory you will about the world;—and still, so far as the vision of the world so constituted is granted to *you,* it must be a frightful one:—and the best that you can believe is that in compensation for the evil of it, there shall one day be greater good; but believing this, still the good is unseen, evil is seen. Try at least to see it. Whatever is to be the final issue for us there ought surely to be times when we feel its bitterness, and perceive this awful globe of ours as it is indeed, one pallid charnel house,—a ball strewed bright with human ashes, glaring in its poised sway to and fro beneath the sun that warms it, all blinding white with death from pole to pole.
>
> (4:376)

There is no rationalization of the bitterness or terror, and no balanced composition. Ruskin suggests a single image for the world's evil, the pallid charnel house,

initially reducing the awful globe to a grotesque. In Ruskin's grotesque prose, however, the single image is not the end. The rest of his sentence step by step expands that image until it regains, finally, the grandeur he could at first only urge us to imagine ("Try at least to see it"). Pallor grows bright, then glaring, then blinding white. The house becomes a ball that is put in majestic motion and set in the vastness of space beneath the sun. The limited death of the charnel house breaks out into those human ashes strewn over the ball, which finally engulf the earth "with death from pole to pole." The confessions of difficulty and limited imagination that form the first part of the paragraph are the prelude to this alternative response to the challenge of sublimity: the grotesque image progressively expanded until it approaches the terrible sublime.

Ruskin's terrible grotesque assigns to the spectator the role of a lesser artist — the amateur, the workman, the critic. But Ruskin also approaches the problem of sublimity from another direction. There is, he suggests, a way to achieve the emotional exaltation of sublime experience without interrupting excursive progress and producing grotesque images. His noble picturesque is explicitly introduced, in *The Seven Lamps of Architecture,* as another version of sublimity — a "parasitical sublime" (8:236–37). In fact it invades unannounced even Ruskin's discussions of the true sublime in *Seven Lamps,* as it does again in the manuscript chapter on terrible sublimity written between 1856 and 1860.

"The Lamp of Power" is a discussion of sublime style in architecture. The notion of sublimity at work is not the terrible or difficult but the awesome: "a severe, and, in many cases, mysterious, majesty, which we remember with an undiminished awe, like that felt at the presence and operation of some great Spiritual Power" (8:100). When Ruskin says that sublime buildings depend on a sense of magnitude proportionate to their surroundings and to the human figure; or that they "have one visible bounding line from top to bottom, and from end to end" (8:106); or that they often rely on breadth of plain wall surface to achieve an effect of weight and massiveness; or that "after size and weight, the Power of architecture may be said to depend on the quantity . . . of its shadow" (8:116)—he is in every instance judging the effect upon a spectator presumed to be standing in one place receiving an impression of the whole. But partway through the chapter there is a change. When Ruskin takes up the importance of shadow, he explains it not as conveying the awe felt before a supernatural power, but as expressing "a kind of human sympathy, by a measure of darkness as great as there is in human life . . . the truth of this wild world of ours . . . the trouble and wrath of life . . . its sorrow and its mystery" (8:116–17). The identification is not with power but with human powerlessness; the emotion is not exaltation but sorrow and sympathy. Similarly, the discussion of shadow that takes up the major part of the chapter pays constant attention to

the mass and breadth of the whole, but as he explains how that effect is achieved, Ruskin moves into closer focus, illustrating by details. "A noble design may always be told by the back of a single leaf" (8:124). The drawings with which he illustrates his text are all of details, parts of a facade drawn from close up, from a point of view quite different from that assumed by the spectator trying to take in the whole at one glance. There is an unannounced change in both emotional and physical perspective within this chapter on the sublime. Comprehension of the visual whole or of the power it expresses is being achieved by an examination of parts, by a sympathetic understanding of how power or overall design is expressed in details.

This focus on expressive details is properly that of the chapter on "The Lamp of Memory." Picturesqueness or parasitical sublimity is there defined as "characters of line or shade or expression" productive of sublimity but "found in the accidental or external qualities" of an object (8:237). Picturesqueness is expressed in independent details; true sublimity in the design or power of the whole, to which the parts of course contribute. Picturesqueness and sublimity are then versions of each other, as Ruskin's alternative term suggests. The difference between them implies a different visual perspective or focus: "the picturesque direction of their thoughts is always distinctly recognizable, as clinging to the surface, to the less essential character" (8:240). As Ruskin writes elsewhere, the picturesque way of seeing involves not so much composition — the artist's power to immediately imagine a whole — as *de*composition, breaking a whole into unrelated parts (12:313). Though the parts may be gathered together, they are not reintegrated into the kind of wholeness that the sublime spectator looks for. The concentration on accidental surface detail also is a mental characteristic of picturesque spectators. They do not concentrate on the "centre of thought" (8:236) of the objects they regard. To become a picturesque spectator is, in one sense, to give up the challenge of the sublime.

Nevertheless — and this is the essential point about Ruskin's picturesque — the decomposing method of seeing can also be emotionally valuable. Ruskin describes a complicated response of sorrowful sympathy to the marks of age:

> [The greatest glory of a building] is in its Age, and in that deep sense of voicefulness, of stern watching, of mysterious sympathy, nay, even of approval or condemnation, which we feel in walls that have long been washed by the passing waves of humanity. It is in their lasting witness against men, in their quiet contrast with the transitional character of all things, in the strength which, through the lapse of seasons and times, and the decline and birth of dynasties, and the changing of the face of the earth, and of the limits of the

sea, maintains its sculptured shapeliness for a time insuperable, con-
nects forgotten and following ages with each other, and half consti-
tutes the identity, as it concentrates the sympathy, of nations: it is in
that golden stain of time, that we are to look for the real light, and
colour, and preciousness of architecture; and it is not until a building
has assumed this character, till it has been entrusted with the fame,
and hallowed by the deeds of men, till its walls have been witnesses
of suffering, and its pillars rise out of the shadows of death, that its
existence, more lasting as it is than that of the natural objects of the
world around it, can be gifted with even so much as these possess, of
language and of life.

(8:234)

This passage is a remarkable illustration of a transformation of emotional re-
sponse linked to a change in visual focus. At the beginning of the passage the
building is a single personified presence that bears "witness *against* men." It
seems a stern and judgmental power in which the spectator hardly participates.
Awe, or more likely fear, is the unexpressed emotional attitude the spectator
adopts. But as the passage goes on, the building seems to be opposing not
human beings but "the transitional character of all things" — a perpetual natural
flux and change to which we are also subject. Viewed this way it becomes, in a
fine reversal, not a witness against us but a point of identity for us. It now serves
to evoke a humanistic sympathy binding us with people of "forgotten and fol-
lowing ages."

That there has also been a change in the way the building is seen is sug-
gested by a suble shift in metaphor. The building that bears witness against men
is immediately a living power; it is above all a voice. The building that can "half
constitute the identity" of nations is a set of walls and pillars differing from "the
natural objects of the world around it" only when it has acquired the visible
marks of age, "that golden stain of time." When it has assumed this character it
acquires language, a language written on its walls. The building is no longer a
living power, impressive simply as "voicefulness" (not yet articulated into "ap-
proval or condemnation"). It is instead a record to be read, a history of human
fame and suffering. In becoming a reader, the observer must shift attention
from the building's overwhelming and unified presence to the scattered in-
dividual marks of passing time on its surface, the stains and cracks and rents in
aging masonry. The change of metaphor implies the shift from immediate grasp
of a whole to the linear or progressive attention to details we have been discuss-
ing as characteristic of the excursive and the picturesque.

In this passage, as throughout the two chapters on power and memory, the

alteration in emotional response seems wholly satisfying. Awe or fear of an alien unknown becomes an expanded human sympathy. The noble picturesque provides an aesthetic response that is emotionally and morally desirable—perhaps more so than that of the true sublime Ruskin's manuscript chapter on terrible sublimity, written mostly in the late 1850s, further explains this preference. In the draft passages for this chapter published by Cook and Wedderburn, the terrible sublime is discussed as a problem, as it is not in the published volumes of *Modern Painters*. Ruskin starts with the difficulty hedged in *The Stones of Venice* and taken up again in *Modern Painters* III: if, as he had once asserted, the sublime is never terrible to the believer, must we understand the terrible sublime simply as a symptom of faithlessness in the perceiver? In the language of *Modern Painters* III, has the modern love of cloudy landscapes any positive value? Ruskin's answer in the draft passages is close to that of *Modern Painters* III: pleasure in terror, in any age of disbelief, is initially a sign of a valuable sensitivity to natural and supernatural power. But the continued pursuit of pleasure in terror is more suspect. The sanest people will turn away from terror as they discover beauty, except under conditions of unusual stress. When we do return to pleasure in terror, we can do so nobly or basely; the difference turns on the nature of the emotional resolution of the experience. In the base sublime, pleasure comes from active identification with the absolute strength of a terrible power and extends even to "actual enjoyment of the idea of pain"—a pleasure that Ruskin rejects completely (4:377). The perceiver in the noble sublime begins by opposing a terrible supernatural power and ends by sympathizing with the human objects threatened by that power. Sympathy may be turned inward: a bad conscience or physical weakness makes the observer unusually attracted to manifestations of destructive powers, in order to resist them. The pleasure of terror comes in the affirmation of the human against a sweeping but fearsome power. The affirmation is, however, purely personal. But the movement of sympathy may also be outward. Then it is compassion for a collective humanity, the most valuable version of the dubious pleasure of the terrible sublime: "a noble, but doubtful and faithless compassion for the agony of the world" (4:380).

In Ruskin's discussion of the emotional responses to terrible sublimity, point of view is, in a purely metaphorical sense, the crucial issue. He insists on a rejection of the comprehensive divine perspective on moral and humanistic grounds: to identify with a terrifying destructive power is to take pleasure in causing pain. But he warns of the dangers of substituting for this supernatural perspective the single, limited view of the isolated spectator. To merely rejoice that one can resist the power that attracts and threatens is selfish. His solution, offered as the best alternative in a world where the divine point of view *is* terrifying,

is a multiplicaton of limited perspectives, an expansion, through compassion, of a deliberately partial but stubbornly human point of view.

Ruskin's grotesque and noble picturesque present what had been simply a spectator's way of looking at pictures or landscapes as a mode of perception equal in epistemological importance, and in emotional and imaginative satisfaction, to the privileged category of the sublime. These altered versions of excursive seeing are alternatives to a conventional sublime which tend actually to replace it. His grotesque and noble picturesque are in part a solution to a personal difficulty. But Ruskin has identified the difficulty as a general cultural one as well—a new terror and fascination at the appearance of destructive natural power, which cannot be enjoyed as the manifestation of a benevolent natural or divine order. In *Modern Painters* III and IV the general cultural difficulty with the sublime affects the artist, too. First grotesque and then picturesque art become a cooperative effort between artist and spectator to comprehend greatness and enlarge sympathies.

The grotesque is examined in *Modern Painters* III not primarily as the rough humor of ordinary people, but as the symbolical or allegorical vision of the artist or poet. In this form it is capable of "giving the highest sublimity even to the most trivial object . . . No element of imagination has a wider range, a more magnificent use, or so colossal a grasp of sacred truth" (5:133–34). The sublimity, the grasp of sacred truth, is nonetheless achieved through a grotesque way of seeing by the artist, and it generates as well a somewhat different kind of grotesque perception in the spectator. Grotesque vision is the most colossal grasp of sacred truth because it is the only way in which such truth *can* be comprehended—with the distortions and fragmentations resulting from a limited point of view. The artist's vision, faced with the challenge of a particular kind of knowledge, is as piecemeal as the spectator's. His grotesques, though capable of giving sublimity, need to be expanded or interpreted like the spectator's. Much of Ruskin's chapter on the grotesque ideal in *Modern Painters* III is devoted to examples of the interpretive process, the reader's and beholder's roles in multiplying the limited perspective of the artist by gathering together connected examples of allegorical imagery from the artist's and from other texts in order to arrive at sublime comprehension. This process is, in art or literature, what Ruskin calls "reading." It is the ordinary person's way of using linear to arrive at comprehensive perception, a reader's sublime—an extension of excursive seeing. The sublimity constructed by the reading process is never more than potentially present in the artist's vision. In this last description of the grotesque or symbolical sublime, reader and artist together use the partial or excursive way of seeing to arrive at an otherwise unattainable knowledge.

In Ruskin's chapter on the noble or Turnerian picturesque in *Modern*

Painters IV there is a similar sense of cooperation between artist and spectator. Here, however, the emphasis is less on necessary limitations to sublime vision in the artist than on the artist's responsibility to make the aesthetic and human values of picturesque vision available to the spectator. Ruskin focuses not on the accidental marks of age in buildings, but on the intentional and sympathetic portrayal of incidental detail in painting.

He had, of course, always delighted in an intricate variety that invited leisurely progress and changing perspectives for an excursive eye. In *Modern Painters* I he praised the purely visual pleasures of an excursive way of seeing and, by implication, placed the responsibility for creating pictures to be seen this way on the artist.

> Often as I have paused before these noble works, I never felt on returning to them as if I had ever seen them before; for their abundance is so deep and various, that the mind, according to its own temper at the time of seeing, perceives some new series of truths rendered in them, just as it would on revisiting a natural scene; and detects new relations and associations of these truths which set the whole picture in a different light at every return to it. And this effect is especially caused by the management of the foreground: for the more marked objects of the picture may be taken one by one, and thus examined and known; but the foregrounds of Turner are so united in all their parts that the eye cannot take them by divisions, but is guided from stone to stone and bank to bank, discovering truths totally different in aspect according to the direction in which it approaches them, and approaching them in a different direction, and viewing them as part of a new system every time that it begins its course at a new point.
>
> (3:492)

The artist in this passage is not necessarily one who sees excursively or picturesquely, but one who creates landscapes that allow a picturesque or excursive way of seeing in the beholder. Pictures possess unity, but the unity is not single. There are as many different systems or wholes as there are possible points of view. The spectator is enabled and encouraged by the strength of the connections between the parts to discover the multiple truths "totally different in aspect according to the direction" from which the parts are approached in an excursion through the picture space.

Ruskin's praise of Turner in the *Modern Painters* IV chapter on the noble picturesque is similar. There the way of seeing is explicitly identified as picturesque, and Ruskin emphasizes the accompanying emotional movement of sympathy as much as purely visual movement. But the artist's role is the same: to

enable the beholder to discover new sympathies as well as new sights while the beholder moves from point to point. The beholder learns and takes pleasure from the process of movement through the picture rather than from an immediate impression of a whole. What Ruskin praises in the Turnerian picturesque is a breadth of sympathy that is conveyed to the spectator by the artist's treatment of intricate detail. The artist is praised in this chapter not for exemplifying a different and extraordinary vision, but for encouraging the development of the spectator's way of seeing.

Clarkson Stanfield's ordinary or "lower picturesque" painting of a decaying windmill has an inviting variety of visual features: "its roof is nearly as interesting in its ruggedness as a piece of the stony peak of a mountain, with a châlet built on its side; and it is exquisitely varied in swell and curve . . . the clay wall of Stanfield's mill is as beautiful as a piece of chalk cliff, all worn into furrows by the rain, coated with mosses, and rooted to the ground by a heap of crumbled stone, embroidered with grass and creeping plants" (6:16–17). Even this surface picturesque is not to be despised, but "ought to be cultivated with care, wherever it exists: not with any special view to artistic, but to merely humane, education" (6:22). But Turner's noble picturesque is still more effective in encouraging that simultaneous movement of sympathy which makes the visual explorations of the spectator so valuable as a means of humane education. Ruskin notes that Stanfield depicts a mill too fragile to function, whose decrepitude he enjoys aesthetically; he has made the mill the principal light of his picture and elaborated the textural interest of its decay. Turner's mill, though also worn, still functions; moreover he underlines its functional purpose through the mill stones he has propped against it. Turner treats the mill as a symbol of the value and the drudgery of work. His mill is a stark, proud object on a hill, cast in shadow to express his sympathy with the continual sorrow of labor (6:16–19). The picturesque way of seeing can encourage sympathy in the spectator even when the artist has not felt it, but the greatest paintings will be those where the artist demonstrates a power of sympathy through his treatment of picturesque visual detail. As with the symbolical grotesque, the spectator can complete the extension of the picturesque from a mode of visual to a mode of moral perception.

Reading and picturesque viewing are a long way from the romantic imagination as celebrated by Wordsworth or Coleridge. Yet these apparently prosaic activities are the models for the sight whose central epistemological importance Ruskin praised in a much-quoted passage from *Modern Painters* III: "The greatest thing a human soul ever does in this world is to *see* something, and tell what it saw in a plain way . . . To see clearly is poetry, prophecy, and religon, — all in one" (5:333). He was praising Turner and Scott as the representative modern seers: representative because of the perfect ease with which they had mastered and could teach a knowledge of the aspects of things. Ruskin's

terms imply the kind of perception we have been tracing as the excursive. "Aspect" carries with it the meaning of looking from a particular direction at one side of a thing. The science of aspects is a body of facts—visual, emotional, and imaginative—consisting of more than one aspect, facts gathered by changing one's point of view. In the last three volumes of *Modern Painters* Ruskin praises Turner not as the painter of nature, or of truth, or of beauty, but as the master of a new mode of perception, of the way in which nature, truth, and beauty will be approached by a modern spectator. The roots of that new mode of perception, we have seen, reach not to the sublime but to the excursive and picturesque.

Readers and critics of Ruskin have not, I think, recognized Ruskin's prescriptions on art and sight for what they are: a program of reform based on an insight into changes in habits of perception. Those changes he linked to a combination of mechanical inventions, new economic and social patterns, and an altered religious and philosophical outlook. His exhortations, his prophecies, his criticisms, his projects for reform assume the future importance of a new way of seeing. That new way was to be distinguished from another way, the sublime grasp he located somewhere in the distant past, or attributed to great poets and artists, or described at other times as an impossible ideal. To a remarkable extent Ruskin accepted the change in seeing he described. I say remarkable because it is equally clear that Ruskin was not happy with this change.

In many ways his attitudes are parallel to those of the twentieth-century critic, Walter Benjamin. Professedly a Marxist, Benjamin described a similar alteration in the way spectators and readers experience art, pointing to technological and economic changes of the same sort that Ruskin had identified seventy-five years earlier. Yet Benjamin's work is, like Ruskin's, permeated with a profound nostalgia for a lost way of seeing—what he calls the "aura" of a work of art and what Ruskin called "awe." Both men accept what they see as an irreversible historical change, but the reforms they urge within this new mode of seeing are conceived in terms of a displaced romantic art. Ruskin's grotesque and picturesque are defined by the sublime; the imaginative and emotional satisfaction to be found in an expanded excursive experience must equal the promise of the privileged romantic moment. Ruskin increasingly realized that this was not going to happen. Like Benjamin, he could see that awe or aura was on its way out. But neither man ever really rejoiced in this fact. For this reason both have appealed more to readers who share their nostalgia and romantic context than to those whom they took as their subjects and sought as their audience—those ordinary modern readers and viewers who can look at art or landscape only distractedly, who feel no awe for the kind of vision they do not possess, whom sublimity leaves, as Byron put it, cold.

GARY WIHL

Unity and Proportion:
Metaphor as Symbolic Representation

The chapter "Of Unity, or the Type of Divine Comprehensiveness" [*Modern Painters* II] (4:92–112) contains, according to Ruskin's gloss in the 1883 edition, some of his most "valuable" and "essential" writing. He refers specifically to the second paragraph of the chapter, which proclaims, in some of the volume's most colorful rhetoric, the unities of matter, human spirit, and living creatures. Each of these achieves unity through integration with like members of its class in the hierarchy of creation. Imperfect, separate members are formed into unified "perfect" complexes. Matter is built up into "temples of the spirit" as dust is transformed into crystal. Human sympathies take us beyond the "dead and cold peace of undisturbed stones" into a "living peace of trust." The class of living creatures, as a whole, has an "inseparable dependency on each other's being."

Ruskin's vision of unity is remarkable for its controlled rhetorical force. Distinct objects or species are not "mysteriously" blurred into a sublimely un-realizable sense of unity. Metaphors capture the working out of the principle of unity in precise ways. The paragraph is as figurative as any purple passage from *Modern Painters* I, but a new precision in the use of metaphor is evident. The "working and walking and clinging together" of personified matter is figuratively extended in the collective image of "syllables and soundings" in air, "weight in waves," and the "burning" of sunbeams, yet these elements do not exchange properties as they do in the earlier text on *The Slave Ship*. The language of the air does not blend into the heavy waves, nor do the waves burden the burning light. In the context of unity, Ruskin strongly emphasizes, difference and variety are essential to the sense of total integrity. The opening rhetorical flourishes

From *Ruskin and the Rhetoric of Infallibility*. © 1985 by Yale University. Yale University Press, 1985.

do not yet define a structural principle, but they do attempt to make *apparent* the emergence of unity out of well-differentiated parts or classes.

I emphasize "appearance" because it is the most frequently recurring term in the definition of unity. "Appearance" is a complex word, not easily defined. It seems to apply to unity in a metaphorical way. Appearance does not seem to have any necessary ontological connection with the concept of unity. Ruskin states that appearance is "essential" to unity, but not in the sense of a total fusion of form and matter or of image and concept. Perfect unity can "appear" as an "appearance" (in the simple sense of "superficial aspect") or as a "sign, type or suggestion." In its "most determined sense" the appearance of unity reduces to the abstract visual unities of "lines, colours or forms." Unity, therefore, may "appear" in a variety of guises, sometimes as a complex of signs and physical objects, sometimes in a thoroughly concretized form, sometimes as a pure sign. All that is essential is the appearance of unity, however nonessential the link between the specific appearance and the concept of unity. Unity, like all the types of divinity in *Modern Painters* II, must have a material, sensory component, but this component is so broadly conceived that abstract lines become as typical as natural objects or phenomena.

Moving from the discourse based on the sign in *Modern Painters* I to the typology of *Modern Painters* II, a sharper focus on the distinct properties of natural objects seems to be found, as in the second paragraph of Ruskin's chapter on unity. But this referential accuracy, in spite of the presence of connective metaphors, seems to have no proper relation to the concept of unity. Though he praises the meaning of the paragraph in 1883, Ruskin condemns, at the same time, the "pedantry" and "tinkle" of the literary art of this paragraph. The "literary" mode of appearance has not falsified or negated the principle of unity. The figurations here have not confused sameness with variety or difference with likeness, but the paragraph by no means presents an authoritative or conclusive image of unity.

The contingent nature of appearance calls for a structural definition of unity. The signs, objects, and vital creatures must somehow be related to each other so as to bring to light the common principle at work. Knowledge of the structure of unity would prevent us from wasting our attention on any appearance, especially one with an arresting literary appeal. The chapter moves toward a structural definition of unity. It proceeds from the most immediate impressions of unity, such as the collective movement of waves and clouds, to analogous but abstract unities in melody, and finally on to proportional unities in the natural world. Yet this movement, the "sequence" of the chapter as Ruskin calls it, is by no means straightforward. The contingency of appearance keeps intruding. As we move from the most immediate to the more cognitive unities, we do not

move, in parallel fashion, from objects to phenomena to signs. Ruskin shifts un-predictably, at every stage of his discussion, from signs to types to objects. By the time we reach the discussion of proportion, the need to explain, in a precise way, the various "appearances" of unity has become crucial.

Ruskin seeks to refute Alison's doctrine that proportion is identical with func-tional "fitness" as well as Burke's dismissal of proportion, as a "mathematical" con-cept, from the sensory realm of beauty. He tries to establish a novel theory of "Apparent Proportion," which would make this form of unity immediately intel-ligible to the eye. Upon the *appearance* of proportional unity rests the joint refuta-tion of Burke and Alison, both of whom argue that it is only by habit or custom that we "associate" irrelevant appearance with the (mathematical or functional) concept of proportion. For Ruskin, the appearance of proportion would prove its external existence. Proportion would no longer be a mental construct.

At this point in his argument, different definitions of "appearance" — signs, objects, types — cannot claim equal value. If the appearance of proportion reduces the object to a semiotic structure, for example, it would be difficult to see how this would differ from Alison's argument that the translation of an ob-ject into a sign is the result of association. At the same time, if Ruskin asserts the immediacy of apparent proportion, it would align proportion too closely with Burke's equation of material forms with sensations. I will trace Ruskin's discussion of unity up to the consideration of proportion, where the relation of appearance to unity must finally be determined. For upon the final status of appearance rests the deeper and fundamental distinction between type and allegory, between essen-tial and nonessential conceptual figures.

Ruskin defers consideration of the ambiguities of "appearance" for most of the chapter. He quickly abandons the issue of sensory appearance versus the "ap-pearance" of signs, types, or suggestions, turning instead to a more accessible set of terms, classed, simply, as the "several kinds" of the "appearances of unity." Throughout the chapter, he seems to remain firmly within a referential discourse. The kinds of unity may be described, named, categorized, and compared. No am-biguity intrudes. There is only finer qualification. The subtlety of the qualification seems only to reinforce the sense of the complexity and diversity of unity's presence. He ranges from the branches of the trees and "starry rays of flowers and beams of light" (Unity of Origin) to the driving of sea waves and clouds (Unity of Subjection) to the higher unities accessible to reason, such as melody, and the "orderly succes-sions of motions and times" (Unity of Sequence), and, finally, the Essential Unity of Membership, "which is the unity of things separately imperfect into a perfect whole." Unity, therefore, is a remarkably dialectical concept. It reconciles the trivial with the sublime, the most fragmentary with the most harmonious, the physical motion of nature with the rationality of melodic arrangements.

The only disruption to universal unity occurs with lapses from awareness of unity-in-difference to variety for its own sake. Membership, the most inclusive unity, depends, by definition, on "difference of variety." Without differentiation among the members, repetition or habit would set in. Unity would cease to expand into its full comprehensiveness. Thus "out of the necessity of Unity, arises that of Variety" (4:96). But where variety is pursued for its own sake, the mind is perceiving only "at the surface of things." The appetite for variety calls forth the most vehement rhetoric of the chapter. The pursuit of variety leads to "disgust, indifference, contrariness and weakness." There is no better test of the perception of unity than its "surviving or annihilating the love of change" (4:99). Only those variations in nature that lead to the melodious growth of unity are acceptable.

The distinction between variety for its own sake and variety that contributes to difference turns out, surprisingly, to have little relevance to the human grasp of the divine harmony that permeates creation. Although the concern over variety's disruptive influence occurs in the context of the unity of membership, variety is discussed in the context of the lesser unities of subjection and sequence. The perfect unity in variety, or the necessity of variety to membership, is never demonstrated. The tirade against variety turns the argument back upon itself, as Ruskin starts over again with subjection, which is to be followed by variety within the unity of sequence, that is, apparent proportion. The discussion of membership has served the limited purpose of clearing away the sensationist notion of variety. As a necessary part of the development of unity, variety had to be made safe, subjected, so that unity may proceed, not to absolute comprehensiveness but to the human spheres of knowledge, melody, and proportion.

The subjection of variety is a relatively simple case of unity. In fact, it is almost an arbitrary act of positing unity, as the term "subjection" would imply. The subjection of variety to unity is exemplified, once again, in winds driving clouds and sea waves. The variety of these natural events seems to be of little interest. The subtle gradations of movement or the play of colorful reflections in agitated sea waves, which received so much attention in *Modern Painters* I, is now ignored. There is really little variety in this impression of unity. Subjectional unity in nature may not be very sensational, but neither is it capable of much dialectical progress. When the winds of unity blow out, so too, presumably, does the notion of unity. As a strictly empirical event, subjectional unity seems to consist of little more than the deliberate eclipse of subtle changes within a broad perspective; the perspective appears to be wide but its elements are narrowly perceived.

Subjectional unity becomes much more complex as it is manifested aesthetically, as in Fra Angelico's fresco *The Spirits in Prison* (St. Mark's cloister, Florence).

The image of Christ in the fresco becomes the literal representation of the principle of subjection. As the object of the prisoners' worship, Christ unifies their "infinite and truthful variation of expression" and "multitudinous passion" of the human heart. The seriousness, the moral intensity, of the fresco offers an image of unity that is hardly sensationist (Fra Angelico's distinct but relatively abstract outlines have little mimetic value), yet the image is wonderfully varied and as extensive as the range of human sympathy. The fresco conveys "ineffable adoration." It places us, as viewers, before a complex image, limitless in its implications, but unified by the central image of Christ. With Fra Angelico, there seems to be no need for temporal unity of sequence. We seem to leap over sequential apprehension into the perfect unity of membership. The image of Christ appears to be typical of our membership with God.

But we cannot make this leap into typical meaning until we are able to determine the status of the fresco's appearance. Empirically, the fresco seems to belong to the realm of signs and abstract forms. Though it may "suggest" the endless variety of human feeling, it does so by severely restricting the scope of its imagery and composing the human figures into a collective expression of subjection. The worship of Christ is various in suggestion but limited in its actual variety of appearance. To vary the appearance of Christ, as Ruskin frequently asserts in this volume, is to degrade and spoil him. Ruskin prefers Tintoretto to Michelangelo, in this volume, because Tintoretto's paintings seem to situate us in an actual landscape; but this mimetic background, it must be remembered, serves the purpose of calling our attention away from the impossibility of imaging Christ.

For subjectional unity to occur in Fra Angelico's fresco, we must see the image of Christ symbolically rather than typologically. His appearance is neither concretely realized nor superficially abstracted (as are the clouds and waves in the previous example). Christ is not a type of divine infinity within human finitude, or even a type of membership. That would require a historically detailed representation of his image, too prone to human imaginative distortion. As a symbol, however, Christ suggests the divine much more "rudely."

But if the fresco is symbolic rather than typological or phenomenological, why has it been squarely placed within a discussion of the problem of unifying our perception of the brilliant variety of natural shapes and colors? Somehow, Fra Angelico's symbolism belongs, for Ruskin, within the context of appearances of variety-in-unity, even though the actual appearance of the fresco is nugatory.

Van Akin Burd's subtle research into what he calls "Ruskin's Quest for a Theory of Imagination" provides a possible explanation. Burd notes the importance of Ruskin's discovery of Fra Angelico during his Italian tour of 1845, the tour that precipitated many of the revisions and additions to *Modern Painters* II.

In Fra Angelico, Ruskin saw a "spontaneous expression of feeling for natural form." Fra Angelico's recording of "pure form," not religious feeling as such, was what fascinated Ruskin. The "soft lines" of Fra Angelico's backgrounds seemed almost detachable. The same lines could be discerned in the hanging vines of brilliant, golden colors in the countryside outside Lucca. Burd discovers the significance of Ruskin's admiration for Fra Angelico's "intense" (because unfinished) yet soft delineation of abstract form: its lack of "associational values." The "purity" of form did not suggest pleasure, pain, joy, or despair. Such a state of aesthetic detachment was rare for Ruskin during this tour, for he felt within himself, as Burd documents, "an inability to separate abstract values from the values of association." As he traced the progress of Italian art from Giotto, through Fra Angelico, on to Tintoretto, and reexperienced the geography of Northern Italy against his memory of earlier trips, Ruskin was troubled by his tendency to "mistake the feeling of association for insight into beauty." Abstract form—which could make a river wave or an aspen branch equivalent, in terms of linear curvature, to a tomb sculpture—solved the problem of mistaking the beauty of these appearances for an associational pleasure. Abstract form provided access to "intrinsic beauty."

Appearance varies with each physical object—a wave, a tree, a sculpture—but remains constant as a formal abstraction. We seem, momentarily, to be back in the realm of the sign, as in *Modern Painters* I. But Ruskin has a new purpose in mind. He does not resort to abstract form to overcome the entrapment of mimesis. As Burd shows, Ruskin found a certain sensuous attractiveness in Fra Angelico's manipulation of light and shadow, but these effects led in no way to an illusory sensation of presence before a real object. The "divine" meaningfulness of Fra Angelico's imagery remains intact, as does the sense of his control over form. In *Modern Painters* II, in an altogether different argument, abstract form is opposed to association, not mimesis. Disembodied lines and forms take us beyond empirical "truth" into a symbolic realm of meanings. Accuracy of perception is not enough, or even, finally, what is desired. Abstract form must deliver us out of the confusing world of associative connections into the symbolic realm of "intrinsic" meaning. The sign now belongs with associationism, the symbol with beauty proper.

Ruskin seems to have realized that his earlier emphasis on signs may have subjected the senses but failed to subject the errors of association. At the conclusion of an illuminating passage in the second volume, "Of Accuracy and Inaccuracy in Impressions of Sense" (4:51–65), he makes clear his fear that associationism, as in Alison, reduces all objects to signs of *equally* expressive value. An object, through association, may *signify* almost any idea, historical or mathematical.

Association transforms objects into signs so as to make what Ruskin calls "meta-phors," "false" or "erroneous" equations between objects that are not *sym-bolically* equivalent. Thus Ruskin criticizes Alison for allowing, in theory, the equation of the "beauty of a snowy mountain and of a human cheek or forehead." Without any proper meaning, the mountain and the face may be "externally" associated in terms of "certain qualities of colour and line, common to both and by reason extricable." Associational abstraction of external appearance denies rather than reinforces proper meaning. When symbolic value is taken into ac-count, the signs of face and mountain cease to interchange with each other: "[T]he flush of the cheek and moulding of the brow, as they express modesty, affection, or intellect, possess sources of agreeableness which are not common to the snow mountain, and the interference of whose influence we must be cautious to pre-vent in our examination of those which are material or universal" (4:63).

Ruskin's "discovery" of Fra Angelico (which was probably more of an arbi-trary decision to call an end to his own associationism) suggests the mastery of varied appearance by the symbolism of form. The high degree of linear relief in the depiction of form in Fra Angelico's frescoes raised, for Ruskin, the prob-lematic, free-floating nature of the sign. But the overt, unassailable Christian context in which these outlines "appeared" in these frescoes grounded them in symbolic expression—indeed, gave them a necessarily symbolic function. With-out the right degree of abstraction, Christ could not appear at all.

The threat of associationism—the potential lapse from symbolic form to the contingency of the sign—has not been conclusively removed. The image of Christ is an exceptional case of symbolic form. Bronzino, as Ruskin argues, may degrade Christ in his attempt to dramatize his facial expressions, but that is a very different argument from attributing modesty or affection to a blushing cheek. Is a modest blush symbolic or associational? Innate and proper or ac-quired by social custom and habit? As we move into the more varied world of animals, flowers and plants, melodies and architectural constructions, symbolic meaning is not always immediately knowable. The problem is to decide be-tween those forms which are symbolic in and of themselves (which would link them to divine creation) and those which are valued primarily for their human associations. Symbolic form finally rests upon what Ruskin calls "Apparent Pro-portion": a "sequential" or "melodious" sort of variety-in-unity that points toward divine harmony.

Ruskin distinguishes two sorts of proportion, the confusion of which, he suggests, has led to the "greater part of the erroneous conceptions of the influ-ence of either." Apparent proportion "takes place between quantities for the sake of the connection only, without any ultimate object or causal necessity."

Constructive proportion "has reference to some function to be discharged by the quantities" (4:102). Apparent proportion is "sensible." No cognition of function is necessary for its appreciation. It is "one of the most important means of obtaining unity amongst things which otherwise must have remained distinct in similarity." Constructive proportion is not necessarily agreeable in appearance; it appeals primarily to the mind. Adopting Alison's example of the constructive proportioning of architectural columns, Ruskin states that they vary in form according to their supportive function. The decision whether to use a wooden or a stone column has to do with the "weight to be borne and the scale of the building." The materials and proportions of the columns have "no more connection with ideas of beauty, than the relation between the arms of a lever adapted to the raising of a given weight." The distinction between apparent and constructive proportion seems to rest on the difference between an appeal to the eye and an appeal to the "intelligence," between theoretic disinterestedness and ultilitarian functionalism. Only apparent proportion is of critical consequence in Ruskin's argument. Constructive proportion, at least since Alison, had been very well defined.

Ruskin makes no attempt to deny that some proportions must be explained in terms of the fitness of the parts within a functioning whole. Such proportions require knowledge of mechanical principles. Only as the constructive shades into the apparent is Alison's emphasis attacked. Alison writes:

> The habit, indeed, which we have in a great many familiar cases, of immediately conceiving the Fitness [of proportion] from the mere appearance of the Form, leads us to imagine, as it is expressed in common language, that we determine Proportion by the eye; and the quality of Fitness is so immediately expressed to us by the material Form that we are sensible of little difference between such judgments and a mere determination of sense.

The intimate link between material form and judgment, to the point where proportion seems to "appear" to the eye with the same immediacy as a sense impression, is not, in itself, cause for objection. Some constructive proportions may, indeed, be immediately intelligible. Ruskin objects to the suggestion that *all* apparent proportions are really immediately recognizable constructions that are familiar through habitual occurrence. The question of appearance, in Alison, does not lead, as Ruskin's distinctions suggest it ought, to the varied realm of the visible. Rather, Alisonian appearances are metonymical substitutions, in the mind, of the visible for the conceptual. Constructive proportion functions like the Lockean sign. The substitution of concept for appearance leads to the far more dangerous substitution of fitness for beauty, for the mind is not actually

paying any attention to the appearance of the proportioned object. The mind thinks it sees, and so ignores the varied visual texture of the object.

All animals, plants, or even well-designed buildings may function equally well, but, Ruskin argues, "all things are not equally beautiful."

> The megatherium is absolutely as well proportioned, in the adapta-
> tion of parts to purposes, as the horse or the swan; but by no means
> so handsome as either. The fact is, that the perception of expediency
> of proportion can but rarely affect our estimates of beauty, for it im-
> plies a knowledge which we very rarely and imperfectly possess, and
> the want of which we tacitly acknowledge.
>
> (4:110)

Ruskin fears that Alison's denial of any necessary connection between beauty and fitness will lead to a haphazard aesthetic. The beauty of an object becomes too relative; beauty is made to depend on an imperfect, associational form of knowledge. The fitness principle may be made to serve any number of associa-tive constructs, including some that may neglect more beautiful ways of looking at a particular object. Alison's notion of a proportional scheme is too neutral for Ruskin, who seeks a definite perceptual value in an object's apparent structure. Alison's example of the architectural column suggests all that is troublesome, for Ruskin, in the equation of appearance with fitness:

> [The] Column (considered as in the former case, merely in relation
> to its peculiar Form, and independent of its ornaments) is not more
> beautiful, as a Form, and perhaps not so beautiful, as many Forms of
> a similar kind. The Trunk of many Trees, the Mast of a Ship, the
> long and slender Gothic Column, and many other similar objects, are
> to the full as beautiful, when considered merely as Forms without
> relation to an End, as any of the Columns in Architecture. If, on the
> contrary, these Forms were beautiful in themselves, and as individual
> objects, no other similar Forms could be equally beautiful, but such
> as had the same Proportions. . . . It would appear, therefore, that
> it is not from any absolute Beauty in these Forms, considered indi-
> vidually, that our opinion of their Beauty in Composition, arises.

Each of the forms mentioned—tree, mast, Gothic column—is externally similar. This very similarity proves, to Alison, their lack of an inherent formal perfec-tion. Only as each form takes on a functional role does its appearance become "beautiful" and distinct from the other forms.

Ruskin's earlier criticism of Alison—that he ignored expressive values— seems to apply to Alison's discussion of proportion. Proportion's "beauty" has

been reduced to fitness. We may apply the term "beauty" to the structure of a face or of a mountain, to the form of a column or of a mast. If these various appearances have an indifferent influence upon us, then they become mere signs. Appearance is significant only as it contributes to the immediate sense of a well-built natural object or machine or piece of architecture. Ruskin would like to set another value upon proportion. Proportion ought to be the orderly grasp of variations in appearance, the discovery of unity in difference. The cognitive movement from appearance to construction must be reversed. Proportion must be discovered in its own right, independent of the judgment that would reduce it.

But Alison is not so easily overturned. He has, at least, offered one possible explanation for the notion that proportion may appear. Ruskin rejects the extension of this explanation to all appearances, but leaves unanswered the question, how else can we recognize proportion? For Alison, all nonfunctional attempts to explain the connection between form and proportion, as in Pythagorean or Albertian doctrines, are "futile." Much more damaging to Ruskin's task, however, is Alison's argument that all nonfunctional appearances that are contiguous to constructive proportions can be reconciled with proportion only as "associations," that is, nonessentially. As we move out of the restricted realm of constructive proportions, the meaning of any appearance becomes difficult to determine. To reverse Alison would be to open up the possibility of associational error in the link between expressive meaning and apparent forms and structures.

Toward the conclusion of his essay on proportion, Alison emphasizes the dangers of associating proportion with any value or concept other than fitness. He notes that architectural proportion often occurs in the context of "Grandeur, Magnificence or Elegance." It is in "such scenes" and with "such additions, that we are accustomed to observe [architectural proportion]; and while we feel the effect of all these accidental Associations, we are seldom willing to examine what are the causes of the complex Emotion we feel, and readily attribute to the nature of the Architecture itself, the whole pleasure which we enjoy." The same associational complex develops around the proportions that are valued because of their venerable historical origin, such as the Grecian. In such complex cases, there are "so many and so pleasing Associations" that it is "difficult," even for a man of "reflection," to determine which portion of pleasure is to be attributed to the proportion "alone." Architecture, says Alison, is a "material sign, in fact, of all the various affecting qualities which are connected with it, and it disposes us in this, as in every other case, to attribute to the sign, the effect which is produced by the qualities signified." But, in the end, in "calmer moments," we are "induced" to consider proportion as the sole source of pleasure. No building, however ornamented, or set in nature or in a particular light, can be pleasing if it contradicts our sense of fitness, if, simply, it looks as if it might collapse or if it

offends our sense of economy. The "assent of all ages" has nothing to do with musical harmonies or the proportions of the human body, but with the time-tested discovery of which sort of buildings stand up and which do not. As for natural objects, particularly animals and plants, their construction is so complex, so beyond human knowledge, that we must be guided by the most "common forms." These forms become the most beautiful to us, but they have no original or independent beauty in and of themselves.

As Ruskin attempts to free the appearance of proportion from the concept of fitness he reencounters the problem of associationism. Apparent proportion must avoid two extremes: first, the extreme of pure appearance, or superficial form, which, Ruskin had shown, leads to aberrant "metaphorical" meanings, like the face of a mountain; second, the extreme of conceptualization, in which appearance is subsumed under the sign of some constant property, such as fitness. This would make variations in appearance responsible for contingent meanings only. Apparent proportion must operate symbolically, like Fra Angelico's frescoes. Like the image of Christ, an apparent proportion must express a proper, not a metaphorical, relation between distinct forms. Furthermore, these forms must remain within the "sensible" realm, as Ruskin stated in his definition.

Ruskin develops his theory of apparent proportion as a reply to Burke. Burke's position is even more reductive than Alison's. Proportion, for Burke, has nothing at all to do with beauty, which is entirely the result of material causes acting upon the senses. Proportion, as a mathematical concept, is simply out of bounds. Burke would not seem to be a promising point of departure, but he offers Ruskin a much greater recognition of the influence of variety, which Ruskin attempts to use against Alison. Burke may treat beauty as sensory stimuli, but he accepts the variety of this experience, the pleasure that seemingly irreconcilable shapes and forms equally afford the viewer. Ruskin sets himself the task of explaining this delight not in terms of the mechanics of sensation but as a hitherto hidden delight in apparent proportions.

Variety itself is not difficult to establish. Ruskin is in complete agreement with the Burkean description of "gradual variation." For example, we take pleasure in lines that continually but gradually change their angles, in curves. Straight lines are monotonous and dull, whereas angles arrest movement. Curves may be observed in the steep descent of a mountain stream, as it gradually flattens out where it meets the plain. A "curious error" intrudes in Burke's discussion, however, as he separates variation in lines from the subject of proportion. Burke, seeing that he could not "fix upon some one given proportion of lines as better than any other," supposed, Ruskin says, that proportion "had no value or influence at all." Variety, in Burke, exists independently of proportion. The

curves of a mountain stream, the outline of a bird, the curvaceous form of a woman are, for Burke, equally pleasing in their gradations of line, but are radically different in their proportions. Ruskin argues that is the same as saying that "because no one melody can be fixed upon as best" no such thing as melody exists (4:108). Ruskin locates Burke's error in a passage from an earlier section of the *Enquiry,* "Proportion not the cause of Beauty in Animals," in which Burke compares the proportions of a horse, a cat, and a dog, and concludes that, each being equally "beautiful" yet so "very different and even contrary" in form, there can be "no certain measures" that would explain their common appeal. The situation is even worse with birds, for they "vary infinitely" in their proportioning of tail to body or neck to body. Often, birds are "directly opposite to each other" (such as the swan and the peacock), yet they are all "extremely beautiful."

Ruskin replies that Burke, in seeking a constant measure that would apply to all animals or birds, has failed to observe "subtle differences" (4:109). Each of these various forms reveals a "harmonizing difference" when all the parts are considered as a whole. We should not compare a swan's neck to a peacock's, or a horse's ear to a dog's. Within each species, form is proportional. Unfortunately, Ruskin goes no further than this. He leaves completely unexplained what the proportion is. If it is not fitness, or constant measure, then what is it? He bluntly asserts that each form *is* harmonic, in which case he is merely repeating Alison's point that, in nature, proportion is simply what is familiar. Ruskin's reply is made even less convincing when we take into account Burke's analysis of a "beautiful bird" from the section on gradual variation, the very section with which Ruskin began:

> [W]e see the head increasing insensibly to the middle, from whence it lessens gradually until it mixes with the neck; the neck loses itself in a larger swell, which continues to the middle of the body, when the whole decreases again to the tail; the tail takes a new direction; but it soon varies its new course; it blends again with the other parts; and the line is perpetually changing, above, below, upon every side. In this description I have before me the idea of a dove; it agrees very well with most of the conditions of beauty.

Burke demonstrates here a refined grasp of the subtle relations of parts within a whole, and he appreciates the harmony of the gradations as each part leads to the next. His description is practically musical. But he is trying to reveal the beauty of variation, not proportion. Proportion, for Burke, would lead to a static, fixed relation of part to whole. It suggests the angular. Ruskin's denial of the harmonic quality in Burkean aesthetics is, simply, a distortion. When Ruskin adds that Burke also misunderstood the term "proportion," whose "whole

meaning" has "reference to the adjustment and functional correspondence of *in-finitely variable* quantities," he is merely substituting "adjustment" for Burke's "gradual variation." "Infinite variation," as Burke had already shown, is of the order of curvaceous lines rather than discrete parts fitted into a whole. If, on the other hand, Ruskin rests his definition on "functional correspondence," he returns, again, to Alison.

Ruskin's third objection to Burke is the most significant, for it is supposed to do away with Alison as well. When Burke says that different, even contrary, forms are "consistent with beauty," he has overlooked the "fact" that "they are by no means consistent with equal *degrees* of beauty." Ruskin equates proportion and harmony of form with "station and dignity." The "horse, eagle, lion, and man" have "better" proportions "expressing the nobler functions and more exalted powers of the animal." If this point is accepted, then we may do away with the leveling theory of constructive proportion, which sacrifices degrees of beautiful appearance for the sake of fitness.

Much is at stake in the recognition of the inherent superiority of some creatures over others, of the swan over the megatherium. We say that a lion or a swan is well proportioned because these creatures have an expressive value — let us say dignity or nobility — lacking in other, less significant creatures. "Proportion," it should be noted, has not been defined as either a concept or an abstract form, but it functions as a *representation.* Proportion is the representation of hierarchical value within the natural order. As a representation it necessarily appears, but these appearances may not be confused or reduced. If, for example, we were to compare a man to a lion, we would have to find the appropriate *proportional* relation. Man compares to lion in terms of their respective lordships over certain domains. But we would not confuse the appearance of a lion with a man to make the same analogy. Degrees of moral stature seem, finally, to stabilize the notion of proportion. Well-proportioned creatures are expressive. They unite around them various forms. They subject other creatures. Proportion thus performs the task that Ruskin had originally assigned to it: it achieves unity of sequence, or unity-in-variety. Proportion, Ruskin suggests, has the continuity of melody, but it goes a step further. As a structure that represents, it refers to concrete objects, or at least appears to refer to them.

What happens to proportion if the values upon which it has been premised are questioned or denied? To rest a theory of proportion upon an analogy with the chain of being would seem to be poor judgment, standing as it does midway between Alison's denial of the inherent meaning of form and the radical Darwinian separation of the appearance of living forms from a divine teleology. A symbolism of form that depends upon proportional value within a divinely sanctioned scheme collapses when the scheme does. At the conclusion of the 1846

text of the chapter on unity, Ruskin invokes Sir Charles Bell's Bridgewater Treatise on the hand in support of the principle that each variation in natural form has an ultimate purpose in God's design. By 1883, however, Ruskin complains that he can no longer find support in Sir Charles's arguments. In fact, Ruskin's faith was never all that secure. It always fluctuated between inner doubts raised by modern science and blind proclamations of faith drilled into him from his earliest days as a reader.

Ruskin's theory of proportion remains one of his decisive epistemological advances, in spite of its link with religion. It determines, I argue, much of his subsequent writings on the imagination, architectural ornamentation, even his speculations on pagan and medieval allegories. Ruskin continues to find in the appearance of proportion meaningful expressions. These meanings may not, following Alison, be proper, but neither are they entirely accidental. Proportion is metaphorical structure, one which intensifies cognition. It has little to do with wit or poetic decoration.

For example, in his discussion of ornamental "treatment," five years later in *The Stones of Venice,* Ruskin takes up the old Burkean example of the swan versus the peacock:

> What, then, *is* noble abstraction? It is taking first the essential elements of the thing to be represented, then the rest in the order of importance, and using any expedient to impress what we want upon the mind, without caring about the mere literal accuracy of such expedient. Suppose, for instance, we have to represent a peacock: now a peacock has a graceful neck, so has a swan; it has a high crest, so has a cockatoo; it has a long tail, so has a bird of Paradise. But the whole spirit and power of peacock is in those eyes of the tail. It is true, the argus pheasant, and one or two more birds, have something like them, but nothing for a moment comparable to them in brilliancy: express the gleaming of the blue eyes through the plumage, and you have nearly all you want of peacock, but without this, nothing; and yet those eyes are not in relief; a rigidly *true* sculpture of a peacock's form could have no eyes, — nothing but feathers. Here, then, enters the stratagem of sculpture; you *must* cut the eyes in relief, somehow or another.

(8:288)

Proportioning has become the "order of importance," emphasis rather than a strict or "rigid" formal imitation. In order to "express" the "whole spirit and power" of the peacock as a distinct form, the sculptor must abstract and exaggerate the most essential characteristic of the bird, and solve the material problem

of representing this characteristic in stone. The eyes (in themselves a metaphor) cannot be literally imitated, but in representing the eyes as sculptural relief, the ornamental peacock approximates the idea and the effect of an actual peacock. No divine value has been invoked to account for this (dis)proportional abstraction of form. We are strictly within the practical context of "treatment." Yet treatment itself is posed as a cognitive problem. The translation of the actual peacock into a symbol of peacockness falls within an epistemological theory of "How ornament may be expressed with reference to the eye and the mind." Noble abstraction must, simultaneously, represent the idea of a peacock and work effectively as an image that appeals to the eye of the viewer. Formal proportioning unites visual effect with cognitive sorting. Far from an addition to a functional structure, architectural ornament reveals the link, in Ruskin, between proportion and representation.

This discussion of the peacock grows directly out of the earlier studies of Fra Angelico, by way of Burke and Alison. In criticizing Alison, Ruskin did not exactly eliminate cognition from the consideration of proportion. In fact, he evolved a theory of how symbolic meaning is structured, how it represents the idea or the value of an object even though the appearance of the symbol may not fit the natural proportion of the object to which it refers. The appearances that concerned Ruskin in subsequent volumes—Gothic ornament, Pre-Raphaelite painting, Greek vase reliefs, Turnerian landscapes (once again)—really have little proportion, in the sense of an elegant, balanced relation of part to whole that would appeal to the eye. But they all have a great deal of condensed, organized meaning for Ruskin.

When Ruskin invokes the term "metaphor" he means the confusion, through a purely external analogy of abstract form, of two distinct objects. His emphasis on appearance, or what he was later to call the "science of aspects," restrains abstract form, subordinates it to purposeful comparisons. But these comparisons are still "metaphorical." They do not constitute proper meanings (how is a peacock noble except by comparison to a royal personage?), and they are open to possible errors of judgment. The confusion of appearance with the symbolic presentation of meaning results in erroneous references to natural objects. Symbols do not, of course, belong to the empirical realm of appearances. An ornamental peacock may express the peacock "essence," but it participates only mentally in the actual world of peacocks that may appear before our eyes. That is why Ruskin emphasizes that the symbolic treatment of a peacock is an operation of the eye *and* the mind. But types, unlike symbols, are supposed to belong to the empirical world, and it is still the type, in *Modern Painters* II, with which Ruskin is concerned. The type is a metaphor that is taken literally. It confuses "apparent" proportion with actual appearance, metaphorical structure

with empirical reality. Compare Ruskin's discussion of vital beauty, based upon the type of purity, to the discussion of the ornamental peacock.

> There are many hindrances in the way of our looking with this rightly balanced judgment [esteeming those most beautiful whose functions are most noble] on the moral functions of the animal tribes, owing to the independent and often opposing characters of typical beauty, as it seems arbitrarily distributed among them; so that the most fierce and cruel creatures are often clothed in the liveliest colours, and strengthened by the noblest forms. . . .
>
> [That moral] perfections indeed are causes of beauty in proportion to their expression, is best proved by comparing those features of animals in which they are more or less apparent; as, for instance, the eyes, of which we shall find those ugliest which have in them no expression nor life whatever, but a corpse-like stare, or an indefinite meaningless glaring, as (in some lights) those of owls and cats; and mostly of insects and of all creatures in which *the eye seems rather an external optical instrument, than a bodily member through which emotion and virtue of soul may be expressed* as pre-eminently in the chamaeleon, because the seeming want of sensibility and vitality in a creature is the most painful of all wants. . . . [B]y diminishing the malignity and increasing the expressions of comprehensiveness and determination, we arrive at those of the lion and eagle; and at last, by destroying malignity altogether, at the fair eye of the herbivorous tribes, wherein the superiority of beauty consists always in the greater or less sweetness and gentleness, primarily; as in the gazelle, camel, and ox; and in the greater, or less intellect, secondarily; as in the horse and dog; and, finally, in gentleness and intellect both in man.
>
> (4:157–59)

Proportion, in this context, cannot be called an appearance. No mention is made of the eagle's superior formal proportions compared to the owl. Rather, "proportion" means intensity of apparent energy, really brightness of eye, as, literally and figuratively, an "expression" of moral worth. Proportion is a metaphor that equates brightness with moral life, and attempts to sort out the "arbitrary" distribution of God's types of perfection in living creatures. Cruel creatures attract our eye, by their often bright colors, but, Ruskin warns, their eyes reveal a sloth and "want of sensibility" beneath their vital exteriors.

Ruskin's own metaphor—bright appearance of eye as moral indicator—is itself completely arbitrary. As Ruskin applies the metaphor over a wide range of

creatures, the supposed sorting of types results in a moral hierarchy. Within this hierarchy, "proportion" has shifted meaning from "structural emphasis," as in the ornamental peacock, to "relative appearance of gentleness in life." The latter meaning, though more arbitrary, has the appeal of direct experience. It seems to refer to actual nature. The cognitive function of proportion is suppressed. We may visualize or imagine Ruskin's argument, for it is, quite literally, an "argument of the eye" (to adopt Robert Hewison's phrase). Strangely, Ruskin's types, though they are supposed to have concrete existence, prove to be more illusory and deceptive than the peacock of stone, with its sensuously appealing, bejeweled eyes set in relief.

The figurative status of "appearance" in Ruskin's argument is finally determined on the somewhat shaky ground of visual relief. The sign, we recall, appears in sharp relief to natural objects. Lines, dots, curves must stand out, be abstract, in relation to the images depicted. The materiality of the sign contributes to its relief. We are supposed to see, immediately, that the sign is just that. But Ruskin quickly discovered that the sign, while guarding the mind against sensory deception, had the effect of floating, freely, into various, not always compatible, contexts. Abstract form was too associational. The material symbol, by contrast, has an internal organization of form, a proportion, that governs meaning, though not by direct imitation. Form is set in relief, often in a distorted way, so as to attract the eye, but the distortion calls forth a cognitive response. Appearance is not referential. It is representational. The type, however, hovers ambiguously between sign and symbol. It is a character of a natural object that suggests an "immaterial idea." The type is like an inscription. It belongs intimately to substance yet emerges as a pure idea. The form of the type may not be abstracted, nor distorted, yet it must be seen in relief. This relief is defined in terms of luminosity, as a brilliant outline relieved by shadow or various colors.

The appearance of the type is always problematic, for as it stands forth it seems to speak clearly and authoritatively to the mind. It seems to require less effort to understand than the sign or the symbol. But in fact it blinds the mind. The type enters the mind as a positive "idea," but the significance of the idea has been predetermined by a metaphor eclipsed at the moment of illumination, as in the text on the animal tribes' apparent worth. The type offers the least opportunity to question the metaphor that underlies each of the modes of signification.

The ambiguities of "appearance" point to a general problem in Ruskin's epistemology: the attempt to determine the proper relation of form to substance, eye to mind, is never free of tropological deflection. "Appearance" connects abstract lines with visual sequence, the brilliance of the life of the soul to varied outer shapes and colors, a decisive meaning to an act of seeing. None of these connections is peculiar to Ruskin. (He is clearly indebted to the philosophers he

criticizes.) What is peculiar is Ruskin's attempt to work through these connections relentlessly, only to fall into ever greater patterns of error. "Appearance," the prereflective empirical certainty of the "thisness" of a signifier—sign, object, icon—constantly occurs in Ruskin's writings, but it never prevents the intrusion of hidden metaphors into his discourse, as "apparent proportion" demonstrates. Ruskin's major blind spot seems to have been his treatment of metaphor as a strictly phenomenal error rather than a property of language difficult if not impossible to avoid. His later writings, the most metaphorically confused that he ever wrote, frantically point to historical events, contemporary behavior, industrial pollution as "living" proof of cultural death. The basic metaphor becomes so mixed that referential certainty is completely lost, though the discourse continues to invoke evil "appearances."

SHEILA EMERSON

Ruskin's First Writings:
The Genesis of Invention

But, the longer I live, the more ground I see to hold in high honour a certain sort of childishness or innocent susceptibility. Generally speaking, I find that when we first look at a subject, we get a glimpse of some of the greatest truths about it: as we look longer, our vanity, and false reasoning, and half-knowledge, lead us into various wrong opinions; but as we look longer still, we gradually return to our first impressions, only with a full understanding of their mystical and innermost reasons; and of much beyond and beside them, not then known to us, now added (partly as a foundation, partly as a corollary) to what at first we felt or saw.

Modern Painters IV (6:66)

The way to Ruskin's juvenilia almost always passes through the last book he wrote, because the revision of his youth in *Praeterita* has created much of the interest that is taken in his early writing, and because Ruskin's memories have the power to withstand the evidence (usually his own) that his past was not quite as he said it was. And Ruskin's relentless insistence in *Praeterita* that he was an entirely uninventive child—"I can no more write a story than compose a picture" (35:304), "I had not the slightest power of invention" (35:608)—has not encouraged his critics to hunt for signs of verbal originality in his first writings. Not many readers have in fact studied what Ruskin wrote before he retained "a certain sort of childishness" and was instead a child himself. The few, including Ruskin, who have read his juvenilia with care have often done so in terms of the

Published for the first time in this volume. © 1986 by Sheila Emerson.

reading to which he was "susceptible," and of which he claims (in *Modern Painters* III) that his responses were never "innocent" (5:365–67). But the focus of this essay is Ruskin's writing and his ideas about writing, and the purpose is not so much to generalize about what Ruskin learned in his youth as to lay the groundwork for an exploration of the very precise and distinctive ways in which he learned what he later taught from how he learned to write. If the Bible, Wordsworth, Scott, and Byron (to mention only some of what he studied) provide a necessary context within which to consider Ruskin's juvenilia, none of this reading can adequately account for that extraordinary "skill of language" (35:225) which was suspected before Ruskin could write and has never been denied since. His instinct to put into words what he thought and saw was at least as remarkable as any he had, and was certainly the one among them that did most to bring him to terms with the sometimes enabling and sometimes maddening world that surrouded him, to bring into relationship what he thought he was, and what he thought there was to know. If there were an Edenic beginning, however eccentric, not only to the life he describes in *Praeterita* but also to the life of his writing—a beginning full of the press and bruise of constraining circumstance but full, too, of the sense of an infinitely inviting prospect and of the incipient power to meet it—then such beginnings must be apparent here, in Ruskin's earliest works. And Ruskin, who quoted and planned to reprint some of his first writings at the end of his working life, seems to have felt that to find such beginnings, and to find them telling, his readers have only to look.

ANIMATION AND INTERRELATION

When we look at the first letter Ruskin composed, we may be disappointed to find that it is written in his mother's hand. And yet Margaret Ruskin's hand in the matter is not uninformative, and not merely because she explains to her husband, on the page below, that she has just transcribed "exactly word for word" what their son "pretended to read" from "scrawling" she thought too indecipherable to send as requested (Burd, 127–29. This and all subsequent letters are quoted from volume I of *The Ruskin Family Letters: The Correspondence of John James Ruskin, His Wife, and Their Son, John, 1801–1843*, edited by Van Akin Burd [Cornell, 1973]). For the punctuation and paragraphing in her own letter are only slightly more orthodox than in her transcription, or in the letters he will soon be writing for himself. The point to be taken is not that Margaret Ruskin was inappropriately skeptical about her son's (or complacent about her own) editorial skills, but that she was rightly confident that her meanings—irregular punctuation notwithstanding—ought not to be in doubt. And this confidence bears a family resemblance to Ruskin's own. No one was clearer on this

point than Ruskin, whose famous acknowledgment of his mother for "the one *essential* part of all my education" concerns her instruction of his ear rather than of his eye, her teaching him to sound the sense of a Biblical chapter rather than to make visible his own meanings through a series of markings of his own paper (*Praeterita,* 35:40–43). In another of Margaret Ruskin's cover letters written six years after the first, her conviction that what is properly pronounced will eventually be properly attended to is implicitly part of the behavior of the son who, "you will be aware . . . not know there is any difference in putting things on paper from saying them" (Burd, 172).

But for all its relationship to his mother, the letter Ruskin first dictated at the age of four is signally his own, and in no way more so than in its extraordinarily precocious grasp of interrelationships. This grasp is so marked that the adult Ruskin might well have owned the letter with the same proprietary amusement that led him to annotate "My First tree! from nature, 1831 (J. R. 6th Jan. 1884)," or a letter and two poems written when he was eight "as evidently the first sketch of the Moral Theory of his work (36:562). It may of course be just fortuitous that the description of a child's model of Waterloo Bridge should open the first letter of the man who would celebrate the intellect involved in the building of a bridge (*The Stones of Venice* I, 9:66–67), and who would elaborate an argument "On Composition" whose third law, "The Law of Continuity," is illustrated with reference to bridge designs that not only relate the shores to the water and to each other, but also interrelate the varying constituents that make a bridge Ruskin's model of continuity in the first place (*Elements of Drawing,* 15:170–76). But what is not fortuitous is the way that Ruskin assembles sentences that begin with the assembling of his toy bridge:

Dear Papa
 I love you — I have got new things Waterloo Bridge — Aunt brought me it — John and Aunt helped to put it up but the pillars they did not put right[,] upside down instead of a book bring me a whip coloured red and black which my fingers used to stick to and which I pulled off and pulled down — tomorrow is sabbath tuesday I go to Croydon on monday I go to Chelsea papa loves me as well as Mamma does and Mama loves me as well as papa does —
 I am going to take my boats and my Ship to Croydon I'll sail them in the Pond near Burn which the Bridge is over I will be very glad to see my cousins I was very happy when I saw Aunt come from Croydon — I love Mrs. Gray and I love Mr. Gray — I would like you to come home and my kiss & my love

 JOHN RUSKIN

If Margaret Ruskin knew how easy it is to misassemble phrases one is only pre-
tending to read, her son could make out that his elders had misassembled their
parts too. His model bridge was so well made, and Ruskin had so thoroughly
analyzed the structural principles that went into its making, that he remembered
sixty-two years later that "I was never weary of building, *un*building, — (it was
too strong to be thrown down, but had always to be *taken* down) — and rebuild-
ing it" (*Praeterita*, 35:58). At that time, Tuesday may have seemed too exciting
to put in its proper place after Monday, and the colorful prospect of a new whip
might have come between the memory of pillars and the fingers which could
bring them down. Even so, the elements of his sometimes "upside down" letter
are, like the bridge which it is about, basically sound enough to be reorganized
into a more serviceable structure — especially by a boy who not only liked to
match the days of the week with their appointed duties, but who showed such
aptitude for rendering geometric ratios out of the experience of familial interre-
lationships. "[P]apa loves me as well as Mamma does and Mamma loves me as
well as papa does": the sentence is balanced satisfyingly on the son in his parents'
midst (a balance which remains untipped by Mamma's capitalization of herself).
Yet the engineering of it is still less accomplished than in the sentence where the
four-year-old imagines himself in Croydon. In this letter so full of feeling for
connectives, a bridge once again makes an appearance near the end, buttressed
this time by a relative pronoun and prepositions which deftly dispose the Pond
and the Burn and the Bridge in syntax that repeats their remembered relation-
ship in space. Far as his phrases have ranged geographically, they are shaped by a
persistent impulse to mark or to make both physical and emotional interconnec-
tions. "[T]he signature," as Margarent Ruskin said, "you will see is his own."

It is much the same signature as in works done three or four years later en-
tirely in his own hand. Ruskin appears to have been helped by no one in produc-
ing his earliest surviving drawings, although he must have helped himself by ex-
amining what other people drew, much as he helped himself to write by using
what he read and heard. This quite ordinary instinct to learn from what has al-
ready been done was distinctively compounded in Ruskin's case by his having
learned so many things, and by his having chosen to make drawings of what he
wrote, and to describe in prose and poetry the subjects he had drawn. By the
time he was twenty-one, he was fluent enough in translating from one medium
to another to say, in recalling his own education, that "In Drawing only, I
learned by *grammar* thoroughly" (36:21). The "grammar" of the untutored
seven-year-old displays itself not only in the writing of his *Harry and Lucy* but
also in the picture of "harrys new road," which was designed to illustrate it and
which Ruskin redisplays in *Praeterita*, thinking it "my first effort at mountain
drawing" (35:52–56). In it the arrangement of mass is coordinated not only with

the small lines which give it texture and direction, but especially with the sinuous line of the road, which interweaves the sections it divides. It is the road which defines the contour and structure of the mountain, which suggests the continuity among discontinuous masses; and its winding, in *Praeterita,* across a page reprinted from *Harry and Lucy* brings out its relationship to the writing from which the child had removed it in imitation of the look of separate "copper plates." For the progress of this road from one level to the next is a smoother realization of one of the impulses behind the rather jolting prose passage — "this piece of, too literally, composition" (35:55) — in which an "electrical apparatus." clouds, and dust give way to lightning and then to rain, a rainbow, and a mist which Harry's "fancy soon transformed into a female form." In calling his excerpt "an extremely perfect type of the interwoven temper of my mind" (35:56), Ruskin refers to the derivation of its subject from *Manfred* and Jeremiah Joyce's *Scientific Dialogues* (1809), and of its format from Maria Edgeworth's *Frank* and *Harry and Lucy.* But as the drawing suggests (and Harry had been drawing when Lucy pointed out the storm cloud), this interweaving is characteristic of the grammar as well as of the genesis of Ruskin's story. Comparison with the original paragraph in *Scientific Dialogues,* which Ruskin has taken care to quote in a footnote to *Praeterita,* shows how the child adapted the actions parceled out into separate sentences by Joyce, and ran them together into a continuous sequence — except, significantly, when it came to one atypically complex and intervolved movement, which Ruskin found attractive enough to appropriate almost unaltered, only substituting "sky" for the final word: "a flash of lightning was seen to dart through the cloud of dust, upon which the negative clouds spread very much, and dissolved in rain, which presently cleared the atmosphere." In dropping all the commas Ruskin brings Joyce's grammar into line with his own, and gives expression to his pleasure in the way things run together.

In another illustration made for the same volume, "harrys river" repeats, in the foreground, the double, progressively deepening bend that "harrys new road" makes around a mountain. The river cuts across the center rather than the edge of the terrain, again and again curving out of sight over the borders of the drawing as it sweeps from side to side down the page. As in "harrys new road," it is a circuitous line that defines both the declivity and the edges of the landscape whose elements it draws together. These elements most prominently include two peaks which appear to rise out of the land rather than being (as in many children's drawings) set down upon it — an effect which the artist enhances by wittily exposing a glimpse of the river behind at a height which shows that it did not, and could not, flow over the land that connects them. And this stretch of land in between is as carefully and continuously rounded as is the top of each peak, as is the river which sets them in relief. It is the curves which give to the

still life of Harry's road and Harry's river an implication of progression, of move-
ment. It is not surprising that when Ruskin drew his "First tree! from nature" he
chose one whose bending trunk and (rather relentlessly) sinuous branches relate
the parts to a unified, and animated, whole.

An interest in animation is also obvious throughout the whole of what may
be his first attempt at poetry. Ruskin's attention in this verse to subjects and
modes that will engross him in the future is no more remarkable than the verbal
energy, facility, and self-consciousness with which he explores them as a child.
Neatly printed on the page facing the conclusion of Harry's adventure with
lightning and electricity, "poem I" shows off a readiness with complex intercon-
nections that is astonishing in a seven-year-old:

> when furious up from mines the water pours
> and clears from rusty moisture all the ores
> then may clouds gather then may thunder roar
> then may the lightnings flash and rain sigh [sic?] may pour
> yet undisturbed the power alone will raise
> the water from the engine might be formed a phrase
> when as it drags the weight of fragment large
> it also drags the weight of smokey barge
> called by us a steam boat and a steam boat saves
> the beings scattered on the furious waves
> by boilers bursting but a steamboat can
> be the most useful engine brought to man
> the grinding stones that by its force are whirled
> and by their force the yellow grains are twirled
> Bruised ground and thrown away in boxes small
> While it doth thunder near the echoing wall
> The whirring wheels arranged in whirling rows
> And on the wheels the spinner cotton throws
> Next moves the noisy beam the wheels do whirl
> And next the wheels the cotton fibres twirl
> The moving bellows that are made to roar
> By its huge strength that melt the red hot ore
> The copper mines that by it emptied are
> And their blue metal now is brought from far
> then it puts forth its power the rollers squeeze
> the metal then another part doth seize
> the flattened metal quick flies the circle round
> And all is stamped at once Brittannia and the ground

then showers the water from the reservoir
and round the town it rushing now doth pour
then runs to cisterns large and fills them all
and turns back homeward in quantity but small
then forms the lengthening and putting link to link
makes a small chain and leaves of that flower the pink
 and so I end
 (quoted from "John Ruskin's 'Harry and Lucy,
 Poems, etc.,'" by permission of the Beinecke
 Rare Book and Manuscript Library, Yale University)

The opening lines follow the "furious" upward flow of waters mechanically raised (as opposed to the natural downpour of a storm), and they come full circle when the engine's "power alone will raise / the water" again at the beginning of the sixth line. Much as the basic machine may be compounded to perform various functions, the word for it may also be combined with another and "from the engine might be formed a phrase." Ruskin's double consciousness of words and things (simple enough here but destined to become deeply complicated) now ramifies into an evocation of the compound "steam boat" as both a destroyer and preserver, as a machine which gathers those whom it has "scattered" on waters which, like those at the outset, are said to be "furious." The workings of the steam engine seem less dangerous but remain reciprocal, cyclical, when harnessed on dry land; and Ruskin's precision of diction and vigorous enjambment — almost half of the rhyme words are verbs — work to create a simulacrum in verse of the chain reaction in which "yellow grains" are "twirled / Bruised ground and thrown" by "grinding stones" that are themselves "whirled" by the force of the engine. The vertiginous medley of responses which the machine sets into play is matched by the virtuosity of a child who can conduct alliteration so confidently that sound is both related to and differentiated from the action which produced it: it is easy to see why even Ruskin's painstakingly accurate editors could have silenced his subtly orchestrated "whirring wheels arranged in whirling rows" when they transcribed them as "whirling wheels arranged in whirling rows." The "roar" of bellows subsequently sounds the recall of the "ore" that Ruskin has rhymed with it in the second line. Only instead of being put through a purgative rinse the metal is now subjected to that paradoxical operation by which a rounded object renders another one otherwise — an operation that caught Ruskin's interest earlier (when rotary action wound up emboxing what it ground, and wheels within wheels at length drew out what they had run circles around), and will again later (when "the circle" controls the stamping of a label flat on pieces of copper). Everything turns on circuitous shapes — not only

the engine which drives the waters to circumnavigate the town but also the poem, which turns "back homeward" with them, where their "small" flow can still be adapted to the "small" concerns of domestic gardening. And thus the verse which begins "when furious up from mines the water pours," and whose "lengthening" depends on the child's "putting link to link" in imitation of the sequences the engine sets in motion, at length comes to rest in the contemplation of a little flower. The pink might seem to displace all the sound and fury on which its life depends; but "having," as Ruskin would say forty-six years later, "their stems jointed like canes" (21:240), the very structure of the plant replicates that additive "chain" of events which the poem both refers to and repeats. "And so I end" with this final link between humanly controlled energy and the God-made nature it derives from and serves. It is what the adult Ruskin would often define as the end of progress.

The poem in itself partakes of the form of a riddle, as do several dialogues inset in the preceding volume of *Harry and Lucy*. Thanks to circumlocution, the steam engine is never indicated by name; by its action, you will know it. The child makes no connection between the evaporation-condensation-evaporation cycle of a compounded steam engine, and the way that, in his poem, what waters a flower in the end flows back, in the memory, to the waters that pour through the beginning. But the syntax and versification attach themselves to and capture the transformations of matter wrought within the larger cycle. The punctuation superadded after Ruskin's death disguises his having bound his phrases each to each, and jams their movement back and forth in the mind. The poem is not, as his editors suggest, "as difficult to follow as most clever children's stories," but more so, for the problem is not that "the links in [the] train of thought are never supplied" but that they connect, as supplied, and as many organic links do, in two directions, on two sides, at once. What makes the poem on the steam engine so difficult, and so amazing, is that it aspires to the ambiguity of interaction in which connections are everywhere, and every ending is arbitrary.

The second poem in the *Harry and Lucy* volume, "on scotland," is far less ambitious. Instead of the transforming animation of its subject (which is here subdued to a matter of dropping water and popping fish), the motion is supplied by the traveler who takes in the changes in terrain as he passes from one part of the country to another. "Spring," copied out into a section labeled "poetry discriptive" [*sic*] in another notebook, elaborates a contrast between "waving" things that bloom in orchard and garden and those less fortunate "stiff" ones which are compensated with height or beautiful flowers. This poem is the second of two that Ruskin recopied in a letter to his father in May 1827 which he passed on to his friend Charles Eliot Norton with the comment, previously

quoted, that it was "evidently the first sketch of the Moral Theory of his work by the great author of 'Modern Painters.'" But it wasn't only in the hindsight of 1869 that he saw something germinating there: during a trip to Scotland in 1853 Ruskin wrote to his father that the landscape was "putting me in mind of my baby verses" (12:xxi), and he quoted the last four lines of the other poem he had first sent to his father in 1827:

<div style="text-align:center">

Wales

That rock with waving willows on its side
That hill with beauteous forests on its top
That stream that with its rippling waves doth glide
And oh what beauties has that mountain got
That rock stands high against the sky
Those trees stand firm upon the rock
And seem as if they all did lock
Into each other; tall they stand
Towering above the whitened land

(Burd, 158)

</div>

In 1853 Ruskin supposed that he had "meant the rocks looked whiter by contrast with the pines — a very artistical observation for a child" (12:xxii), but what is more artistical, and what probably locked the lines in his memory, is the way they interlock with each other just where their subjects do. When the great author of *Modern Painters* comes to lecture on the vital interrelationship among things, he will make it clear that their interrelationship is a sign of their vitality, and that they are vital in his sight partly because they are interrelated. And it is his nascent sense of these truths that vitalizes the verse of the eight-year-old as he tries to represent their effects in words and rhyme and meter. The elements of the scene are so ordered that their individuality, and position in life, are at once precisely delineated and shown to depend, in their fulness of aspect, on what is nearby. After these elements are firmly characterized in the first four self-contained, alternately rhyming lines of iambic pentameter, the unrhymed (yet internally rhymed) fifth introduces both a change to more swiftly pronounced tetrameter and the sky against which everything stands that is locked into the subsequent pair of couplets. Even a detail like the small "a" which begins line 6 of the fair copy suggests Ruskin's eagerness to move the reader's eye continuously along the enjambment and the continuities which it represents without blurring, without confusion. And the distinction of such a detail is no more answered for by generalizations about the influence on the child of Wordsworthian intercommunion, than an awareness of Carlyle's Mechanical-Dynamical argument

can answer for the fine points of a poem on the stream engine written three years before the "Signs of the Times," to which it can indubitably be related. For the question is not whether the spirit of the age made its way into the drawing-room niche where the child was "shut . . . well in" behind a "good writing-table" (35:61), but what Ruskin made of it once it got there.

Appearing in the "poetry discriptive" collection just after "Wales," "The hill of kinnoul" also dwells on river, rock, mountain, and trees, but the grouping is complicated now by the phenomenon of reflection. The River Tay not only winds around the objects of Ruskin's attention (as in the drawings of Harry's road and Harry's river), but also mirrors what it flows beneath, so that the "high topped trees" are at once "above below" (quoted by permission of the Beinecke Rare Books and Manuscript Library, Yale University). By moving his body, or merely his eyes, the viewer can alter the appearance of what he sees, and set it into the motion of a narrative, creating that apparent animation taken on by a series of scenes when it passes rapidly before the eyes, or through the memory. No sooner does he sight "the glass tay" than he recalls seeing it when it was not "quite so smooth"; no sooner does he depict a rock rising from the river's surface than he gives the order to climb it and look down on the dizzying height from which the Tay "appears like a little rivulet . . . /dwindling into nothing mong / the distant mountains." That sound as well as sight can evoke and depend upon the position of those who respond to it is demonstrated in "Highland Music," which Ruskin presented to his father instead of "a small model of any easily done thing." With its awkward but deliberate preference for coordinating rather than the subordinating structures he has already mastered, this poem about a sequence of sounds and silence models Ruskin's awareness that poetry is itself a composition of sounds or writing that defines an experience as it occupies and develops in time. It is, not surprisingly, in her next letter that Margaret Ruskin is certain her husband "will be aware that John does not know there is any difference in putting things on paper from saying them" (Burd, 170–72).

Perspectival changes, and the ways that physical moves can seem to activate a subject and render it audible, fascinate Ruskin again in a poem in which the first pair of imperfectly rhymed lines (9–10) end with the words "far" and "near." Ruskin reprints it in *The Queen of the Air* (1869), commenting that "It bears date 1st January, 1828. I was born on the 8th of February, 1819; and all that I ever could be, and all that I cannot be, the weak little rhyme already shows" (19:396).

Glenfarg
Papa how pretty those icicles are
That are seen so near that are seen so far

Those dropping waters that come from the rocks
And many a hole like the haunt of a fox
That silvery stream that runs babbling along
Making a murmuring dancing song
Those trees that stand waving upon the rock's side
And men that like spectres among them glide
And waterfalls that are heard from far
And some in sight when very near
And the water-wheel that turns slowly round
Grinding the corn that requires to be ground
And mountains at a distance seen
And rivers winding through the plain
And quarries with their craggy stones
And the wind among them moans
(quoted by permission of the Beinecke
Rare Book and Manuscript Library)

Once again Ruskin's scene is variously yet interrelatedly animated — waving, winding, turning round; even its sounds are the sort — babbling, murmuring, moaning — that are usually continuous. But Ruskin's being animated to write by the animation he regards has a new dimension in "Glenfarg," a dimension opened up not only by his choosing to keep his distance or to come in for a closer look, but especially by his interweaving his own activity with the activities that he notes. "And waterfalls that are heard from far / And come in sight when very near": the approach seems equidistant, mutual. The child drops himself out of the picture after pointing out its prettiness; but his movements in verse dramatize nature's own.

It is what Ruskin takes to be the anima in and behind "Glenfarg" that moves him to cite it in *The Queen of the Air*, just after insisting that his own "art-gift" derives "from the air of English country villages, and Scottish hills." The poem is unmarked by the kind of animus that actuates the earlier "Glen of Glenfarg" (1826), in which the inertia and activity of the landscape are a sermon to higher creatures to keep striving upward in accordance with God's plan. His New Year's address to his father of January 1, 1827, develops this moral imperative to move on into a self-delightingly grotesque play on the quick and the dead. In "Papa whats time" it is not now a question of the interlocking elements of the landscape but of "the quick course of time" relentlessly speeding minutes into hours, and hours into days, and days into years — and "past times gone for ever so he has a lock / of hair upon his forehead and the proverb is / take time by his forelock" (Burd, 150–51). This keen feeling for one thing's giving way to the

next informs the composition of "On Skiddaw and Derwent Water," Ruskin's first piece of published writing. Appearing in 1830, and written in 1828 about scenes he saw on a tour to the Lakes in 1826, the printed text differs from both the 1829 fair copy and the original draft. But all three versions share an opening in which the yielding of sunshine on the cliffs to a cloud, and of the cloud to the returning sun, is a prelude to "fancy's play" in which clouds resemble unmanned implements and architecture of war which appear to chase what precedes them and then to be chased off in their turn. Derwent Water's being "a looking-glass" is the occasion not only for a conventionally picturesque set piece in which nature has "painted" and "framed" a couterpart to the original, but also for the implication that the image held by reflection can be released into action by it too. The mirroring surface is likened to a boy who builds a snowman, only to "play / At tearing it to pieces":

> Trees do first
> Tremble, as if a monstrous heart of oak
> Were but an aspen leaf; and then as if
> It were a cobweb in the tempest's blow.
> (2:266)

Upon reflection, the aspect of nature takes on new activity, new life. Earlier poems like "The hill of kinnoul" and "Glenfarg" demonstrate how physical movement in the landscape is related to physical gestures of the viewer; "On Skiddaw and Derwent Water" suggests that it is not simply a change of position that can set things in motion, or seem to, but also a change of mind.

> Thus like Penelope thou weav'st a web
> And then thou dost undo it.

By the time he was ten years old, this aspiring poet for whom writing was a favorite form of play had thoroughly understood how the "play" of a reflective surface could be like "play" in the snow of just such a boy as himself, and like "fancy's play" with the position, and disposition, of the objects of sight. To take things to pieces (whether in fact, as with a model of Waterloo Bridge, or in analysis, as with the operation of a steam engine, or a lake) is not just to see how they work but also to give oneself an opportunity to reassemble them again, showing other people how they work. And every assembly is a sequence in time and in space of elements that may be as distractingly varied as they are satisfyingly related, and as diverse in their contours, and continuities, as they are coherent in one's own imagination.

"LAWS OF MOTION"

Capacities like those which Ruskin discovered as a boy were involved in

assembling some of the major Victorian novels, but what has been called his only attempt to write a novel comes to a stop after two chapters and the Shakespearean epigraph to a third: "'What am I, sir? nay, what are you, sir?'" (1:551). In considering *Velasquez, the Novice* (1835–36) Ruskin's editors are indulgent about his not being a novelist, and refer the reader to one of the many moments in *Praeterita* when he affirms that since his childhood he has been patiently observant, methodically analytical, and incapable of composing a design or a story (l:lv). But neither Ruskin nor his editors convey an adequate sense of the remarkably full and subtle awareness he showed as a boy of the issues involved in composition—issues raised for him by fundamental questions about what to write and how to write it; about how to start and continue and attach part to part in the meantime; about how to accommodate the range of his interests and to bring them into line with his strongest motives; about what to make of the relation between a subject and his responses to it, and between his thoughts (once he has them) and their almost instantaneous expression in language.

These issues begin to be considered in his earliest letters. From the time he was ten, Ruskin puzzled over and protested his needing a subject in order to be off and writing ("Well then to begin, but what shall I begin with, I dont know"); yet he was quick to recognize ("It really is singular how one makes substance out of nothing") that the want of a subject is itself a subject, or at least the beginning of one: "I think I have been writing about writing about nothing as I have been writing a poem upon the want of a subject" (Burd, 191, 175, 252). He founded not one but several poems upon this subject, which preoccupies him in the beginning, and in the midst, of letter after letter. Of course these writings might be considered in terms, or as proof, of Ruskin's claims in *Praterita* that he entirely lacked invention. But there is often invention in the ways that he meets the sense of something missing in his equipment; and, more importantly, there is often something present that he prefers to working up a subject "'out of [his] head'" (*Praeterita,* 35:75). Ruskin's experience with his drawing master, carefully detailed for his father, is a case in point. Although the adult Ruskin complained of Mr. Runciman that he "gave me nothing but his own mannered and inefficient drawings to copy, and greatly broke the force both of my mind and hand" (35:76), the boy of thirteen meant it (and possibly meant to double his words) when he said that in "drawing drawing [*sic*] there Im comfortable again" (Burd, 258, his interpolation). At any rate, it was a new and significant departure when Ruskin was first directed by his teacher to invent his own subject:

> I now proceed to communicate important information respecting my lessons. . . . Well I took my paper & fixed my points, & I drew my perspective, & then as Mr Runciman bid me, I began to invent a scene; you remember the cottage that we saw, as we went to Rhaidyr

Dhu, near Maentwrog where the old woman lived whose grandson went with us to the fall, so very silently. I thought my model resembled that so I drew a tree, such a tree, such an enormous fellow, & I sketched the waterfall, with its dark rocks, and its luxuriant wood, and its high mountains, & then I examined one of [his cousin] Mary's pictures, to see how the rocks were done, & then another to see how the woods were done, & another to see how the mountains were done, and another to see how the cottages were done, and I patched them all together, & I made such a lovely scene. Oh I should get such a scold from Mr Runciman, (that is if he ever scolded).

(Burd, 262–63)

On the contrary, when Ruskin eventually showed him the drawing and "told him how I had patched it up, . . . he said that that was not copying" and decided his pupil was ready to begin painting with color. And what excited Ruskin about painting as opposed to drawing was not that it would allow him to be more inventive with distant or wild scenery, but that it would allow him to be more veracious:

how much superior painting would be, if I wanted to carry off Derwent Water, & Skiddaw in my pocket, or Ulles Water, & Helvellyn, or Windermere, & Low-wood, Oh if I could paint well before we went to Dover I should have such sea pieces, taken from our windows, such castles & cliffs—hanging over the ocean, And ships on those waters, in heaving commotion. There would be a night scene, with the waters in all the richness, of Prussian blue & bright green, having their nightly billows crested, with Reeves best white, & the sky above, a very heaven of indigo, with the moon, & attendant stars, pouring their bright rays upon the golden waters, in all the glory of Gamboge . . .

(Burd, 267–68)

As usual the prospect stimulates more than one of his favorite activities, and he falls quite naturally into geography, rhyme, and artistic techniques for producing effects from their causes. In the meantime, the boy's sense of getting away with something uninventive and naughty has yielded to his finding himself in possession of a subject which will do his talents justice, and to which he wants to do justice. The command to compose a drawing, like the self-imposed command to compose a letter, brings him self-consciously face to face with the question of what there is to compose: in discovering the connection between a

subject and thinking about a subject, Ruskin discovers that a composition may be an arrangement of things that preexist their arranging. This recognition, and his finding a vocation in *Modern Painters* as a critic of the words of God and man, are separated by the experience of about ten years; but even in 1832 he is already his own critic, who knows that his lack of one kind of subject is his access to another which suits him better. The poem of 1831 which begins "I want a thing to write upon, / But I cannot find one," concludes, ten stanzas later, with a new insight into his uncooperative muse:

> And lest she urge her airy flight
> From my so drowsy brain,
> Upon no subject I will write,
> That so she may remain.
> (2:321)

The resolve is emancipating. As an Oxford undergraduate, full of his first major successes as a critic, Ruskin tells his father, "I dislike having things to tell—I would rather write about nothing, so I shall write again soon—less laconically" (Burd, 499).

Once begun, "Composing gets on too amazingly fast" (Burd, 227)—particularly in a letter written when he was ten in which he says he is bombarding his reader with the subjects which have fought with him and each other for his attention. The martial images he adopts in describing this competition are in fact less appropriate to his response to it than are some lines from the poetry of Bishop Heber, who provides the main subject of his letter: "I suppose you know that when I repeat a line of poetry that I am much taken with I involuntarily keep repeating it the whole day my Rhyme today is ["]I see them on their winding way, About their ranks the moonbeams play &c.["] . . . After all I shall not get what I have to say into this letter." Under the circumstances, the certainty of failure doesn't concern him very deeply:

> by the by my discourse is not a regular one it is irregular. . . . I
> believe my discourse has a conclusion, and a beginning too though
> that is not mentioned among the learned terms of Rhetoric. . . .
> but to return to bishop Heber—The original port from which I set
> out and wandered over the world of Rhetoric. And yet I think that
> world is rather too large to let me wander over it in a few minutes
> though it may be something smaller than that province over which
> bishop Herber . . . of calcutta travelled. But pull up, pull up*
> observe this asterisk papa. What off at full gallop again, check,
> check, take care, pull him not in too suddenly. He's a capery fellow

that, gently, let him have some of his own way, turn, thats it, thats
it, now back, back, not too fast, not too fast, take care, Ay ay, that
it, come away gently, gently, Ay now. . . . [*] only a wee bit
metaphor papa I found myself galloping off from the subject[.]

<div align="right">(Burd, 193)</div>

He writes about writing here as if it were a mode or vehicle of progress which has
a will of its own but is also controlled by Ruskin's will to have "some of his own
way." Instead of resisting he authorizes his impulses to play themselves out,
enacting movements of mind and subsequently of pen which seem to answer to
the behavior of his subject, as if they rhymed in and of themselves, or corres-
ponded to each other like two sides of "the quadrilateral plan" of his dominant
interests (*Praeterita*, 35:120–21). And while his language is charged, and over-
charged, with the implication of its being a direct translation from the terrain
that he sights, Ruskin's writing is also its own terrain:

you would be overdone smothered under a mountain of words and
of rhymes also if I wrote more. Oh you will groan under the weight
of lines the sea of rhymes which I shall load you with on your return.
. . . But I shall not make you quite overburdened for as fast as I
load you with mountain after mountain heaped gigantic I shall
lighten you of your money Hurra Forty lines per day regularly as
the sun goes down. We were very much delighted when we heard
your intention of going to Dover. . . . now we shall cut right up by
Bath and Bristol and so into Wales Oh we shall have such fun such
delightful walks It will be expensive I shall be sure to make a poem
of it. Steamboats dashing, Paddles splashing, Coach a going, Horn a
blowing, Such a bustle, Crowd and tustle, Engines fizzing, Steam-
boats whizzing, Oh gloriosities, Such curiosities, Hop sa sa Fal lal
la—Oh I shall make such a collection of shells Univalves bivalves
mutivalves and sea urchins O papa we are making you out
such a tour in Wales We have dragged you over bridges
. . . over chasms some hundreds of feet deep with torrents roaring
at the bottom, over mountains which seem to have a mind to make
war with the stars over over over I am lost in the wilderness of
wonders in the ocean of overs
 I write regularly a page of Clarke['s Latin grammar] as you
desired me One thing puzzles me a little When you say Anger will
hurt me more than injury do you put the Adjective or the Adverb
More if the Adjective what case do you put it in.

<div align="right">(Burd, 220)</div>

He draws no more attention to the pace of his subject than to his keeping pace with his thinking about it: once the impulse is taken from his father's traveling, or from Bishop Heber's mount, the Pegasus to whom Ruskin is fond of referring in his letters breaks into some sequacious prose that not only follows the sequence it regards but also regards itself in the act of following. It is the element of self-reference in this prose written in propria persona which makes explicit a connection only implicit in Ruskin's poems and stories between what he takes to be the continuous movements of his own mind and those of the world that is not himself. And as his verbalized thoughts run on continuously, like their subject matter, Ruskin begins to see that they are themselves internally composed and interconnected in ways that can be transferred intact onto paper, like the design of a road or river, or the sequential operations of a steam engine. This is why Ruskin's discourse is no sooner said to be irregular than it is affirmed as an eventual course toward his desired destination, for the wilfully "winding way" of his writing can provide Ruskin with a sense of expressive accomplishment even in passages where "I found myself galloping off from the subject." In the exuberant didacticism of these early letters—"think," as Ruskin pedagogically puts it, "(and in the thought find teaching good)" (Burd, 291)—the sense of an affinity between the behavior of his subjects and of his own responses to them develops into a principle of composition, a principle which links the composition of his prose to that of the spectacles it seeks to represent.

So that if "Composing gets on too amazingly fast," it is at least in part because being watchful of what comes to him, or of what he comes to next, doesn't simply deflect the pressure to invent his subjects but also suggests to him that they can be represented as, and as rapidly as, they have presented themselves to him. Not that he pretends his letters are unpremeditated, or unaltered once they are written. Although he can draft a letter very fast—"as fast I think as I could speak it," says his mother (Burd, 270)—he is eager to show his father how much forethought goes into what he writes: "letters are of such importance that I always slate them first" (Burd, 235). Among the things he considers in advance, and records his consideration of, are the styles in which he might compose his subjects, having learned from looking, reading, and especially from his drawing masters that a given subject may be approached in various ways, and that it makes a difference in the results when he has found what he calls, in a verse letter, "a style and metre that looked knowing" (Burd, 294). And like the readiness of his rough-drafting, Ruskin's drawing attention to his preliminary choices sometimes makes him seem more expressive than he has thoughts to express. Yet the distinction only serves to deepen the connection between the enumerated things that occur to him and the innumerable actions by which he modifies and makes use of them. As in the beginning of the section in *Modern Painters* III where he explores his childhood feeling for landscape, Ruskin's observation of

his own mental moves discloses not only the elements they negotiate between but also a suggestion that the mind and its objects — the movement of the one and the fixity of the other, or the animation of them both — are somehow bound together:

> though there is much work to be done in the world, it is often the best thing a man can do, — to tell the exact truth about the movements of his own mind. . . . The first thing which I remember, as an event in life, was being taken by my nurse to the brow of Friar's Crag on Derwent Water; the intense joy, mingled with awe, that I had in looking through the hollows in the mossy roots, over the crag, into the dark lake, has associated itself more or less with all twining roots of trees ever since. . . . Only thus much I can remember, respecting [this gift of taking pleasure in landscape], which is important to our present subject.
>
> First: it was never independent of associated thought. Almost as soon as I could see or hear, I had got reading enough to give me associations with all kinds of scenery I also generally knew, or was told by my father and mother, such simple facts of history as were necessary to give more definite and justifiable association to other scenes which chiefly interested me.
>
> (5:365–66)

This prose of 1856 confidently entwines into a single passage the twining roots and the inalienable associations which clung to what he saw, and goes on just as confidently to insist that as a boy he elaborated plenty of reflections and fancies about nature but never invented any himself (5:367). His account of this elaboration — like the result of focusing on Ruskin's writing rather than his reading — suggests that his retrospective denials of his own creativity are crucially related to his valuing his ability "to tell the exact truth." In the 1820s and '30s, Ruskin is more proprietary about the ideas he expounds, and less purposeful as he feels his way in prose; but even so elementary an exploit in language as the "wee bit metaphor" he produced when he was ten gives evidence of some confidence that the analogies which he makes can be treated as if they are not merely private fancies, provided one goes deeply enough into one's subject and one's own responses to it, or gives them room enough to grow in.

But if it requires a free rein to follow the mind's pursuit of its interests, Ruskin has also discovered that the burden of having too much space and too much time when he was at a loss for a subject has now been replaced by the frustration of having too little of either. "I believe you will find that in most of my former letters, the great subject is want of time" (Burd, 263). And since "time is,

in fact, just as we feel it" (Burd, 279), Ruskin continually experiences time as space that is too small ("a little spare scrap of time" [Burd, 353]), as well as finding space insufficient in itself: "I have had more to do than I could do without all possible cramming and ramming and wishing days were longer and sheets of paper broader, though that is a wish which has nothing to do with time." The constraint does have its incentives and compensations. In addition to his certainty that "in common things it is having too much to do which constitutes happiness and too little unhappiness" (Burd, 200), Ruskin's feeling "forced to write . . . as it were by inches" (Burd, 325) contributes to the pleasing conclusion that his meandering lines of prose may be counted as a composition, a work which occupies space and time like the lines of verse which he carefully numbers and amasses, or the drawings which he executes inside boundaries that define or contain them. And it is in those letters which he regards as compositions that Ruskin most clearly affirms his attachment to the manner of writing which not only cleaves most closely to the movements of his mind, but is also the mind's best solution to the problem of how to make his surface hold all he has to say. For Ruskin's insistence on drawing out his lines of thought is precisely what makes a habit out of his attraction to the "winding way"—admittedly attractive in itself, like the serpentine or undulating double curve which Hogarth, and Ruskin's drawing master J. D. Harding, celebrated as "the line of beauty"; and arguably appropriate to retracing many favorite courses of study; but most welcome for its expanding the amount of ground he has to cover within the perimeters of any given subject. "[E]very curve divides itself infinitely by its changes of direction"; like the gradations of shades and colors, the curvature of lines "is their infinity, and divides them into an infinite number of degrees." These axioms do not appear unto *Modern Painters,* where Ruskin's assertion that the visual and the verbal arts are governed by the same laws suggests a relevance to his own prose of his claims that curves are always more beautiful than straight lines, and that almost all natural forms are composed entirely of curves. (4:87–89). But some of the experience from which he derives these arguments and their adversarial fervor is already evident in his boyhood remarks, and in the figures cut by his circuitous letters as they proceed amidst his cousin's and especially his mother's complaints that he is going on too aimlessly in his writing, and too long.

Ruskin records these complaints not only because he is a dutiful son who knows that the first reader of his letters to his father is his mother, and because he knows that his father will indulge what she calls self-indulgence, but also because he thinks that his writing can stand up to the protest. Far from concealing the structure of his letters, Ruskin repeatedly points it out, making so much of the multiplication of his turns that at times he seems to be deliberately attenuating

his thought in order to demonstrate (while risking) its remaining continuous. That adversarial fervor just mentioned sometimes makes itself felt in recurrent adversative conjunctions like "but," "yet," and "though," which signal changes in direction that give their pattern to his prose. The silently curving passages of his drawings and the often mute juxtapositions of his poems become, in his letters, undauntably loquacious transitions—"By the bye (how often Ive said <that> you must be quite tired" (Burd, 259)—that enhance the impression of a mind on the move which draws the distance it covers along in its train. But Ruskin's transitions don't simply link his thoughts end to end. They display what to him is the extremely amusing fact that one remark can be drawn out of another, and nestled back in, as relentlessly as a curve can be subdivided into an infinite number of degrees:

> this whole page and a half through which I have dragged you by the nose, has been a parenthesis, though perhaps you do not know it, you will find the first hook of it about in the middle of the first page (I have made it black, that it may catch your eye and be of importances proportionable to the length of the parenthesis) and am just going to put the other, only I judge it expedient first to give you fair warning that I am going to resume the thread of my lucubrations, because I am often much puzzled by Thucydides, who interrupting himself in the middle of a sentence, and perhaps giving the whole history of a nation, in a parenthesis, recommences or rather continues his original sentence, taking it up where he left it off, without warning you.) There.
>
> (Burd, 342–43)

The compositional difficulty of how, technically, to relate part to part in his letters seems to have gone the way of his search for the subjects he found he had already got. This is true not only of their overall design—of the sections or digressions, whether parenthetical or not, which declare their attachment to a pre-existing "hook"—but also of the patterns of his individual sentences, whose involutions are made to take in the turns within the grander sweep of an imagined scene: "the mountain ridges would be peaked & crested with snow, throwing their summits against the clear blue sky, and the torrents whose force the frost is totally unable to bind, fringing their banks with icicles" (Burd, 269). Ruskin was barely thirteen when he wrote the relative clause in this sentence; unsustained as it is compared to the syntax of interrelationship that he mastered three years later in his geological diary, it has the advantage of self-consciously appearing in a letter written expressly to show off what he is learning about art.

This letter, previously quoted, in which he describes his first lesson in water colors, and then his having been thrown off his high-flying poetical course by his now "reinless Pegasus" (Burd, 268), begins and ends with attempts "to picture" his father who is traveling on business. The separation and its anxieties are naturally relieved by his imagining a reunion — "Oh I do like to picture all this!" — but what is extraordinary is the way Ruskin plays with verbal connections in considering a physical and emotional separation that puts him in mind of Gray's *Elegy* and Hamlet. The first sentence of his letter refers to his father's "last paper conversation, or communication, or in common language, letter"; and his continuing to assemble and reuse words emphatically related to each other in sound and in meaning makes a special occasion of the likelihood that any sentence will relate to something that precedes it. While it is in part Ruskin's management of repetition, synonyms, assonance, alliteration, and other visual and aural patterns that leads his reader to what is nearby, Ruskin himself seems to be led by the inherent properties of words — by a "reinless Pegasus" which flies on without him:

> all those letters, that have come before have only been accounts of anxiety, of terrible anxiety, of sleepless anxiety, caused by the cholera, & your love for us, but the last told us that, that same anxiety was abating, was decreasing, was retreating, retiring, departing, and running away. Great was the joy occasioned by the abridgment of your journey. I believe we may thank anxiety for that. I like when I am snug in bed, & the candle retiring, "which leaves the "room" to darkness, & to me" to picture our meeting "in my mind's eye Horatio" . . .
>
> (Burd, 266–67)

Verbal play like this can seem aimless; or it can seem overdetermined by the aim to give to language the responsibility for his own need to make connection with his reader, and to find connections among the elements of the world. It is a responsibility that the boy seems to think language can easily bear. For he treats verbal association as if it were not just a matter of his relating words to each other by their look or sound or definition, but of their already being so complexly interrelated and so deeply attached to the ideas they evoke that a word can bring a word in its train — a word an idea or an idea a word. As he had with the separate parts of his letters, Ruskin finds evidence inside of his words that their continuity with each other corresponds to his own mental figures and figurings. So that his best sequences tumble forth as if he needn't add his words one by one because the connections between them are built into the language of his thought: they

are part of his inheritance as a speaker of English. "Mamma says you are spoiling me," Ruskin tells his father about his birthday gift of books; "I say I am spoiling, despoiling, and taking the spoil of your pocket" (Burd, 278). He seizes what he considers to be there for the taking — whether worn-out homonyms like the one about the "tail" of his letter of which "unluckily one cannot say . . . that thereby hangs a tale" (Burd, 271), or the rewarding knowledge of those familiar words whose etymological careers can take him around as many bends as his own careering Pegasus.

It is for some of the same reasons that puns roll on and on in his boyhood writing, like ball bearings that smooth the friction between separate surfaces, or like the relentless rolling of his own prose over the things that he regards. This process and Ruskin's consciousness of it are worked together over the long stretch of a remarkable letter which, more than any other, sums up the compositional theory and practice of them all:

Tuesday, 15 Jany 1833

My dear Papa

I would write a short, pithy, laconic, sensible, concentrated, and serious letter, if I could for I have scarcely time to write a long one. Observe I only say to write, for as to the composition 'tis nothing, positively nothing. I roll on like a ball, with this exception that contrary to the usual laws of motion I have no friction to contend with in my mind and of course have some difficulty in stopping myself when there is nothing else to stop me. Mary declined writing to you for a reason which gave me peculiar and particular offense, namely, that I wrote nonsense enough, and she had nothing else to offer, as if my discreet communications, merited the cognomen of nonsense: However I did not quarrel with her as she surrendered her half sheet to me which space I was very glad to fill up with my nonsense as this additional space gave me much greater freedom & play of cogitation, as I had then not to compress my ideas, like the steam of a high pressure engine but was enabled to allow them to flow forth in all their native beauty & elegance, without cramping, by compressing, or confusing by curtailing I like elbow room in everything. In a letter it is essential and in a stage coach I should opine, that before these sheets can have reach you, you will have found the want of it, as Dogberry says "very tolerable and not to be endured." In time I know the trouble occasioned by the want of it. If the maxim which mamma is always inculcating upon me, that nothing is well done in a hurry, is without exceptions, this letter is fated for I

seldom have been more pressed. Yet letters never thrive on mature consideration. The same impulse continued or ought to continue from the "my dear" at the top to the "your affectionate" at the bottom. The momentum once given and the impetus obtained, the word is forward, and it is enough to guide, with restraining the Pegasus of thought.

I can sympathise with you in your present situation as mine is similar in a great degree. You are bogged amongst the marshes (horrid things those bogs in this season, horrid sir horrid), and I am sadly bogged in my algebra. I cant get over division, it appears to me very long-division. It is positively not to be understood and I dont like to be made a fixture of, not by no means, and I have come to a very unhandsome fix. Mr Rowbotham will pronounce my head to be – understanding, and I pronounce his lessons to be + difficulty and yet with all my algebra This minus & plus will not add & make nothing. If they would I should be on my four wheels again progressing onward to fractions which look as if they would as the Doctor says crack anybodys skull and reduce it to fractions. But I will not anticipate difficulty.

Really Sir I think the drawing room, withdrawing room or room into which I withdraw to draw, owes all its beauty to your presence. We have sat in it two nights and the vacancy of the throne which you are wont to fill and from which thou are wont to impart the learning contained in the volumes of literature enlivening it by your conversation and facilitating its comprehension by your remarks, the vacancy of that chair I say made the room appear vacant and the absence of that conversation made conversation flag. Return, oh return from thy peregrination, fly from the bosom of the bogs to the bosom of those who wait thee in anxious expectation. As the eagle returns to its eyrie, as the bird that wanders over distant climes returns to its place of rest so <do> thou return to us who are sorrowing for thy presence. <. . .> winder up!!!! Factas meas admire And now χαιροτε, as Anacreon says pour la présente pro non quantum sufficit temporis ut literam longam scriberem I remain

Your most mightily affectionate son

JOHN RUSKIN
(Burd, 274–75)

He finds his first subject in reflecting on his composition — in reflecting, that is, on the "positively nothing" with which he is so fully compatible that he can

describe it as himself: "I roll on like a ball." The only counterforce comes from without—not from his mind's interaction with his subject, which seems to involve as little "friction" as its articulation in prose, but from resistant phenomena like time and space and his cousin Mary. Unlike the latter, time and space will not move in on him but they are more stubborn in holding their ground when he starts to get expansive. And one of them can stand in for the other, so that his experience of a tight fit remains after Mary vacates the premises because the continuing lack of time reminds him of what it's like to lack space ("In time I know the trouble occasioned by the want of it"). Even his quickness to embrace time and space as subjects leaves them still unabsorbably around him, constricting the "flow" which is necessary to demonstrate that his prose is the very "play of cogitation." It is not because "greater freedom" improves his thought but because it does not impinge on virtues that are "native" to it that Ruskin's partiality to this condition displaces his conditional desire to write a "short," "pithy," "laconic," "concentrated" letter. Displaces, not replaces: a reminder of the advantages of concentration persists in the simile likening the compression of his ideas to "the steam of a high pressure engine," which, in his first memorable poem, was seen to generate numerous fruitful activities, including his own writing. And that expansive and vigorously enjambed verse seems all the more energetic for its being held within his chosen couplet form. Like the steam engine, the constraint which he writes under is a preserver as well as a destroyer, making it likely that if his "impulse" survives at all it will continue as it "ought to continue" from the top to the bottom of his letter. This is why his mother's stricture against hurry, instead of being suppressed, becomes the setting for his own maxim that "letters never thrive on mature consideration." The pressure he complains of has "pressed" him into writing the kind of letter with which he has reason to be pleased. The lack of "elbow room in everything" protects and enhances the "momentum" which is a sign that he is writing on, as well as about, Pegasean wing.

But if "the word is forward," there is still the question of exactly how to accommodate unrestrained movement within the fixed bounds which he has come to consider advantageous as well as ineluctable, " 'very tolerable and not to be endured.' " This is where what Mary calls his "nonsense" comes in—and he plays on it as ironically as he does on the variants of "pressure," first disowning "the cognomen of nonsense" and then taking it up as a cover under which to bring in what is actually "sensible" and "serious." His "nonsense" comprises not just jokes and puns but also mental turns which they express or facilitate, and which make them continuous with each other. Whether the turns in this letter are disconcertingly short and sharp, as on a word, or open out over a longer stretch as he revolves an idea in his mind, they participate in a single extended meditation

on the "laws of motion." The obstacles presented to his own rolling on like a ball bring to mind his father's rolling on in a stage coach, which brings on a second paragraph in which he associates his father's being "bogged among the marshes" with his own "bogged" progress through the field of mathematics. The matter of algebra is assimilated to his previous discourse on how one makes one's way through a letter as "the Pegasus of thought" carries him "over" one algebraic difficulty only to deposit him "on my four wheels again progressing onward" toward another. His refusal to dwell on this destination prompts him to recur to his present situation without his father, whose movements back home he imagines in a final paragraph which returns Ruskin to his opening complaint that he hasn't enough time to write a long letter. In the meantime he has managed to produce a letter which is not "short" yet is "concentrated." He has made something substantial enough to occupy space and time out of the "nothing" he calls the process of composition, substantiating his paradoxical claim that it is "positively" nothing. In fact he thinks pervasively in terms of this kind of paradox, in which the absence of one thing (a subject, for instance) is experienced as the presence of something else that suggests it. From the first, the "I" which identifies itself with an act which is "nothing" nonetheless demands, and fills, all the "elbow room" it can muster — the absence of which makes its presence felt as the incentive to get it, or as duress. The "no means" by which Ruskin finds himself able to "make nothing" by way of progress is a mathematical operation which constitutes so palpable an obstruction that Ruskin finds it not merely hard to understand but "positively not" comprehensible.

As they draw in the various and obviously related images of moving through time and space, these paradoxes eventually give to them a wider reference, a subtler coherence. This becomes clearer when the letter writer, who relentlessly multiplies his words and his turns, declares that what he cannot "get over" is "division." The believer in the continuity of a single impulse is alarmed enough by the prospect of "fractions" to decline to "anticipate difficulty." But the difficulty already tells in the next paragraph, where his father's being withdrawn from the "withdrawing room" leaves the family a fraction of itself — and introduces another instance of the way that being "minus" something can paradoxically amount to being " + difficulty." Once again "This minus & plus will not add & make nothing," and while these operations do not cancel each other out, the nothing that they do make is the composition of his paragraph. For in the absence of a Papa who can fill with meaning those "volumes" of literature and of space that he was vacated, his son must — and can — fill them up himself. Like the pressure created by the lack of ample time and space, absence (whether of a subject or of his father) has a double valence, conducing not just to an uncomfortably positive presence that is a sign of what is missing ("the absence of

that conversation made conversation flag"), but contributing also to the presence of a compelling opportunity. In both cases the sense of what he lacks helps to "guide, without restraining the Pegasus of thought." The shortness of time and space work to maintain the coherence of the expansively winding way of writing which they tend to induce; the experience, or even the anticipation, of division or fragmentation, of a separation between his thoughts or a "vacancy" in the wholeness of his world of Herne Hill — all of these are controlled by writing that makes and emphasizes connections, that sustains the one impulse that "ought to continue from the 'my dear' . . . to the 'your affectionate.'" Out of the negative experience, something positive is generated, something that reticulates and extends itself far beyond the initial connection made by a letter to an errant father. It is partly under the pressure of division and separation that the fragments of his composition coalesce.

As do his ideas about composition. To write about writing, as well as to write, is to move through time and space, contending with the pressures they create and with those that set one in motion in the first place. Ruskin naturally imitated what he heard and read about how a writer "ought" to compose, but his early letters are distinguished by the great ingenuity with which he also learns, and teaches, from his own processes of composition. It is partly on the basis of his own writing that he theorizes about writing itself and about the writing of others — a method that will come to fruition when he undertakes to draw Turner's subjects as an approach to understanding what Turner aimed at and achieved. Those were working studies, and this rose is merely "play"; but when he lays down his pen in allusion to Anacreon's laying down his lyre, it is because Ruskin believes that he has not only played for the amusement of his father but has also produced a kind of composition. At the end of his letter he translates its beginning into an array of languages, the real point of which is no longer that he hasn't time to write a long letter but that he has mastered several means of having his say. But what is most impressive about his letters is not the profusion of words which he finds to express a given idea, or to express the givens he takes on when he writes. The achievement of his best letters is their demonstration that any composition worthy of the name is put together according to "laws of motion" that are discernible in it ever after. The laws are built into it along with the words.

When he returns, in *Modern Painters* IV, to "our first impressions," it is with "a full understanding of their mystical and innermost reasons; and of much beyond and beside them, not then known to us, now added (partly as foundation, partly as a corollary) to what at first we felt or saw." Ruskin's first prose and poetry provide the best access to those experiences of writing which shaped and were the basis of the works by which he is known. To read them is to see how a beginning can eventually lead not only to a corollary but also to the discovery of its own foundation.

Chronology

1819 John Ruskin born in London, February 8, son of John James Ruskin, a prosperous wine merchant, and Margaret Cox Ruskin.

1823 The Ruskins move to Herne Hill, a suburb of London.

1835 Ruskin family begins a series of tours through Europe.

1836 Ruskin enters Christ Church, Oxford.

1838 John Ruskin fall in love with Adele Domecq, the daughter of his father's Spanish partner.

1839 Ruskin awarded the Newdigate Prize for poetry. The family moves into a large country house at Denmark Hill, near Dulwich.

1840 Suffers hemorrhage and, on the advice of his doctors, spends the spring in Italy, accompanied by his family. Makes friends with the painter George Richmond.

1842 Graduates from Oxford. Begins work on *Modern Painters*.

1843 *Modern Painters* I published to acclaim.

1845 Sets out on exploration of northern Italy, producing many sketches.

1846 Meets Carlyle. The second volume of *Modern Painters* appears in April.

1848 Marries Euphemia (Effie) Chalmers Gray in April.

1849 Publishes *The Seven Lamps of Architecture*. Spends winter in Venice studying its architecture.

1851 The first volume of *The Stones of Venice* appears. Ruskin is introduced to the Pre-Raphaelite Brotherhood, becoming friends with Edward Burne-Jones and with John Everett Millais, who becomes romantically involved with Effie. Ruskin writes the pamphlet, *Pre-Raphaelitism*.

1853 Publishes *The Stones of Venice* II and III.

1854 Effie successfully petitions to have the marriage annulled, citing Ruskin's impotence.

1855 Effie marries Millais.

1856 Publishes *Modern Painters* III and IV.

1857 Ruskin spends most of the year cataloging and arranging the drawings that Turner bequeathed to the National Gallery. Gives frequent lectures, publishing some as *The Political Economy of Art* (later retitled *A Joy for Ever.*)

1858–59 Spend six weeks in Turin, Italy, alone save for a valet and guide. Works on the fifth volume of *Modern Painters.* Becomes enamored of Rose La Touche, a young and mentally unstable Anglo-Irish girl.

1862 Publishes a series of essays on the nature of wealth and labor as *Until This Last.* Retires to Mornex, Switzerland, for a rest.

1864 His father dies, bequeathing him 120,000 pounds, an excellent collection of paintings, and various properties. Ruskin lives with his mother at Denmark Hill.

1866 *The Ethics of the Dust* is published.

1867 Publishes letters to workingmen *Time and Tide, by Weare and Tyne.*

1869 Ruskin appointed the first Slade Professor of Fine Art at Oxford University.

1871 His mother dies. Ruskin sells the house in Denmark Hill and moves into Brantwood, a house on Coniston Water in the Lake District.

1871–84 Publishes more letters, *Fors Clavigera,* a publication of the Guild of St George.

1872 Spell of madness following Rose La Touche's refusal of his offer to marry her.

1878 In November, the painter James McNeill Whistler sues Ruskin for libel, in response to Ruskin's vitriolic criticism of him; he is awarded one farthing in damages.

1879 Ruskin resigns the Slade chair, citing Whistler's successful suit against him.

1881 Ruskin's mental state enjoys some improvement. He resumes his position in Oxford, despite recurring attacks of mania.

1884 Resigns Slade chair again, prompted by the establishment of a physiology laboratory in which vivisection took place. Lives in Brantwood, looked after by his cousin, John Severn.

1885–89 Works on his autobiography, *Praeterita*, but is unable to finish after his sixth attack of madness in the summer of 1889.

1900 In the midst of an influenza epidemic, Ruskin dies on January 20, and is buried at Coniston, Lancashire.

Contributors

HAROLD BLOOM, Sterling Professor of the Humanities at Yale University, is the author of *The Anxiety of Influence, Poetry and Repression,* and many other volumes of literary criticism. His forthcoming study, *Freud: Transference and Authority,* attempts a full-scale reading of all of Freud's major writings. A MacArthur Prize Fellow, he is general editor of five series of literary criticism published by Chelsea House.

GEORGE LANDOW is Professor of English at Brown University and the author of *The Aesthetic and Critical Theories of John Ruskin; Images of Crisis: Literary Iconology, 1750 to the Present, Ruskin; Victorian Types, Victorian Shadows: Biblical Typology in Victorian Literature, Art, and Thought;* and *William Holman Hunt and Typological Symbolism.*

JAY FELLOWS is Mellon Professor of Literary Theory at the Cooper Union School of Architecture. He is the author of two remarkable studies, *The Failing Distance: The Autobiographical Impulse in John Ruskin* and *Ruskin's Maze: Mastery and Madness in His Art,* and of two distinguished forthcoming books on Pater, entitled *Paterian "Under-Textures"* and *White Indeterminacy in Walter Pater.*

JOHN DIXON HUNT is the author of *Andrew Marvell: His Life and Writings; The Figure in the Landscape: Poetry, Painting, and Gardening during the Eighteenth Century; The Pre-Raphaelite Imagination, 1848–1900;* and *The Wider Sea: A Life of John Ruskin.*

WILLIAM ARROWSMITH is Robert L. Woodruff Professor of Classics and Comparative Literature at Emory University. He is noted, among other things, for his translations of Euripides, Aristophanes, Montale, and Parese.

STEPHEN BANN is the author of *The Clothing of Clio: A Study of the Representation of History in Nineteenth-Century Britain and France.* He is a Reader of History and Art History at the University of Kent at Canterbury.

ELIZABETH HELSINGER is Associate Professor of English at the University of Chicago and the author of *Ruskin and the Art of the Beholder*.

GARY WIHL teaches English at McGill University, Montreal. He is the author of *Ruskin and the Rhetoric of Infallibility*.

SHEILA EMERSON is Assistant Professor of English at Tufts University and has published articles and reviews about nineteenth-century literature. She is writing a book about Ruskin.

Bibliography

Alexander, Edward. "Art Amidst Revolution: Ruskin in 1848." *Victorian News-letter* 40 (Fall 1971): 8–13.

———. *Matthew Arnold, John Ruskin, and the Modern Temper.* Athens: Ohio University Press, 1973.

Anthony, Peter. *John Ruskin's Labour: A Study of Ruskin's Social Theory.* Cambridge: Cambridge University Press, 1983.

Ball, Patricia M. "The Science of Aspects: The Changing Role of Fact." In *The Work of Coleridge, Ruskin, and Hopkins.* London: Athlone Press, 1971.

Beetz, Kirk H. *John Ruskin: A Bibliography, 1900–1974.* Metuchen, N.J.: Scarecrow Press, 1976.

Bell, Quentin. *Ruskin.* New York: Braziller, 1978.

Burd, V. A. "Another Light on the Writing of *Modern Painters.*" *PMLA* 68, no. 4, pt. 1 (September 1953): 755–63.

———. "Ruskin's Defense of Turner: The Imitative Phase." *Philological Quarterly* 37, no. 4 (1958): 465–83.

———. "Ruskin's Quest for a Theory of the Imagination." *Modern Language Quarterly* 17, no. 1 (March 1956):60–72.

Conner, Patrick. *Savage Ruskin.* London: Macmillan, 1979.

Dearden, James S. *Facets of Ruskin: Some Sesquicentennial Studies.* London: Charles Skilton, 1970.

Dougherty, C. T. "Of Ruskin's Gardens." In *Myth and Symbol,* edited by B. Slote, 14–151. Lincoln: University of Nebraska Press, 1963.

Evans, Joans. *John Ruskin.* New York: Oxford University Press, 1954.

Fain, J. T. *Ruskin and the Economists.* Nashville: Vanderbilt University Press, 1956.

Fellows, Jay. *The Failing Distance: The Autobiographical Impulse in John Ruskin.* Baltimore: The Johns Hopkins University Press, 1975.

———. *Ruskin's Maze: Mastery and Madness in His Art.* Princeton: Princeton University Press, 1981.

Fitch, Raymond E. *The Poison Sky: Myth and Apocalypse in Ruskin.* Athens: Ohio University Press, 1982.

Fontaney, P. "Ruskin and Paradise Regained." *Victorian Studies* 12, no. 3 (March 1969): 347–56.

Garrigan, K. O. *Ruskin on Architecture: His Thought and His Influence.* Madison: University of Wisconsin Press, 1974.

Hayman, John. "Ruskin's *The Queen of the Air* and the Appeal of Mythology." *Philological Quarterly* 57, no. 1 (Winter 1978): 104–14.

―――. "John Ruskin and the Art of System-Making." *The Yearbook of English Studies* 4 (1974): 197–202.

Helsinger, Elizabeth K. *Ruskin and the Art of the Beholder.* Cambridge: Harvard University Press, 1982.

Herrman, L. *Ruskin and Turner.* London: Faber & Faber, 1968.

Hewison, Robert. *John Ruskin: The Argument of the Eye.* London: Thames & Hudson, 1976.

―――, ed. *New Approaches to Ruskin: Thirteen Essays.* London: Routledge & Kegan Paul, 1981.

Hunt, John Dixon, and Faith M. Holland. *The Ruskin Polygon: Essays on the Imagination of John Ruskin.* Manchester, England: Manchester University Press, 1982.

Johnson, W. S. "Memory, Landscape, Love: John Ruskin's Poetry and Poetic Criticism." *Victorian Poetry* 19, no. 1 (Spring 1981): 19–34.

Kirchhoff, Frederick. *John Ruskin.* New York: Twayne, 1984.

Ladd, H. *The Victorian Morality of Art: An Analysis of Ruskin's Esthetic.* New York: Long & Smith, 1932.

Landow, George P. *The Aesthetic and Critical Theories of John Ruskin.* Princeton: Princeton University Press, 1971.

―――. "Ruskin's Revisions of the Third Edition of *Modern Painters, Volume 1.*" *Victorian Newsletters* 33 (Spring 1968): 12–16.

―――. "Ruskin's Version of 'Ut Pictura Poesis.'" *The Journal of Aesthetics and Art Criticism* 26, no. 4 (Summer 1968): 521–28.

Leon, D. *Ruskin, the Great Victorian.* London: Routledge & Kegan Paul, 1949.

Luytens, Mary. *The Ruskins and the Grays.* London: John Murray, 1967.

Penny, N. "John Ruskin and Tintoretto." *Apollo* 99, no. 146 (April 1974): 268–73.

Quennell, Peter. *John Ruskin, the Portrait of a Prophet.* New York: Viking, 1949.

Rhodes, Robert, and Del Ivan Janik, eds. *Studies in Ruskin: Essays in Honor of Van Akin Burd.* Athens: Ohio University Press, 1982.

Rosenberg, John D. *The Darkening Glass: A Portrait of Ruskin's Genius.* London: Routledge & Kegan Paul, 1963.

———. "Style and Sensibility in Ruskin's Prose." In *The Art of Victorian Prose,* edited by George Levine and William Madden. New York and London: Oxford University Press, 1968.

Sawyer, Paul. *Ruskin's Poetic Argument: The Design of the Major Works.* Ithaca: Cornell University Press, 1985.

Shaw, W. D. " 'The Very Central Fiery Heart': Ruskin's Theories of the Imagination." *Journal of English and German Philology* 80, no. 2 (April 1981): 199–225.

Sherburne, J. C. *John Ruskin or the Ambiguities of Abundance.* Cambridge: Harvard University Press, 1972.

Sonstroem, D. "John Ruskin and the Nature of Manliness." *Victorian Newsletter* 40 (Fall 1971): 14–17.

Spear, Jeffrey L. "Ruskin as a Prejudiced Reader." *ELH* 49, no. 1 (Spring 1982): 73–98.

Sprinker, Michael. "Ruskin on the Imagination." *Studies in Romanticism* 18, no. 1 (Spring 1979): 115–39.

Stein, Richard L. *The Ritual of Interpretation: The Fine Arts as Literature in Ruskin, Rossetti, and Pater.* Cambridge: Harvard University Press, 1975.

Stein, Roger B. *John Ruskin and Aesthetic Thought in America, 1840–1900.* Cambridge: Harvard University Press, 1967.

Sussman, Herbert L. *Facts into Figures: Typology in Carlyle, Ruskin, and the Pre-Raphaelite Brotherhood.* Columbus: Ohio State University Press, 1975.

Townsend, Francis G. *Ruskin and the Landscape of Feeling.* Urbana: University of Illinois Press, 1951.

Walton, P. *The Drawings of John Ruskin.* London: Oxford University Press, 1972.

Acknowledgments

"Introduction" (originally entitled "Ruskin as Literary Critic") by Harold Bloom from *The Ringers in the Tower: Studies in Romantic Tradition* by Harold Bloom, © 1971 by The University of Chicago Press. Reprinted by permission of the publisher.

"Ruskin's 'Language of Types'" (originally entitled "Ruskin and Allegory") by George Landow from *The Aesthetic and Critical Theories of John Ruskin* by George Landow, © 1971 by Princeton University Press. Reprinted by permission of the publisher.

"Capricious Sinuousities: Venice and the City as Mind" by Jay Fellows from *Ruskin's Maze: Mastery and Madness in His Art* by Jay Fellows, © 1981 by Princeton University Press. Reprinted by permission of the publisher.

"*Ut pictura poesis,* the Picturesque, and John Ruskin" by John Dixon Hunt from *MLN* 93, no. 5 (December 1978), © 1978 by The Johns Hopkins University Press. Reprinted by permission of the publisher.

"Ruskin's Fireflies" by William Arrowsmith from *The Ruskin Polygon: Essays on the Imagination of John Ruskin* edited by John Dixon Hunt and Faith M. Holland, © 1982 by William Arrowsmith. Reprinted by permission of Manchester University Press.

"The Colour in the Text: Ruskin's Basket of Strawberries" by Stephen Bann from *The Ruskin Polygon: Essays on the Imagination of John Ruskin* edited by John Dixon Hunt and Faith M. Holland, © 1982 by Manchester University Press. Reprinted by permission of Manchester University Press.

"The Ruskinian Sublime" by Elizabeth Helsinger from *Ruskin and the Art of the Beholder* by Elizabeth Helsinger, © 1982 by the President and the Fellows of Harvard College. Reprinted by permission of Harvard University Press.

"Unity and Proportion: Metaphor as Symbolic Representation" by Gary Wihl from *Ruskin and the Rhetoric of Infallibility* by Gary Wihl, © 1985 by Yale University. Reprinted by permission of Yale University Press.

Index

Abstract form, appearance and, 138
Abstraction, associational, 139
Alberti, Leon Battista, 64
Alciati, Andrea, 60
Alison, Archibald, 139; appearance and, 140; architecture and, 142; beauty and, 141; proportion and, 135, 140, 141–42
Allegory: analogy versus, 17; demise of, 28; differences between figural interpretation and, 26–27; Evangelicals and, 27; Melvill and, 26, 27; Roche and, 28; Ruskin's use of, 11, 26; Ruskin's views on, 15
Alps, the: ruins of, 54; Ruskin's views on, 9, 54, 55–56, 83–84
Analogy, allegory versus, 17
Andrews, Rev. E., 19
Angelico, Fra, 136–38, 139
Animation, Ruskin's poems and, 156, 158
Apparent proportion, 135, 139–40, 143
Appearance: abstract form and, 138; Alison and, 140; proportion and, 135, 143; Ruskin and, 147; types of, 135; unity and, 134
Architectural: ornament, 61–63; proportion, 141, 142
Architectural Magazine, 55, 60
Architecture: Alison and, 142; the sublime in, 125–26
Arnold, Matthew, 27, 101
Art: definition of grotesque, 120; morality of, 6–7
Artists: the grotesque and the sublime and imaginative, 123, 129; role of, in *Modern Painters* I, 130; role of, in *Modern Painters* IV, 130–31; seeing and, 123, 129, 130, 131
Associational abstraction, 139

Associationism, 138–39
As You Like It (Shakespeare), 92
Aurora Leigh (Elizabeth Barrett Browning), 7

Ball, A. H. R., 13
Beauty: Alison and, 141; Burke and, 143, 144, 145; proportion and, 140, 141, 142; Ruskin and, 141, 148; theory of typical, 27
Beever, Susan, 37, 91, 92
Bellini family, 53
Benjamin, Walter, 132
Bible: types in, 22; Melvill and types in, 26
Bible of Amiens, The, 86
Bible reading, influence of, 18–19, 89
Biblical symbols, 12
Blake, William, Ruskin compared to, 12
Bridgewater, Sir Charles Bell, 146
Bronzino, Il (Agnolo di Cosimo), 139
Brown, Walter, 8
Browning, Elizabeth Barrett, 7
Brunelleschi, Filippo, 43
Burd, Van Akin, 137, 138, 152
Burke, Edmund, 54; beauty and, 143, 144, 145; proportion and, 135, 143, 144; variety and, 143–44
Burkean sublime, 117, 119
Burnet, Thomas, 54
Byron, George Gordon, Lord, 11; sublimity and, 118, 119, 132

Carlyle, Thomas, 71, 102
Carpaccio, Vittore, 53
Cézanne, Paul, 107
Childhood, Ruskin's, 7–8

189